Nature Observed, Nature Interpreted

DISTRIBUTED BY UNIVERSITY PRESS OF NEW ENGLAND

HANOVER AND LONDON

Nature Observed, Nature Interpreted

Nineteenth-Century American Landscape Drawings & Watercolors
from the National Academy of Design and Cooper-Hewitt
National Design Museum, Smithsonian Institution

CATALOGUE BY
Dita Amory & Marilyn Symmes

INTRODUCTORY ESSAY
Linda S. Ferber

CONTRIBUTIONS
Gail S. Davidson, David B. Dearinger
Elizabeth Horwitz, and Abigail Messitte

National Academy of Design *with* Cooper-Hewitt
National Design Museum, Smithsonian Institution
New York · 1995

The exhibition and catalogue *Nature Observed, Nature Interpreted: Nineteenth-Century American Landscape Drawings & Watercolors from the National Academy of Design and Cooper-Hewitt National Design Museum, Smithsonian Institution* have been generously supported by the Henry Luce Foundation, Inc. and the National Endowment for the Arts with additional support from Warren J. Adelson and the Gilbert & Ildiko Butler Foundation

EXHIBITION DATES

National Academy of Design, New York	April 7 – June 13, 1995
Amon Carter Museum, Fort Worth	July 8 – September 3, 1995
The Detroit Institute of Arts, Detroit	October 7 – December 3, 1995

FRONT COVER: William Trost Richards, *Landscape with Trees on a Hillside* (no. 74)
BACK COVER: Thomas Moran, *Half Dome, Yosemite* (no. 55)

Edited by Kathleen Luhrs
Designed by Christopher Kuntze
Printed by Hull Printing Company, Meriden, Connecticut
National Academy photography by Anthony F. Holmes
Cooper-Hewitt National Design Museum photography by Ken Pelka
Figs. 4, 5, and 6 are from Rare Books and Manuscripts Division
The New York Public Library, Astor, Lenox and Tilden Foundations

LIBRARY OF CONGRESS CATALOGING-IN-PUBLICATION DATA

National Academy of Design (U.S.)
Nature observed, nature interpreted: nineteenth-century American landscape drawings & watercolors from the National Academy of Design and Cooper-Hewitt, National Design Museum, Smithsonian Institution / catalogue by Dita Amory & Marilyn Symmes; introductions, Linda Ferber; contributions, Gail S. Davidson . . . [et al.].
p. cm.
Exhibition catalog.
Includes bibliographical references and index.
ISBN 1-887149-00-7
1. Landscape in art—Exhibitions. 2. Art, American—Exhibitions. 3. Art, Modern—19th century—United States—Exhibitions. 4. Art—New York (N. Y.)—Exhibitions. 5. National Academy of Design (U. S.)—Exhibitions. 6. Cooper-Hewitt Museum—Exhibitions. I. Amory, Dita, 1954– II. Symmes, Marilyn F.
III. Cooper-Hewitt Museum. IV. Title.
N8214.5.U6N36 1995
758'.1'09730747471—dc20 95-5941
 CIP

Contents

List of Color Plates

Foreword

Nature Observed, Nature Interpreted is the first collaborative exhibition derived from the remarkable collections of the National Academy of Design and Cooper-Hewitt National Design Museum, Smithsonian Institution. These two New York institutions, with proud origins in the nineteenth century, each approach design from a different perspective. During a century when unprecedented geographical and cultural expansion occurred in the United States, many artists sought inspiration from studying nature or experiencing spectacular wilderness landscapes on this continent and beyond. Eighty-six works from this pictorial legacy, dating from the 1820s to the 1890s, are featured in this exhibition.

While our neighboring institutions, located just a block apart on Fifth Avenue, both have the word *design* in their names, each has its own distinct history, identity, and purpose. The National Academy of Design was founded in 1825 by a group of young artists. First called the New York Drawing Association, it became the National Academy of the Arts of Design in 1826. The "arts of design" then designated what is now considered the fine arts: painting, sculpture, architecture, and engraving. In the nineteenth century, *design* was often equated with drawing, the basis of most art education. Although drawing did not feature as an independent discipline when the organization was formalized to include painters, sculptors, architects, and printmakers, the art of drawing was always of fundamental importance to the National Academy. The catalogue of the Academy's first annual exhibition stated the founders' mission to be "the advancement of the arts they profess, the benefit of the Public generally, and of all artists throughout the United States." The annual exhibitions, uninterrupted since 1826, have from their inception featured works on paper along with paintings and sculpture.

As one of the oldest arts organizations in the United States, the National Academy still honors its original directive to "promote the fine arts in America through instruction and exhibition." It is today a museum, a school, and an honorary association of artists. The membership has included prominent American painters, sculptors, architects, and printmakers, many of whom are represented in this exhibition. Their drawings and watercolors, chosen from the Academy's extensive holdings, were generally donated through gift or bequest by artist members themselves or their descendants.

Cooper-Hewitt National Design Museum is the only museum in the United States devoted to documenting historical and contemporary design. Defining *design* as a "process of shaping matter to a purpose," the National Design Museum's collections, research, and educational programs investigate the creation and consequences of designed objects amid the designed environment we all inhabit. In 1897, Amy, Eleanor, and Sarah Hewitt, the grand-

daughters of the industrialist Peter Cooper, opened the Cooper Union Museum for the Arts of Decoration. Its collections of drawings and prints, books, textiles, wall coverings, ceramics, glass, furniture, metalwork, and other decorative arts were acquired to educate and inspire generations of artisans and designers. The Museum was originally located in Lower Manhattan at the Cooper Union for the Advancement of Science and Art, founded by Peter Cooper in 1859 as a free school open to students regardless of race, creed, color, or sex. Students were taught fine workmanship and respect for materials and technology; they were also encouraged to explore traditional and innovative ideas about function, form, and ornament. In 1967, the Cooper Union Museum collections became part of the Smithsonian Institution. In 1976, the Museum relocated to the 1902 Andrew Carnegie Mansion at Fifth Avenue and 91st Street. The Museum's name, Cooper-Hewitt National Design Museum, honors its founders and reflects its mission.

In addition to gathering vast numbers of works pertaining to architecture, decoration, and ornament, the Hewitt sisters acquired major collections of landscape and figure drawings directly from American artists or their families. Cooper Union students were encouraged to study these original works in order to better understand the importance of drawing as a tool for observing and selecting natural motifs that might be adapted or developed for a decorative or artistic purpose. Selections from some of these early gifts of drawings by Frederic Edwin Church, Winslow Homer, and Thomas Moran, among others, are featured in this exhibition.

Dita Amory, National Academy curator, and Marilyn Symmes, Cooper-Hewitt National Design Museum curator of drawings and prints, are responsible for conceiving and organizing this exhibition. For their commendable skills and tireless efforts in realizing this joint venture we extend our special thanks and appreciation. They, along with exhibition catalogue contributors David B. Dearinger, National Academy associate curator and archivist; Gail S. Davidson, National Design Museum assistant curator of drawings and prints; Elizabeth Horwitz, National Design Museum curatorial assistant of drawings and prints; Abigail Messitte, and the staffs of both our museums set an admirable standard for a cooperative effort and the sharing of resources between institutions. The National Academy assumed the prime responsibility for fundraising for this project, and Sandy Repp, National Academy director of development, expertly coordinated various logistics for funding support. As with any major exhibition and publication, there are numerous individuals whose participation and cooperation have made this project possible. They are named in the Acknowledgments.

We wish to express our deep gratitude to the Henry Luce Foundation, Inc., the National Endowment for the Arts, and other funders, Warren J. Adelson and the Gilbert & Ildiko Butler Foundation, for generous grants in support of this exhibition, hosted by the National Academy of Design, and for the catalogue which accompanies it.

We are exceedingly pleased to present this exhibition and catalogue at the National Academy of Design and later at the Amon Carter Museum and the Detroit Institute of Arts. We thank Jan Mulhert, director, and Jane Myers, associate curator, at the Amon Carter, and Samuel Sachs II, director, and Ellen Sharp, curator of graphic arts at the Detroit Institute of Arts, for their enthusiasm for this endeavor.

Edward P. Gallagher
Director
National Academy of Design

Dianne H. Pilgrim
Director
Cooper-Hewitt National Design Museum

Acknowledgments

THIS EXHIBITION and publication have provided a welcome opportunity for the National Academy of Design and Cooper-Hewitt National Design Museum to collaborate—integrating what are two very complementary drawing collections. It has proved to be both an enjoyable and informative endeavor. We very much appreciate the encouragement and support we received from our directors, Edward P. Gallagher and Dianne H. Pilgrim, to embark on this venture, aimed at furthering knowledge of American drawing and presenting our museum audience with fine examples of the genre.

Many staff members from both museums were instrumental in facilitating this project. We could not have accomplished this work without the crucial efforts of key staff, volunteers, and interns. At the National Academy of Design, we are grateful to the following members of the staff for their many contributions: Abigail Messitte, research intern; Souhad Rafey; Heidi Rosenau; Larry Spain; Colin Thompson; and David B. Dearinger, who kindly answered innumerable archival questions in addition to writing several of the entries. At Cooper-Hewitt National Design Museum, very special thanks go to Gail S. Davidson, Elizabeth Horwitz, John Randall, and Scott Ruby, volunteers Dorothy U. Compagno and Eylene King, interns Anna Eschapasse and Marta Weiss. We are also appreciative of the efforts of the following staff: Nancy Aakre, John Corbo, Linda Dunne, Laura Ford, Juliette Ibelli, Laura James, Steven Langehough, Barbara Livenstein, David McFadden, Caroline Mortimer, Bradley Nugent, Cordelia Rose, Larry Silver, Rona Simon, Pauline Sugino, Lois Woodyatt, Susan Yelavich, and Egle Zygas. In the Smithsonian Institution Libraries, Cooper-Hewitt National Design Museum Branch, Stephen Van Dyk, Leonard Webers, and Tim Sullivan were particularly helpful in responding to numerous research requests.

Konstanze Bachmann, Cooper-Hewitt National Design Museum paper conservator, and Daria Keynan, formerly National Academy of Design paper conservator, were responsible for treating objects in the exhibition, many of which are shown here for the first time since conservation. We are also grateful to Deborah Evetts, book conservator, for her contributions. Their scrupulous care has assured the presentation of these collections in the best possible state of preservation.

We are grateful to Linda S. Ferber, chief curator at the Brooklyn Museum, for providing a general overview of nineteenth-century landscape drawing. In addition, she was unfailingly helpful in assisting the exhibition team, particularly on matters pertaining to William Trost Richards. For their insightful guidance and for ably nurturing this book through demanding production stages, we thank Kathleen Luhrs for editing expertise and Christopher

Kuntze for providing the publication's handsome graphic design. Anthony F. Holmes and Ken Pelka were responsible for photography.

Colleagues were extraordinarily generous in sharing their research resources, their time, and their knowledge of American art. Every contributor to this catalogue benefited enormously from visits to William H. Gerdts's research library; we are indebted to him for kindly responding to many requests that tapped his far-reaching experience in the field. Kevin J. Avery, Department of American Paintings and Sculpture, Metropolitan Museum of Art, greatly facilitated the authors' use of his department's research resources, and he gave invaluable art historical and editorial advice on many entries. Robert Bardin graciously provided crucial information on the career of Samuel Isham. Gerald Carr, University of Delaware, and Elaine Evans Dee, Cooper-Hewitt National Design Museum curator emerita, were helpful consultants on matters pertaining to Frederic Edwin Church. Ellwood C. Parry III, University of Arizona, furnished important insights regarding Thomas Cole at critical stages of our research process. The special efforts of Roberta Waddell, Print Room, New York Public Library, in researching Owen G. Hanks and William James Bennett are especially appreciated.

We wish to thank the many other people who kindly assisted us in important aspects of this project: Diana Arecco, New-York Historical Society; Martin Bansbach; Sherry Birk, Octagon Museum, American Architectural Foundation; Annette Blaugrund, New-York Historical Society; Lillian Brenwasser, Kennedy Galleries; Thomas Bruhn, William Benton Gallery, University of Connecticut; Michael Butterfield, Portland Art Museum; Bernadette Callery, New York Botanical Garden; Teresa Carbone, Brooklyn Museum; Ellen Cimini, formerly National Academy of Design; Martin L. Cohen, Belmont Historical Society; Susan Danly, Mead Art Museum, Amherst College; Gerry Eaton; M. Alison Eisendrath, Museum of the City of New York; Amy Eller, Guild Hall, East Hampton; Andrea Henderson Fahnestock; Lynn Ferrara, Brooklyn Museum; Sandra Feldman, Hirschl & Adler Galleries; Barbara File, Metropolitan Museum of Art; Martha Fleischmann, Kennedy Galleries; Carter Foster, New York Public Library; Kathleen A. Foster, Indiana University Art Museum; David Franz, New Jersey Historical Society; the staff of the Frick Art Reference Library; Abigail Booth Gerdts; Wendy Greenhouse; Mary Haas, Fine Arts Museums of San Francisco; Philip Hayden, New Jersey Historical Society; Donica N. Haraburda and her colleagues, National Museum of American Art Inventories of American Painting; Andrew Henderson, New York Botanical Garden; Mattie Kelly, Bowdoin College Museum of Art; Dr. Kenneth Kenigsberg; Marilyn Kushner, Brooklyn Museum; Leonard Milberg; Elizabeth Milleker, Metropolitan Museum of Art; M. P. Naud, Hirschl & Adler Galleries; the staffs at the Newport Historical Society and New Britain Museum of American Art; New York State Office of Parks, Recreation and Historic Preservation Photographic Services staff; William O'Reilly, Salander-O'Reilly Galleries; Janet Parks, Avery Architectural and Fine Arts

Library, Columbia University; Ronald Pisano; Paul Provost, New-York Historical Society; Michael Quick; Sue Welsh Reed, Museum of Fine Arts, Boston; Sarane Ross; Dr. and Mrs. Ira Rothfield; Jack Rutland, New-York Historical Society; Melissa M. Seiler, Brooklyn Museum; Marvin Schwartz, Metropolitan Museum of Art; Wendy J. Shadwell, New-York Historical Society; Barbara Shapiro, Museum of Fine Arts, Boston; Marc Simpson, formerly Fine Arts Museums of San Francisco; Cheryl Sobas, Brooklyn Museum; Ira Spanierman and the staff of Spanierman Gallery; Lane Sparkman, Hirschl & Adler Galleries; Elizabeth Stevens, Salander-O'Reilly Galleries; Kathryn Talalay, American Academy of Arts and Letters; Timothy Warren; Mr. and Mrs. Willard Clinton Warren; Bruce Weber, Berry-Hill Galleries; H. Barbara Weinberg, Metropolitan Museum of Art; Nelson Holbrook White; Tony P. Wrenn, American Institute of Architects.

A Tale of Two Collections

Dita Amory & Marilyn Symmes

THE WATERCOLORS, drawings, and sketchbooks featured in this publication and exhibition represent two distinguished public collections formed in nineteenth-century America. The National Academy of Design, founded in 1825, and Cooper-Hewitt National Design Museum, Smithsonian Institution, founded in 1897, were among the first art institutions in New York to build collections of American drawings, and their holdings are complementary and intersect in many significant ways.

While the two museums have amassed comparable collections of American draftsmanship, they vary in size and scope, as did the impetus for their development. The National Academy's drawing collection reflects its history as an honorary association of professional artists. From the Academy's inception artists' contributions have shaped the collections. An invitation to membership was indispensable to aspiring professionals in the fine arts. Academy members selected the vaunted annual exhibitions and actively participated in formulating the curriculum of its School of Fine Arts. The Academy was the standard bearer of aesthetic taste in the nineteenth century, and its collections represented the best the country had to offer.

Cooper-Hewitt National Design Museum's drawing collection was initiated by the Hewitt sisters—Eleanor, Sarah, and Amy—as part of the Cooper Union Museum for the Arts of Decoration, a study facility for the progressive art school founded by their grandfather Peter Cooper. The Cooper Union for the Advancement of Science and Art was established in 1859 at Astor Place in New York, where it still exists. Cooper Union offered training to a broad public in many artistic disciplines: architectural drawing, mechanical drawing, life and cast drawing, ornamental drawing, oil painting, and illustration. It prided itself on its democratic admissions policy, and, to this day, tuition is free. It was in the spirit of Cooper's philanthropic mission as an educator that his granddaughters set out to build a collection of drawings and prints so that Cooper Union could supplement students' art education. That collection became part of the Smithsonian Institution in 1967 and became the Cooper-Hewitt Museum in 1976. The almost 10,000 drawings and watercolors by nineteenth-century American artists in the Museum's collection rank among the richest and most extensive in public hands today.

THE NATIONAL ACADEMY OF DESIGN

The National Academy of Design was one of the country's first professional organizations for artists. Combining a membership, a drawing school, and exhibition opportunities,

its founding in 1825 proved a pioneering step toward the training of professional artists in this country. An honorary association of artists to this day, the National Academy owes its origins to a group of spirited young New York artists, principally Samuel F. B. Morse, who later invented the telegraphic code. Though the founding members were mostly history and portrait painters, landscape painters played a role as well. Thomas Cole and, especially, Asher B. Durand were among its illustrious first promoters.

Over time, the Academy became the single most influential force in the development of the fine arts in New York. Modeled after the Royal Academy in London—then under the presidency of Sir Thomas Lawrence—the founders determined to offer young artists a rigorous training in drawing, which had long been available in European academies. The initiation of an annual juried exhibition provided artists with much needed exhibition opportunities, and a stringent admission policy set an aesthetic standard by which aspiring professionals were ultimately evaluated.

As the Academy's constitution evolved, it was determined that newly elected members should give a portrait of themselves as a condition of membership. On advancing in rank to National Academician, members were asked again to contribute to the collection, this time an example of their mature work. Known as "diploma pieces," these submissions in painting, sculpture, and printmaking have, over time, accumulated to form one of the largest collections of American art in the country. The Academy's collection thus grew directly, and almost without exception, through membership contributions rather than through curatorial selection. Artists joined the organization either as painters, sculptors, architects, printmakers, or watercolorists (a class of membership added only in 1943). Because most members have been painters, paintings comprise the major portion of the collection.

Until the introduction of watercolorists into its membership, and thus the regular submission of watercolors to the collection, the National Academy had no systematic program for collecting drawings. Even today its little-known collection remains small—numbering some 1,100 sheets and sketchbooks. Drawings and watercolors, however, were featured in the Academy collections by the mid-nineteenth century. The second inventory (1852), for example, lists this exhibition's unfinished watercolor by William James Bennett (no. 5).[1] Indeed, the drawing collection was largely formed in the nineteenth century, through generous gifts and bequests from artist members and their descendants. Along with a selection of his paintings, Samuel F. B. Morse left the Academy a bequest of drawings, letters, and manuscripts relating to the many facets of his productive career as an artist and scientist. In 1902 the prolific printmaker James David Smillie donated a varied selection of his own prints,

1. *Constitution of the National Academy of Design and Schedule of the Property* (New York, 1852). For further discussion of the growth of the Academy's collections, see New York 1989a.

along with a lovely watercolor by Owen G. Hanks (no. 36).[2] The following year Samuel Colman gave a significant collection of etchings, books, and photographs. Though the Academy records lack a precise date for Samuel Isham's gift of landscape and figure drawings, it is likely they were deposited sometime in the first decade of this century when he was a frequent lecturer at the School.

In the course of the National Academy's long history, families of deceased members have prevailed upon the institution to assist in the disposition of artists' estates to other museums and art institutions throughout the country. In this role, the Academy augmented its own holdings, assured the consolidation and preservation of works of art, and contributed to building collections of American art nationwide. Cooper-Hewitt National Design Museum was often a major beneficiary, receiving many works by William Trost Richards and William Stanley Haseltine under the Academy's provisions of estate dispersal. In 1952, the National Academy received a vast inheritance of paintings, watercolors, drawings, and sketchbooks by William Trost Richards from the artist's daughter, Anna Richards Brewster. Recognizing the size and importance of the gift, it was decided to retain a selection and then distribute the remainder to other museums, including Cooper-Hewitt National Design Museum. In a similar fashion, in 1961 the National Academy assisted William Stanley Haseltine's daughter and biographer, Helen Haseltine Plowden, in distributing close to one hundred paintings and drawings by her father. Cooper-Hewitt National Design Museum was given more than seventy drawings and watercolors at this time. The National Academy selected only two works from the Plowden gift, a drawing (no. 38) and painting of Capri. This conservative selection was probably due to space and preservation considerations, for the National Academy then lacked a sizable art storage facility.

While the National Academy's acquisition of drawings via gifts and bequests has been intermittent, drawings were shown alongside paintings in the annual exhibitions from the very beginning. For example, William James Bennett, the Academy's first keeper of collections, showed watercolors as early as 1827 in the second annual exhibition. The American Society of Painters in Water Colors, founded in 1866, shared exhibition galleries with the National Academy, first in its building at 23rd Street and Fourth Avenue and later in the present building at 1083 Fifth Avenue. There were many artists over the years who took an active role in both organizations, including American Society of Painters in Water Colors founder Samuel Colman and printmaker James David Smillie.

At the National Academy's School of Fine Arts, the training of young artists in drawing classes provided the impetus for its founding and remains the core of its curriculum today.

2. Smillie was the first to teach etching at the National Academy's School beginning in the 1893–1894 term, and it was to that School that he donated his etching press.

The systematic consolidation and registration of the Academy's collection of drawings, and indeed prints, did not begin until the early 1980s when the organization expanded with the introduction of year-round exhibitions and curatorial departments. In its 170th year, the venerable association, run by artists for artists to promote the fine arts in America, now provides for the study and viewing of historical and contemporary paintings, sculpture, watercolors, drawings, and engravings.

COOPER-HEWITT NATIONAL DESIGN MUSEUM

The Cooper Union for the Advancement of Science and Art was founded in 1859 by the inventor and industrialist Peter Cooper. Cooper was self-educated, and, after he amassed a fortune, he was committed to giving the working classes opportunities for self-improvement. Cooper Union was a progressive forerunner in offering a practical education to enable its graduates to enter well-paying art and science professions.

Along with initiating night classes for working men, Cooper Union was intent on providing job training in the arts and design for women, so that they might become art teachers or illustrators, and thus be self-supporting.[3] Shortly after its founding, Cooper Union took over the Woman's Art School, which flourished into the early twentieth century. Peter Cooper envisioned that there would also be a teaching museum at Cooper Union, but it was his granddaughters, the Hewitt sisters, who realized this goal in 1897—fifteen years after his death. From the beginning, the Museum founders planned to acquire examples of fine and applied arts and make them readily available for study or copying. They believed that students and practicing artisans who studied original works, as technical and creative models, might be inspired to achieve higher levels of quality in both design concept and execution.[4] Thus, old master drawings and prints were avidly collected from 1898 onwards.

Cooper-Hewitt National Design Museum today boasts a collection of approximately 160,000 drawings and prints, most being European designs, dating before 1925, for ornament, architecture, decorative arts, wall coverings, and textiles. Acquisition efforts in recent decades have concentrated more on collecting examples of modern design—particularly works by American industrial designers, architects, and graphic designers, but representation of design innovations from other parts of the world is also sought. The fact that this Museum also possesses almost 10,000 drawings and watercolors by nineteenth-century American artists is not widely known. Although the original vision of the Museum's founders focused on European art and design, the formation of its significant collection of American art came to be a crucial component of the Museum's resolute educational purpose.

In 1901 Francis Hopkinson Smith presented one of his drawings as a gift. While research has not yet revealed the circumstances of this gesture, it appears to be the first American

3. See New York and Washington 1989, p. 1.
4. *Cooper Union Annual Report 1896–1897*, pp. 12 and 17.

drawing to enter the collection. The Museum's first major acquisition of American drawings, however, only occurred following encouragement from artists who taught at the school. R. Swain Gifford, a respected artist affiliated with Cooper Union for several decades and art director of the Cooper Union Woman's Art School from 1896 until his death in 1905, suggested in his 1903 annual report that "it might be well to mention the need of a number of fine drawings from life to hang on the walls of the Life Class. We have been able from time to time to borrow drawings, but the owners of them do not wish them to remain in the school indefinitely.... If some could be purchased for the school and become its permanent property, the students would be very much benefited."[5]

In 1904, a committee of artists—J. G. Brown; Frederick Dielman, president of the National Academy of Design from 1899 to 1909 and director of the the Cooper Union Woman's Art School from 1905 to 1931; R. Swain Gifford, and John La Farge—selected more than five hundred drawings and an oil painting as a gift to the museum from the estate of Robert F. Blum. While some of these were sketches from Blum's travels to Italy and Japan, the majority were figure and drapery studies.[6] Here is a parallel with the drawing collection of the National Academy of Design. It, too, inherited many Blum drawings—figure studies, drapery studies, and schematic designs.

Only a handful of American drawings entered the collection during the remainder of the decade. A possible reason for the hiatus in developing the Museum's American art collection may have been the general artistic climate, which favored more traditional and modern European art. Not until 1912 did the Museum receive another substantial gift of American drawings. After Winslow Homer died in 1910, the contents of his studio were bequeathed to his brother Charles Savage Homer, Jr., who presented the Museum with almost three hundred drawings two years later and twenty-two oil paintings in 1917 and 1918. In 1916 two more Homer drawings were given by Charles W. Gould, a Cooper Union trustee. These remarkable holdings of Homer's work clearly demonstrate the artist's mastery of landscape and seascape, but most of the group is significant for providing insights on his figurative work from his early years as a Civil War reporter until the 1890s. Another 1912 gift came from

5. *Cooper Union Annual Report 1903*, p. 103. It is interesting to note, however, that the Museum possesses no drawings by Gifford himself. This may be because he did not wish to misuse his position to promote his own work. All *Cooper Union Annual Reports* are a valuable source of information regarding the early years of the Museum and its acquisitions, as well as its interrelationship with Cooper Union's Night Art and Woman's Art schools. Susan N. Carter, who was stepping down as head of the Woman's Art School after over twenty years of dynamic leadership, provided interesting insights about its role in her "Report of the Principal of the Woman's Art School, May 4th, 1896" found in the *Cooper Union Museum Report 1896–1897*, p.25.

6. This important gift was duly reported by Sarah Cooper Hewitt in her 1904 annual report. Almost sixty figure and compositional studies were for Blum's major mural decoration, *The Vintage Festival* (now in the Brooklyn Museum), originally commissioned for New York's Mendelssohn Hall (built in 1893 on West 40th Street for the Mendelssohn Glee Club, but later demolished). Blum completed this project about 1898. At his death in 1903, the Mendelssohn Hall murals were regarded as his most famous works.

the widow of Walter Shirlaw: 126 drawings exemplifying the artist's characteristic way of studying the figure and nature, as well as developing decorative schemes.

In 1914 more than 360 drawings by Francis L. Lathrop, mostly studies of religious figures, entered the Museum. Three years later, the Museum received two impressive gifts of works by two of the nineteenth century's most preeminent landscape artists, Frederic Edwin Church and Thomas Moran. Since the Hewitt sisters did not know Church, Moran, or many other American artists, they relied on the contacts, advice, and intermediary efforts of Cooper Union's affiliated trustees, donors, and artists, among them Charles W. Gould and his friend Eliot Clark, a landscape painter. One of the few letters in the National Design Museum's files pertaining to the acquisition of American drawings is from Eliot Clark to either Eleanor or Sarah Hewitt, dated June 20, 1916, which mentions his plan to approach Church's son regarding his father's work.[7] Through Clark and Gould, Louis P. Church was persuaded to give the Cooper Union Museum an astonishing gift of 2,002 drawings and oil sketches by his father. The extraordinary importance of this huge gift—the largest single group of works by an American painter in the museum—was more fully recognized once interest in Church was revived by David C. Huntington in the 1960s.

Museum legend holds that when the eighty-year-old Thomas Moran learned of the major Church gift, he was immediately prompted to give over eighty of his own drawings and watercolors. Moran liked the idea that students would refer to his sketches and studies to better understand his landscape drawing process. He did not anticipate that they would be featured in exhibitions as they are today.[8]

In the 1920s and 1930s, the Museum received several major gifts of drawings from widows of American artists—motivated in part by their wish to preserve their respective husband's artistic legacy for posterity and in part by a genuine wish to benefit an educational institution. In this way the Museum obtained drawings and watercolors by Kenyon Cox and Francis Hopkinson Smith in 1923, Arnold W. Brunner in 1927, and Samuel Colman in 1939. Nearly eight hundred drawings—portraits, figure and nature studies, landscapes, and preparatory studies for allegorical and religious paintings—by the venerated Daniel Huntington came to the Museum in two groups (in 1938 and 1942) via the bequest of Erskine Hewitt, the Hewitt sisters' brother. How and why he acquired such a cache of Huntington drawings is not known; perhaps he purchased them at one of the major sales of the Huntington estate after the artist's death in 1906.[9]

7. Gail S. Davidson has kindly shared her draft for an article in preparation on Eliot Clark and his role in the Museum's acquisition of Frederic Edwin Church's works and other American artists' drawings.

8. Clark 1980, p. 29.

9. These major studio sales of Huntington's art occurred in 1912 and 1916. Marilyn Symmes would like to acknowledge Elizabeth Horwitz's suggestion that Hewitt may have obtained his Huntington collection in this way.

Apart from being one of the first to publish an article on the collection, "American Masters at Cooper Union," (1927) Eliot Clark re-entered Cooper Union's history later. He was also very active in the National Academy of Design, serving as secretary (1949–1956) and president (1956–1959), and writing an invaluable institutional history (published in 1954). As a representative of the National Academy, he was instrumental in steering substantial gifts of drawings from the descendants of at least four artists to the Cooper Union in the 1950s and 1960s: Kenyon Cox (a 1960 gift from his son augmented what had been given earlier), William Stanley Haseltine, William Trost Richards, and Walter Shirlaw. In 1955, seventy-one figure and drapery studies by Elihu Vedder were transferred from the American Academy of Arts and Letters, which had unconditionally inherited over three hundred drawings from the artist's daughter Anita, who died in 1954. The remainder of that bequest was distributed to the Brooklyn Museum and other American museums.

Since the growth of the American drawing collections of both the National Academy of Design and Cooper-Hewitt National Design Museum depended entirely on gifts, the selection of artists represented was governed less by a particular acquisition plan than by opportunity. While admittedly neither institution can offer a comprehensive survey of nineteenth-century American draftsmanship, both collections await further scrutiny to fully tap the wealth of insights that they may yield on the history of American draftsmanship. It has been gratifying for the authors of this book to research and publish a selection of drawings and watercolors from our respective collections. Those who wish to enjoy the drawings and learn more about the role of drawing in the design process are invited to visit both museums.

Drawing from Nature: Sight and Insight

Linda S. Ferber

We generally look at drawing as an accomplishment, something complete in itself rather than what it truly is, a means for becoming better acquainted with Nature.[1]

THE COLLECTIONS of two of America's most venerable art institutions—the National Academy of Design and Cooper-Hewitt National Design Museum—have been mined to produce this handsome exhibition and catalogue. We are invited to survey eighty-six American landscape drawings, watercolors, and oil studies. These works range from energetic pen sketches of the 1840s (nos. 32, 33) by Thomas Cole—the English emigrant who would found the American landscape school—to Elihu Vedder's vigorous 1911 pastel (no. 86)—the product of a New York expatriate long settled abroad. This brief introduction provides an overview of these diverse riches, placing the works within the context of nineteenth-century ideas about landscape and drawing. We also point out the endlessly varied ways in which artists use a simple sheet of paper: the common denominator of the works in this exhibition and a support that took many forms. William Trost Richards, for example, used a pocket sketchbook to execute marine meditations under evening lamplight (no. 78). Frederic Edwin Church packed paperboard for oil studies to be painted on site in Jamaica, Ecuador, and the North Atlantic (nos. 15, 17, 10, 11). Thomas Moran enlisted a sheet of letterhead from the Denver and Rio Grande Railroad Company to make a quick sketch, probably from a moving train, of Lizard Head Peak in Colorado (no. 62). Economy of means unites these sheets as well. An artist may assemble a medley of studies on a single sheet in sequential fashion (nos. 15, 34). He may compress an image into a vignette in the center of the sheet (nos. 63, 68, 81) or create a panorama extending from edge to edge (nos. 18, 38, 39, 44, 58). Like Cole, Samuel Colman, and Samuel Isham, he may use both sides of the paper (nos. 33, 35, 53). Upon these diverse sheets, our seventeen artists have applied many media—from "dry" to "wet"—in a dazzling variety of techniques. The traditional "dry" drawing media of graphite (pencil), charcoal, chalk, or pastel are demonstrated one way or another in the work of every artist included here. The "wet" techniques, often combined with a graphite outline, are as varied. They include inks applied as pure outline in Cole's mountain vistas (no. 33) or

1. "Elementary Drawing," *Crayon*, 1, 1855, p. 305.

deftly brushed as masterly monochromatic washes in Winslow Homer's *Fisherman in Que-bec* (no. 43). They encompass as well the polychrome richness of the skilled application of transparent and opaque watercolors that we find in the works of Richards, Moran, Colman, and Francis Hopkinson Smith (nos. 73, 76, 55, 58, 34, 83) as well as the meticulous use of oils in detailed tropical studies by Church (nos. 10, 15, 17).

There are many approaches to this wonderfully rich body of material, each offering particular insights. We might begin with the observation that the histories of the National Academy of Design and the National Design Museum are themselves bound up with the practice of drawing as a means of art instruction. This method of pedagogy led to the formation of the collections from which this exhibition is drawn: indirectly, one senses, at the National Academy and purposefully at Cooper-Hewitt National Design Museum.

The National Academy of Design, founded in 1825, was dedicated to training artists in the traditional study of the antique by drawing from casts. This method prepared students for the technical and intellectual challenges of history painting; the subject at the apex of the academic hierarchy. By mid-century, however, landscape painting in the United States had also ascended to a very high rank, demonstrated in the election of Asher B. Durand to the Academy presidency in 1845 for a sixteen-year term. Durand's famous "Letters on Landscape Painting," published in the *Crayon* in 1855, may be interpreted as a series of presidential addresses promoting the values and vision of the New York landscape school to which most of the artists included here either belonged or aspired.[2] Like a good Academician, Durand urged the students to begin drawing from nature before painting. However, he also advised them to persist in the habit of such direct study from nature as both a perceptual and spiritual exercise, as an aid, in other words, to what I have called in my title "sight and insight."

Durand counseled that such constant study not only honed the sharpness of perception and technical facility demanded of an American artist, but that the power to comprehend and record natural detail was really ordained to serve a higher purpose. Landscape paintings conceived according to such principles would convey "lessons of high and holy meaning" to an American audience anxious to gain intellectual, moral, and spiritual enlightenment via the earnest contemplation of nature. This prevailing attitude was surely a contributing factor to the huge production of studies on paper by Church, Richards, and Moran, all of whom were members of the National Academy.

Nevertheless, upon election to membership, Academicians were generally expected to deposit not drawings but oil paintings as their diploma works. It is probably due to the long-established artist practice of exchanging works on paper with colleagues that the Academy owes its interesting and little-known collection of landscape works on paper. A litany of sources for some of these works conjures up the close-knit community, social life, and in-

2. The publication record of the "Letters" is cited in Ferber 1980b, p. 395. For further discussion see Ferber, in Washington 1980, pp. 236–265.

formal exchange of influences among New York artists in the nineteenth century. For example, the Cole drawings come from an album of sketches—similar to those from meetings of the Sketch Club—which belonged to the Academy's founding president, Samuel F. B. Morse (nos. 32, 33). The watercolors and drawings by the well-traveled Alfred Thomas Agate came from James David Smillie (nos. 1–4). Smillie gave the delightful little 1859 *Landscape with Birch* by Owen G. Hanks (no. 36), who like Smillie, was also an engraver. Helen Haseltine Plowden made gifts of the work of her father William Stanley Haseltine to the Academy (and the National Design Museum) as did William Trost Richards's daughter, Anna Richards Brewster. From Samuel Isham's estate came the series of tree and landscape studies shown here; splendid drawings from an artist now remembered only as the author of an early history of American art (nos. 48–53).

While the National Academy focused upon the art education mainly of young men aspiring to the lofty professional callings of painter and sculptor, the Cooper-Hewitt National Design Museum collections are the legacy of another New York institution, the Cooper Union for the Advancement of Science and Art. The school, open to men and women, was devoted to the free education of the working classes. Drawing was taught primarily as a manual skill to provide the basis for future employment in a variety of trades. Later in the century, a broader devotion to the causes of both vocational training and more generalized art education led Cooper's granddaughters, Amy, Eleanor, and Sarah Hewitt, to form a museum for decorative arts and design. Long before there was general or even scholarly interest in such works, the Hewitt sisters sought out drawings by American landscape and figure artists as models and inspiration for the men and women who were students at the Cooper Union. From the families of Winslow Homer, Samuel Colman, and Frederic Edwin Church, they acquired major deposits of graphic work. In 1917, Thomas Moran himself gave some eighty-three drawings and watercolors.[3] It is important to note that in the nineteenth century there were also legions of self-taught amateurs at work recording the landscape. They participated with professional artists in a popular and powerful movement that embraced the landscape in literature and poetry as well as a rapidly growing tourism industry. Each complemented the other, and both were stimulated by the visual records provided by landscape prints and paintings. For example, Richards's 1854 vignette after Bayard Taylor's poem (no. 63) was to appear in an engraved portfolio whose plates interpreted "The Landscape Feeling of American Poets." Charles Cromwell Ingham's pocket sketchbook (no. 47) documented a visit to the Catskill Mountain House—the first great tourist hotel, which opened a year after the Academy was founded. Central to this landscape culture was the widespread practice of sketching from nature. In preparation, amateurs studied and copied models from the so-called drawing books or manuals that were widely available in the

3. This information is drawn from Davidson, in New York 1989c, pp. 1–4.

United States. These texts form a vast pedagogical and didactic literature: "how-to" books that instructed an eager public in how to perceive and draw nature.[4] Such instruction took the form of plates demonstrating formulaic patterns of clouds, trees, and other elements of the landscape vocabulary to be mastered by rote and then freely reinterpreted in terms of the student's own experience of nature. The standardized visual conventions found in these illustrations were frequently the first form of training for professionals as well as amateurs. The rhetoric of the drawing book texts, which also reinforced the premise of sight and insight, was as important as the imagery. Like Durand, these authors insisted that not only practical but intellectual and spiritual benefits might be gained by drawing from nature. Not just artists, they claimed, but every educated citizen should possess the visual and manual skills with which to record external appearance. The very act of such concentrated observation was presented as a means to develop powers of perception that probed beneath the surface of nature to deeper meanings. While Durand's "Letters" were addressed to the fledgling professional, he was nevertheless articulating the widely held belief in the value of drawing directly from the landscape.

Professional artists, among them some of the most celebrated names of the nineteenth century, created the works shown here. Despite their beauty and technical brilliance, most of these drawings were working documents never intended for public exhibition. Retrieved, often by chance, from the portfolios of the studio, they reveal aspects of the creative process no longer traceable in a "finished" work. For example, Cole, Isham, and Richards used drawings not only to study in the field but to aid in picture making in the studio as well. They tried out various compositions by imposing the rectangle of the frame upon their pen and pencil sketches to see what would work best (nos. 32, 53, 78). We know that some drawings, such as Church's *Study for "Rainy Season in the Tropics"* (no. 12) and his sketches of the Parthenon, 1869 (see figs. 1 and 2), are directly associated with known exhibition works. They provide valuable clues to the evolution of his sensational panoramic landscape paintings of the Old and New Worlds: resonant images that drew huge audiences.

Works on paper come to us from those studio portfolios in varied states of "finish." Some are rapidly executed, such as Haseltine's eloquent thirty-minute impression of a moonlit canal near Bruges (no. 40). In contrast, Richards's delicate drawing of the Wissahickon's forested banks, made over five days in August and September 1869, bears witness in its phenomenal detail to prolonged and determined study (no. 66). Drawing is, perhaps, most intimately associated with the notion of "study"—both a process and a visual record of an artist's careful, even intense, observation of an object. Such intent and prolonged contemplation has left us a series of marvelous tree studies, including Daniel Huntington's extensively annotated White Mountain hemlock of 1855 (no. 45); Church's Jamaican coconut

4. The manuals and their widespread influence are discussed in Marzio 1976.

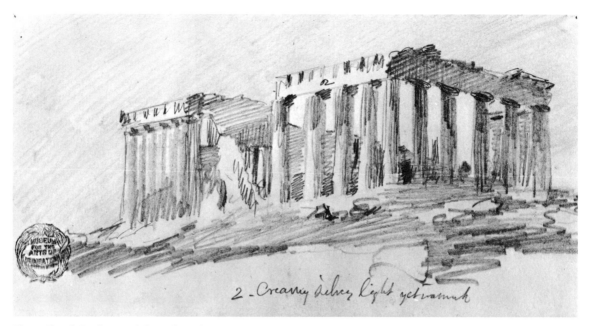

Fig. 1. Church, Parthenon, Athens, from the Southeast, *1869, drawing, Cooper-Hewitt National Design Museum, Smithsonian Institution, 1917–4–378b*

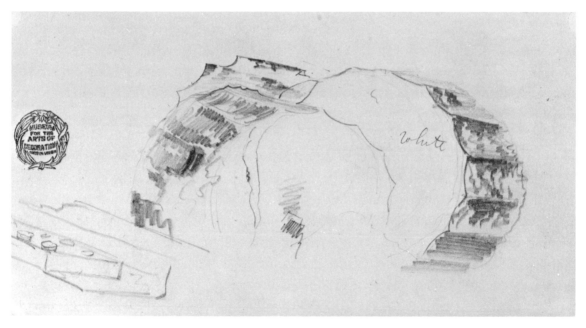

Fig. 2. Church, Column and Entablature Fragments, *1869, drawing, Cooper-Hewitt National Design Museum, Smithsonian Institution, 1917–4–577*

palms of 1865 (nos. 13, 14); Homer's majestic Waverly Oaks, probably drawn at Belmont, Massachusetts, in 1878 (no. 42); and Colman's windswept oaks recorded at Montauk, Long Island, in 1880 (no. 35). These studies record not only the features peculiar to each species but also the expressive character of each specimen in its particular environment. For example, Isham's stunted pollards, drawn in March 1884, bristling and bare (nos. 48, 49), offer sharp contrast to the stately grace of his summer study, *A Thicket of Trees in Foliage* (no. 51). Church documented Jamaican flora with a sense of botanical energy in his graphite study of a tree trunk encumbered by a serpentine parasite vine (no. 16). Although different from one another in style and medium, these tree studies have in common the intensity with which every twist of branch and turn of leaf has been recorded, an intensity conveyed by linear clarity and intricate silhouette. Church's sharply focused tropical oil studies—also executed in Jamaica with the added power of local color—are distributed across the sheet in an episodic fashion, reinforcing the cumulative and random nature of direct experience (no. 15).

Henry Tuckerman undoubtedly had works like these in mind when he commented in 1867 upon a certain "scientific bias," noting that Church was "keenly on the watch for facts, and resolute in their transfer to art."[5] Church was not alone. The documentary bent of artists and audiences in the middle and late nineteenth century stimulated the production of studies like these. We may speculate upon the multiple influences of science and photography as well as the exhortations of the influential English critic John Ruskin to landscape painters to follow a "new path" of absolute truth to nature.[6] In this complex matrix we may locate the inspiration for the emphasis upon detail that characterizes the drawings from nature of Moran, Haseltine, Richards, Church, and others. They were responding to a new set of demands made upon the landscape painter: to understand and delineate the operation of geological and meteorological forces that shape the earth's surface. Landscape study was redefined from the mastery of a picturesque vocabulary based upon old master precedents to the documentation of a system of landscape forces at work in an endless process of eruption and erosion, whether depicted at the base of Chimborazo (no. 10), the Gorge of Niagara (nos. 8–9), the Valley of Yemen (no. 18), the rim of the Grand Canyon (No. 58), or the Narragansett coast (no. 72).

Documents on paper seemed to be the artist-traveler's natural companions. Maps and guides charted a course, while sketchbooks and diaries recorded experiences both close to home and far away. William Trost Richards found compelling subjects on familiar territory, for example, the wooded course of the Wissahickon, a winding creek flowing into the Schuylkill River (no. 66), while Frederic Edwin Church's aerial vista of the Yemen Valley captured the harsh but thrilling topography of the Holy Land (no. 18). Two versions of Alfred Thomas Agate's *Indian Burial Place* allow us to trace the evolution of an image from

5. Tuckerman 1867, p. 375.
6. For an extended discussion of Ruskin's influence on American painting see Brooklyn 1985.

an Oregon site document taken in August 1841 (no. 2) to the more synthetic vision probably intended for the engraver (no. 3). William James Bennett's unfinished *Figures in a Landscape* demonstrates the technique of reserving areas of the sheet for later development, here producing charming "ghosts" of foreground figures never to be completed (no. 5). Agate, whose Pacific travels with the Wilkes Expedition were later engraved, and Bennett, who produced popular prints from his own landscape sketches, remind us of the long-established topographical tradition fostering partnerships between landscape draftsmen and printmakers that lasted well into the nineteenth century. The latest technologies of the mass media were often used in these collaborations between art and commerce. Thomas Moran first went west in 1871 as an expedition draftsman. His Yellowstone, Grand Canyon, and Yosemite images, first executed as field sketches and later as brilliant watercolors and oils, gained their widest audience when published as engravings and chromolithographs.

The far-flung subject matter of these works, representing the scenery of a dozen countries from Fiji to Ecuador, points to the peripatetic nature of the American landscape painter as well as to the hunger of nineteenth-century audiences for visual information and vicarious experience. Agate kept a visual record of extensive travels from Oregon to the Pacific islands. His charming sepia and watercolor drawings of Fiji and Manila document these exotic locales with a domestic tidiness (nos. 1, 4). In contrast, Church's drawings of the ruined Parthenon and architectural fragments littering the plain of the Athenian Acropolis (see figs. 1 and 2) evoke a mood of nostalgic melancholy, suggesting the dynamics of history in the decline of great civilizations. For this generation of artist-explorers and their audience, exotic sites and remote destinations in the Old and New Worlds—Greece and Palestine; Yosemite and Ecuador—represented journeys that seemed to fuse space and time into an extended reverie about the past. This impression was conveyed in the frequent conflation of grand topographical features with human associations: architectural and historical. The deeply eroded Yemen Valley (no. 18), traversed on Church's journey to the ruins of ancient Petra, could also assume powerfully architectonic forms as might the Canyon of the Virgin River and the Grand Canyon documented by Moran (nos. 56, 57, 58). Naturally formed towers and pinnacles suggested the remains of undiscovered civilizations. In his journal, Church noted the Yemen's "amphitheatric chasms" and rocks that "looked like castles of enchantment." Moran annotated a drawing of the Canyon of the Virgin River with references to a "Temple of Janus" and a "Cleopatra's Needle" (no. 57). Richards, whose frequent travels took him to remote reaches of the British Isles, easily reversed the association, equating a ruin with nature's handiwork, in an eloquent description of Stonehenge that might apply to Church's Acropolis as well: "[Stonehenge] has that pathetic look which is peculiar to all human work which has reverted to nature. Architectural enough to be a ruin, and as rude and moss covered as though ages ago it had been left by some glacier" (fig. 3).[7] Indeed, Yosemite's

7. Ferber 1980b, pp. 332–333.

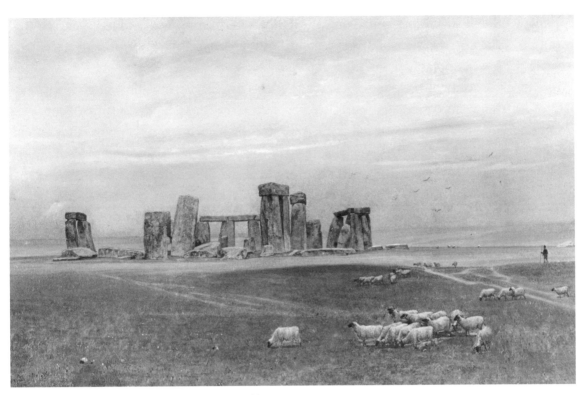

Fig. 3. Richards, Stonehenge, *ca. 1882, watercolor, Brooklyn Museum, 83–199*

geological landmarks—the great exfoliated granite outcrops recorded in Moran's water-colors (nos. 54, 55)—are still called the Domes and Arches, perpetuating such romantic associations today.

While the near obsession of nineteenth-century artists and audiences for documentary information fueled forays into distant terrain, the external world was by no means the only realm recorded by the landscape draftsman. "Insight" also suggests the mind's eye looking within to the rich visual stores of the artist's imagination, filled with imagery drawn from other works of art, from literature, as well as personal fantasy. For example, Cole's vigorously penned compositions owe far more to the history of art than they do to American scenery. These little drawings (nos. 32, 33) are really exercises in classical landscape composition; so too is the frame of twelve miniature *Imaginary Landscapes* (nos. 20–31), fascinating late reminiscences in the manner of Cole by his onetime pupil Church. One is tempted to spec-ulate that Cole's and Church's images, with their old master resonance, both reflect the in-spiration of J. M. W. Turner's *Liber Studiorum*. This set of seventy-one prints, published in London between 1807 and 1819, offered a recapitulation of seventeenth-century landscape prototypes as interpreted by Turner, the presiding genius of English landscape painting. For those of Church's generation, Turner's most ardent promoter was John Ruskin, best known through his multi-volume treatise on landscape, *Modern Painters* (1843–1860), and his draw-ing manual, *The Elements of Drawing* (1857). Turner's visual influence, spread widely via the

engravings after his paintings and engraved vignettes illustrating books of travel and poetry, was a powerful current throughout nineteenth-century American landscape imagery from Thomas Cole to Thomas Moran.

Without a doubt, the young Richards saw the English artist's illustrated works as a model for his own ambitious but unrealized project of the middle 1850s: a suite of engraved images titled "The Landscape Feeling of American Poets" (no. 63). Compressing a deep mountain vista into an energetic cluster of landscape elements at the center of the page, Richards visualized a passage from Bayard Taylor's poem "The Metempsychosis of the Pine" by evoking Turner's famous Alpine vignettes. Forty years later, the same format still served for his watercolor vignette of the British coast (no. 81). Church's poetic meditation on South American scenery, *Study for "Rainy Season in the Tropics"* (no. 12), is a vaporous graphite image built upon a Turnerian armature appropriating the English master's signature fusion of light, form, and spectacular atmospheric effects. This American homage to Turner would have been both recognized and admired. Early on in a long career, Moran also felt Turner's influence. One might easily suggest that a Turnerian system of landscape organization continued to inform his Grand Canyon panoramas and Yosemite views right into this century.

We close this brief introduction with a few words about American watercolors.[8] While we make a distinction today between drawings and watercolors, the terms were virtually synonymous in the nineteenth century. Many drawing manuals also included instruction in the use of watercolors. In fact, a close investigation of the works shown here will reveal that most watercolors were executed over a lightly drawn graphite outline. In England, primary source of inspiration and influence for the American watercolor school, the medium had evolved by the early nineteenth century into a separate area for artistic expression, supported by its own societies and institutions. However, the prevailing academic hierarchy of medium [oil was deemed superior] still kept watercolor in a subordinate rank. In England and the United States, the medium was long associated with amateurs and women or with preparatory work for the engraver—as in the productions of Agate, Bennett, and probably in the delightful miniature landscape by Hanks as well (nos. 4, 5, 36). John Ruskin's enthusiastic endorsement in the 1840s and 1850s of the watercolor medium as a viable one for serious work and his widely published admiration for Turner's watercolors spurred Americans to emulate the English in perceiving watercolor as a medium worthy of independent exhibition and patronage. Production accelerated in the late 1860s with the founding of the American Society of Painters in Water Colors (1866). Based upon English models, the society promoted an agenda that encouraged watercolor practice, cultivated patronage, and provided hospitable display spaces where watercolors were not exhibited in direct competition with oil paintings. Many among the first generation of watercolor specialists—Colman, Homer,

8. For American watercolors, see Stebbins 1976 and Foster 1983.

Moran, and Richards—were already accomplished draftsmen, illustrators, and oil painters by the 1860s.

Many were also members of the National Academy of Design. Others were "amateurs" like Francis Hopkinson Smith, a successful civil engineer and well-known writer of popular novels and travel books, who was also a highly skilled plein-air painter in watercolors (no. 83). Samuel Colman, founding president of the Society of Painters in Water Colors, is represented here by a splendid graphite study enhanced by the sparing application of delicate watercolor washes (no. 34). Thomas Moran also utilized watercolor in his field sketches (nos. 56, 59, 61) as well as in his more polished interpretations of the spectacular scenery of the Far West (nos. 54, 55, 58, 60). Winslow Homer's brilliant monochromatic watercolor *Fisherman in Quebec* (no. 43) demonstrates skills honed early during a long career as an illustrator in black and white. His often-quoted prophecy—"You will see, in the future I will live by my watercolors"—has indeed been realized.[9] In contrast, William Trost Richards's large body of important watercolor work—lauded during his career and later forgotten—is a wonderful rediscovery. Some of the best among them are exhibited here, from the exquisite portfolio watercolors of the early 1870s, capturing every nuance of seaside light (nos. 69, 70, 71), to the masterful large gouache of 1877, *Mackerel Cove, Conanicut Island, Rhode Island* (no. 72).

9. Cited by Cooper, in Washington and New Haven 1986, p. 239.

CATALOGUE OF THE EXHIBITION

List of Contributors

DA Dita Amory EH Elizabeth Horwitz
DBD David B. Dearinger MS Marilyn Symmes
GSD Gail S. Davidson AM Abigail Messitte

The contributor's initials appear after each artist's biography. The entries for that artist are written by the same contributor unless otherwise noted (see William Trost Richards and Frederic Edwin Church).

Notes to the Reader

The catalogue is arranged alphabetically by artist. Citations in the text and notes appear in shortened form; the full references will be found in the Bibliography beginning on page 157. In the headings, dates have been supplied for undated drawings where it seemed appropriate. In the technical matter, the color of a sheet of paper has only been noted when it is not white or off white.

Full dates have been given for major mentions of American artists and for foreign artists influential in the work of the artists in this catalogue. Major references to artists in this exhibition in the entries of other artists are indicated by q.v. (*quod vide*, which see).

The following abbreviations have been used:

* Drawing exhibited in New York only
Founder NA Founding member, National Academy of Design
ANA Associate member, National Academy of Design
NA National Academician, National Academy of Design
HM Honorary member, National Academy of Design

Cooper Union stamp 1: MUSEUM FOR THE ARTS OF DECORATION COOPER UNION (in black ink)

Cooper Union stamp 2: COOPER UNION MUSEUM NEW YORK (in brown ink)

Alfred Thomas Agate

Sparta, New York 1812 — Washington 1846
ANA 1832, HM 1840

ALFRED THOMAS AGATE spent his childhood years in Sparta, near Ossining, New York. The younger son of Thomas and Hannah Agate, natives of England, he received his first artistic training from his older brother Frederick Stiles Agate (1803–1844) and from Thomas Seir Cummings (1804–1894), both among the founding members of the National Academy of Design.[1] Under their tutelage, the young Agate learned the rudiments of portraiture and miniature painting. In 1829, he enrolled in the National Academy's Antique School. By 1831, his proficiency as a miniaturist earned him a prized place in the Academy's annual exhibition. An invitation to membership followed in 1832.[2] Agate continued to exhibit miniatures and a few portraits in the National Academy's exhibitions right through the decade, a period when he generally resided with his brother in New York.

Agate did not begin to draw landscapes until after 1838, when he was invited to join the United States South Seas Surveying and Exploring Expedition under the naval command of Lieutenant Charles Wilkes. This ambitious voyage, from 1838 to 1842, represents one of the most remarkable expeditions in the history of American exploration.[3] Its contributions to research in the natural sciences led to the emergence of the United States as a naval and scientific power. The artists Alfred Agate and Joseph Drayton were among the expedition's nine-man scientific corps appointed to collect ethnographic data and record the flora and fauna of the distant lands and islands on the itinerary. Although Agate and Drayton were the official draftsmen on board ship, Titian Ramsay Peale, artist and naturalist, and James D. Dana, mineralogist, also made drawings along the way for later reference.[4] The expedition traveled to the South Pacific, the Antarctic, and the Northwest Territory, spending the greatest concentration of time in the islands of the South Pacific.

Agate was much admired by his fellow explorers and withstood the inevitable hardships of the journey with stoicism. Charles Wilkes warmly described him in his autobiography:

I had in my command a young artist [Agate] of great promise . . . a most amiable person but of very great deli-cacy of constitution. His talents in landscape were of a high order and [he was] duly appreciated by all my officers for his kind and gentle temper.[5]

With zealous determination to precisely capture every observation, Wilkes's artist-explorers made copious drawings, many first sketched in the field and later finished on board ship. In her study of Titian Ramsay Peale's expedition journals, Jessie Poesch notes the great value of the artists to the voyage. It was, after all, their paints and inks which provided the first visual records of new lands, new peoples, new birds and beasts.[6] Following the completion of the expedition, Agate spent the remaining years of his brief life in Washington, preparing his sketches for Charles Wilkes's planned publication. Agate died of consumption at the age of thirty-two, certainly a consequence of the rigors of his many years at sea. His drawings were still unfinished when he died, a factor which delayed the ambitious publication.

The hundreds of sketches made by Agate during the Wilkes Expedition are his only known drawings. Large collections of these sheets are found in the Naval Historical Foundation, Washington, and in the Gray Herbarium Library, Harvard University. The four drawings selected for this exhibition were ultimately published as engravings in Wilkes's five-volume account of the voyage, *The Narrative of the United States Exploring Expedition* (1845).[7] The National Academy's drawings entered the collection in 1902 as part of the gift of James David Smillie. DA

1. Frederick Stiles Agate and Thomas Seir Cummings were fellow students in New York in the early 1820s. Thwarted in their efforts to study casts in the collection of the American Academy of the Fine Arts, the reigning art school at the time, they joined Samuel F. B. Morse, Asher B. Durand, and others in founding the National Academy of Design. Both Frederick Agate and Cummings played an active role at the nascent National Academy, the former serving as the organization's keeper of collections and instructor of drawing (1840–1844) and the latter as the first treasurer. Thomas Cummings also wrote the invaluable *Historic Annals of the National Academy of Design* (Philadelphia, 1865).

2. Alfred Agate was designated an honorary member of the National Academy of Design in 1840, a special status conferred while he was traveling with the Wilkes Expedition. This honorary designation released him from the general rule that artists advancing in rank from ANA to NA should have demonstrated a continuous commitment to the arts both at the National Academy and in New York's cultural community.

3. As a result of the Wilkes Expedition, the ice-bound Antarctic was identified as a continental land mass; vast areas of the South Pacific as well as the Northwest Coast of the United States were surveyed and explored.

4. The remaining members of the scientific corps were: Charles Pickering, naturalist; Joseph P. Couthouy, naturalist; William K.

Rich, botanist; William D. Brackenridge, assistant botanist; and Horatio Hale, philologist. Poesch 1961, pp. 67–68.

5. Wilkes 1978, p. 226.

6. Poesch 1961, p. 149. Titian Ramsay Peale recorded the following in his journal on August 1, 1839: "The seas sufficiently smooth for Mr. Agate and myself to be occupied in finishing up some of our paintings & sketches." Ibid., p. 3.

7. *The Narrative of the United States Exploring Expedition* comprises five volumes, to which Agate contributed sketches for 105 wood engravings, 48 full-page plates, and 23 vignettes. Wilkes's ambitious publication became one of the most widely read travel books of the decade. Collectively, Wilkes and his staff published some nineteen volumes of reports and atlases describing their findings. These publications represented a contribution to science of unprecedented scale in mid-nineteenth-century America. They stand as remarkable achievements in the development of naval sciences, navigation, cartography, and hydrography. For additional discussion of the impact of this expedition, see Washington 1985a.

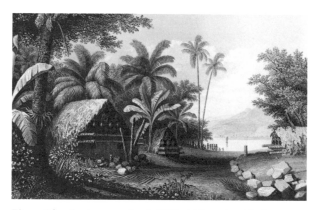

Fig. 4. After Agate, engraving in Wilkes's Narrative *(1845), 3, opp. p. 231*

idea. These houses were entirely vacant. Before some of them spears and poles were crossed in the form of an X; before others a stick was planted in the ground, with its top tied around with sennit; near others were long pieces of tape, suspended from poles, with clubs, spears, and a canoe laid beside them. . . . The graves of the common people (kai-si) had merely stones laid over them.[1]

Agate's early training as a miniature painter using watercolor on ivory well suited his task as scrupulous recordkeeper on the Wilkes Expedition. His relentless attention to detail, drawing with a pencil or brush on a very small scale, produced documents of invaluable visual reference for later study. The compositional balance, even brushwork, and degree of finish in this drawing suggest that the artist made several site studies of the tombs before realizing this image for the published engraving.

1. Wilkes 1845, 3, pp. 230–231.

1

Tombs at Muthuata Island, Fiji, 1840

Brush and brown wash over graphite, touch of pen and ink on paper

Image: 4⅝ x 7⅛ inches (117 x 181 mm)

Sheet: 10 x 13⁵⁄₁₆ inches (254 x 354 mm)

Signed in graphite, lower left below image: *A.T. Agate.*

National Academy of Design

Gift of James David Smillie, 1902 [1980.29]

This highly finished wash drawing of a burial site in the Fiji Islands precisely details the tombs and ceremonial implements used by islanders in reverence of the dead. Wilkes and his staff spent two months surveying the Fiji Islands, eventually accumulating one of the most comprehensive collections of botanical and ethnographic materials ever collected in that region. Agate's drawing was used as a preparatory study for the engraved illustration (see fig. 4) accompanying Wilkes's text describing the Muthuata Island burial customs:

Mr. Hale succeeded in getting permission to disinter some skeletons on the island of Muthuata, which lies immediately off the town. This island not only protects the harbor from the north wind, but adds much to its beauty by its high and luxuriant appearance. It is a little over a mile in length. It appears to have been for a long time a chief burial place for both chiefs and common people. The graves are scattered in groups along the shore, those of the chiefs being apart from the rest, and distinguished by having small houses built over them, from two to six feet. The fronts of these houses were of a kind of lattice-work, formed of braided sennit, of which the cut will give an

2

Indian Burial Place, Oregon, 1841

Graphite on two seamed sketchbook sheets

8⅝ x 7¾ inches (220 x 197 mm)

Signed and dated in brown ink, lower right: *Agate. del. Aug. 1841*; and inscribed in graphite, lower left: *Aug* [partly obscured]

National Academy of Design

Gift of James David Smillie, 1902 [1980.47]

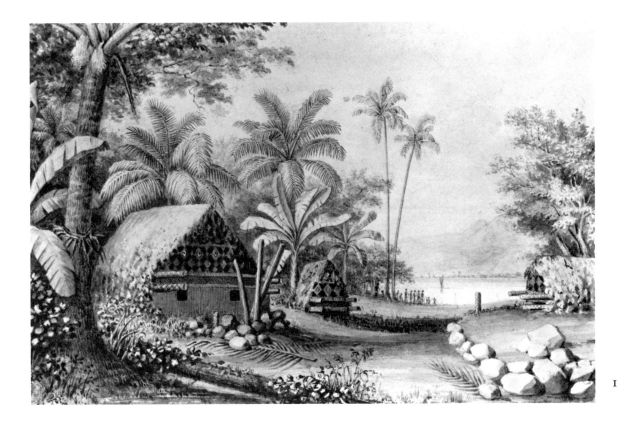

I

2

3

Indian Burial Place, Oregon, 1841

Brush and brown wash, graphite on paper

4⅛ x 4⅝ inches (103 x 118 mm)

Signed in brown ink, lower left: *A. T. Agate*

National Academy of Design

Gift of James David Smillie, 1902 [1980.46]

After two years of exploration in the Pacific, the Wilkes Expedition sailed to the West Coast of North America and spent six months traveling overland and by sea from the Columbia River to San Francisco. Oregon was a vast uncharted territory, encompassing land in present day Oregon, Washington, and Idaho. Apart from some Native American settlements along the coast, a few fur traders, and scattered farming communities, the land was uninhabited. The United States government sent Wilkes and his expedition to survey the region, map its geography, and assess its land value.

Agate made many sketches while traversing the Northwest Territory, among them these studies of a Native American burial place. The pencil drawing and its smaller companion sheet in brown wash give us an indication of his working technique. The pencil study, drawn on facing sheets of sketchbook paper, very likely preceded the wash drawing, which would have been used as the final drawn composition for the engraved plate in Wilkes's *Narrative* (fig. 5).¹ In Agate's sketchbook study of the site (no. 2), his scratchy, cross-hatching pencil line describes the surrounding foliage in precise detail, while, in the delicate wash drawing (no. 3), considerably smaller, he eliminates any attention to botanical transcription. Streamlined in content and scale to conform to the typographic framework of the printed page, the vignette now pointedly illustrates Wilkes's description of the grave site:

They found the country very beautiful, and the land rich. Their route lay over hills and through prairies. The hills were wooded with large pines and a thick undergrowth of rose-bushes, Rubus, Dogwood, and Hazel. The prairies were covered with variegated flowers, and abounded in Nuttallia, Columbines, Larkspurs, and bulbous-rooted plants, which added to the beauty, as well as to the novelty of the scenery. . . . During the time of their stay, Mr. Agate made many sketches. One of these is a burying-place, which I have thought worth inserting, as exhibiting one of the peculiar features of a race which is now fast disappearing. The mode of burial seems to vary with almost every

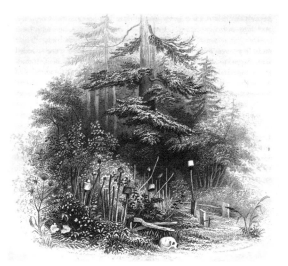

Fig. 5. After Agate, engraving in Wilkes's Narrative *(1845), 5, opp. p. 219*

tribe: some place the dead above ground, while others bury their departed friends, surrounding the spot with a variety of utensils that had been used by the deceased. . . . The graves are covered with boards, in order to prevent the wolves from disinterring the bodies. The emblem of a squaw's grave is generally a cammass-root digger, made of a deer's horn, and fastened on the end of a stick.²

The camass-root digger noted above is the root pick in the right foreground of the drawing. Camass, an edible bulb with a blue flower, served as a food source for Native Americans of the Northwest. It is from the same plant family as the hyacinth.³ Also emblematic of a burial place are the upended baskets on poles staking the site. The pencil sketch was likely made in the Willamette River Valley, where the overland expedition spent five weeks prior to leaving for San Francisco. If indeed Agate sketched this burial place in that valley, the deceased was probably from the Mandan, Arikara, or Hidatsa tribes.³

1. The title for the two drawings was taken from the engraved vignette.

2. Wilkes 1845, 4, p. 219.

3. Laila Williamson of the American Museum of Natural History, New York, kindly clarified the origins of camass.

4. Henry 1984, p. 200. For a further discussion of the Willamette Valley people around 1840, see Thomas et al. 1993, p. 215.

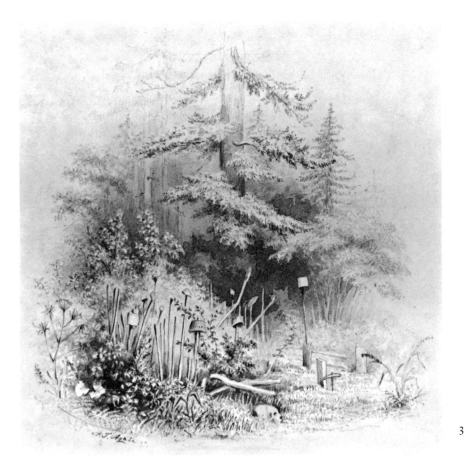

3

4
Native House near Manila, 1842

Watercolor, touch of pen and ink on paper; ruled in graphite

Image: 6⁹⁄₁₆ x 8¼ inches (167 x 210 mm)

Sheet: 8⅝ x 11¹⁵⁄₁₆ inches (220 x 304 mm)

Signed in brown ink, lower left inside image: *A.T. Agate del.*; inscribed in graphite, center below image: *Native house near Manila / Luzonia 6*

National Academy of Design

Gift of James David Smillie, 1902 [1980.28]

The Wilkes Expedition landed in the Philippine islands in January 1842, one of the last visits on their journey home. This finely rendered watercolor, painted with a light even touch, was probably sketched while Agate and Titian Ramsay Peale explored the island of Luzon together. A passage in Peale's diary describes the site:

> Made an excursion to Maraguina [Marikina], which is 8 to 10 miles from Manilla. The country was very beautiful, abounding in highly cultivated farms where the Natives produce rice, maize, sugar, etc. They are generally surrounded with bamboo groves with the stems of which the houses are built, fences made. . . . The houses are mostly built of Bamboo, & Mat trees and are all elevated 6–8 feet from the ground on posts. . . .[1]

Throughout the expedition, Agate made frequent excursions into the countryside to sketch the native scenery, often in the company of Peale and Joseph Drayton. In their eagerness to accurately record everything they saw, these artist-naturalists often sketched using a camera lucida, a four-sided prism of glass which allows the artist to trace the outlines of a particular view directly onto a sheet of paper. This

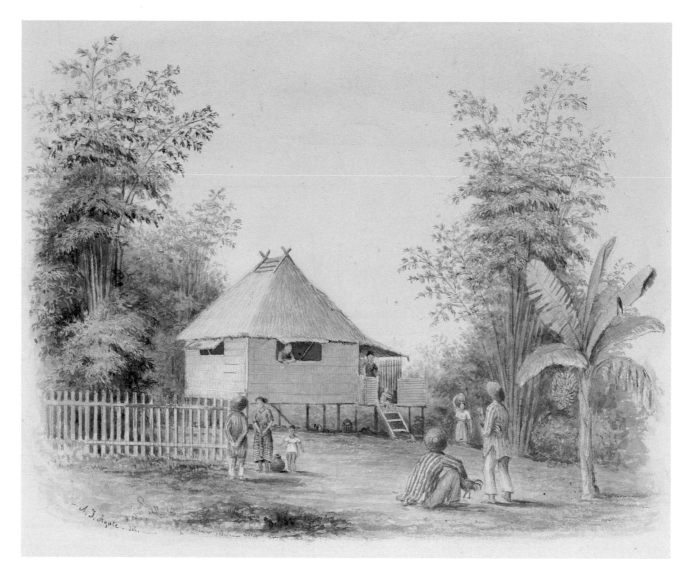

4

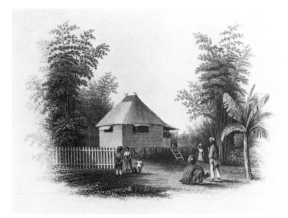

Fig. 6. After Agate, engraving in Wilkes's Narrative *(1845), 5, opp. p. 292*

procedure made for a more precise transcription of the whole. The watercolor was preparatory to an engraved plate in Wilkes's *Narrative* (fig. 6).

Native House near Manila again calls to mind Agate's early training as a miniature painter working in watercolors. His technical command of the medium and evenness of handling in this drawing owe a debt to those early years in New York.

1. Poesch 1961, pp. 200–201.

William James Bennett

probably London ca. 1784 — New York 1844
ANA 1827, NA 1829

WILLIAM JAMES BENNETT was one of the foremost watercolor painters and a master of aquatint landscape and city views in the United States in the first half of the nineteenth century. Of English origins, Bennett trained at the Royal Academy in London under the figure painter Richard Westall. Bennett showed an early preference for the landscape, an impulse encouraged by several trips to the Mediterranean—Egypt, Malta, and Italy—as a member of the medical staff of the British military forces. It is said that he returned to London with portfolios full of drawings and watercolors of Mediterranean views.[1]

At the turn of the nineteenth century, watercolor painting was a flourishing pursuit in London, recognized by artists for its potential to capture fleeting light and atmosphere in tonal, transparent color.[2] The popularity of watercolor led to the founding of the Society of Painters in Water-Colours in 1804 and the Associated Artists in Water-Colours in 1807. Bennett was a founding member of this latter organization and one of its frequent exhibitors between 1808 and 1812.[3]

Bennett's early activities in watercolor painting and aquatinting owe a great debt to the British landscapists Thomas and Paul Sandby, who were among the founders of the British watercolor movement. It was Paul Sandby, in particular, who introduced the British public to the aquatint process, an etching technique that could simulate the broad washes and delicate shading of watercolor painting. Aquatints enjoyed a ready market in England right through the mid-nineteenth century, and William James Bennett profited from its successes. Between 1812 and 1825, he produced dozens of watercolors and aquatints, often at the behest of London's finest publishers.[4]

By 1826, soon after the founding of the National Academy of Design, Bennett had settled in the United States. He drew instant recognition as a master of aquatint and was invited by the publisher Henry J. Megarey to paint and execute in aquatint a topographic view of New York for a projected series of city street views.[5] Bennett was elected to membership at the National Academy in 1827, the year he also exhibited his first two landscapes in its annual exhibition. This association with the National Academy was a felicitous one, both from his perspective as an artist and from theirs as a fledgling arts organization. His work was shown in the Academy's exhibitions nearly every year for the rest of his life. As William Dunlap noted in his pioneering 1834 publication:

The gallery of the National Academy of Design in New-York . . . is yearly decorated by his [Bennett's] landscapes and sea-pieces, in water-colours, the latter altogether unrivalled; and at the same time with prints from his engravings.[6]

In 1829, the year he was elected to full membership at the National Academy, Bennett was invited to execute two topographic watercolors to be engraved by Asher B. Durand for Durand's forthcoming enterprise *The American Landscape*.[7] Thomas Cole (q.v.), Robert Weir, and Durand himself contributed to the launching of this serial publication intended to celebrate native American scenery. Although the ambitious undertaking never advanced beyond the issuing of its first quarto in 1830, the effort proved a significant step toward recognizing landscape as an accept-

able subject for American artists.[8] William Cullen Bryant was to have written the text for the entire series, as he had for its first issue. Also in 1829, Bennett traveled to Niagara Falls where he made several watercolors for later translation into aquatint. From these spectacular waterfalls, he painted some of his best topographical views; his Niagara scenery was so popular that lithographs were also printed to give the imagery wider circulation.

The following year Bennett was appointed keeper of the National Academy of Design, assuming duties similar to those of the keeper of the Royal Academy. An undated manuscript written and signed by Thomas Seir Cummings in the National Academy's Archives describes Bennett's projected responsibilities:

Mr. Bennett having been appointed keeper of the Academy, the Council hereby authorizes him to take charge of all the property belonging to the Institution, and to attend to the safe keeping of the same, also to take charge of the school during the hours of drawing, preserve order and see the premises safe after the departure of the students.

As custodian of both the collections and the Academy Schools, Bennett was given quarters in Clinton Hall, the organization's first site. Despite his many administrative demands, he continued to flourish as a printmaker. His landscapes and city views, shown not only at the National Academy but later at the American Art-Union and the Apollo Association, continued to enjoy great critical praise, especially from the *New-York Mirror*.[9]

Much to his regret, Bennett was dismissed as keeper of the National Academy on January 6, 1840, the minutes citing his "inability to control the students" as an explanation. Actually, according to the *New-York Mirror*, Bennett's students were deeply chagrined by his dismissal. On March 21, 1840, it reported that the National Academy students presented Bennett with a gold snuffbox engraved as follows:

Presented to J. W. [sic] Bennett by the students of the National Academy of Design, as a mark of their respect for his gentlemanly deportment while Keeper of that institution. New York, March 12, 1840.[10]

While Bennett naturally withdrew from the National Academy's annual exhibitions, he continued to issue engravings, and in 1843–1844 he was commissioned by the *New Mirror* (formerly *New-York Mirror*) to reproduce ten watercolors of American settings in aquatint for publication in the weekly. Six of these were nautical views, demonstrating the artist's skills as a marine illustrator.

Bennett died in 1844 and was buried in Greenwood Cemetery, Brooklyn, in a "Stranger's Vault."[11] The National Academy minutes of May 15, 1844, recognized his passing, and fifty dollars was appropriated for the purchase of several of his engravings. There is presently no record of these engravings. Apart from a few manuscript letters, the watercolor in the present exhibition is the only example of Bennett's work in the collections. The National Academy is most fortunate to have at least this one watercolor painted by its first keeper. DA

1. *New-York Mirror* 17, March 21, 1840, p. 310.

2. Dale Roylance has noted the growing popularity of watercolor painting in England toward the end of the eighteenth century among both practicing artists and amateurs. Easily portable watercolor cakes, developed by Reeves & Co. around 1780, enabled anyone to roam the English countryside with a supply of watercolor paper and a flask of water or spirits. Newly published drawing manuals instructing in this new enterprise gave further impetus to the endeavor among amateurs. New York 1988, p.3.

3. The Society of Painters in Water-Colours underwent several changes over time, both conceptual and financial. It eventually became the Royal Society of Painters in Water-Colours in 1881, under the patronage of Queen Victoria. The Associated Artists in Water-Colours was dissolved after 1812 and reactivated with a very limited membership under the title Society of Painters in Oil and Water-Colours. Bennett renewed his affiliation with the Society of Painters in Oil and Water-Colours in 1819 when it resumed its previous identity exclusively serving painters in watercolor.

4. The aquatint process retained its popularity in England until around 1840, when it was superseded by lithography. New York 1988, p. 4. Between 1816 and 1819, in particular, Bennett produced thirty-one aquatints after England's most eminent oil and watercolor painters. He worked for three outstanding publishers, Ackermann, W. H. Pyne, and Murray. De Silva 1970, p. 38.

5. Impressions of Bennett's first topographic view of an American city entitled *Broadway from the Bowling Green* are found in the New-York Historical Society (two examples) and in the Print Room of the New York Public Library (three examples). A very fine preparatory drawing, in gray wash and graphite, for this aquatint is also in the New York Public Library.

6. For a complete record of Bennett's exhibition history at the National Academy of Design, consult Cowdrey 1943, 1, p. 30–31; Dunlap 1834, 1, p.275.

7. Bennett's watercolors for *The American Landscape* were titled *Weehawken, from Turtle Grove* and *The Falls of the Sawkill*. Durand's engravings after the watercolors were issued in the serial's first quarto, a copy of which is in the New York Public Library. These engravings were also published in the *New-York Mirror* in 1833. *The American Landscape* series was later revived and published in its entirety in the 1850s. The New-York Historical Society has a copy of this later, inclusive publication.

8. In the "Prospectus" of the first issue of *The American Landscape*, Asher B. Durand and Edward Wade, Jr., outlined the plan for the projected series: "the proprietors of the American Landscape . . . now present to the public the first number of a series of views intended to embrace some of the most prominent and interesting features, of our varied scenery. It is contemplated to extend the work to ten numbers, each containing six views, in quarto, with letter

press illustrations, to appear at intervals of six months, or oftener if possible." *The American Landscape* (New York: Elam Bliss, 1830).

9. Both Henry Megarey and Lewis P. Clover published Bennett's engravings with regularity. Ronald De Silva has noted (De Silva 1970, p. 2) that in Bennett's day few American engravers produced engravings from their own watercolors. They usually executed engravings after the original works of other artists or earned their income from the more certain trade of bank note engraving. Contrary to practice, Bennett's reputation as a topographic engraver was solidly in place from the very start. He sustained a market for his work throughout his years in the United States.

10. *New-York Mirror* 17, March 21, 1840, p. 310.

11. Although William Dunlap records Bennett's marriage to an American woman sometime after 1826, she does not appear in any documentation following his death. Bennett left no will. Dunlap 1834, 1, p. 275.

5

Figures in a Landscape

Watercolor and graphite on heavy paper, partially varnished, ruled in graphite

14 x 17⅝ inches (355 x 449 mm)

Signed in brown ink, lower right: *Bennett*; inscribed on verso in brown ink, upper right: *41 not by Bennett* and, lower center: *N⁰. 5*

Collection of the National Academy of Design [1980.35]

Although this unfinished watercolor cannot be traced definitively to Bennett's hand, there are several arguments which certainly challenge its puzzling verso inscription. Circumstantial grounds alone point to him. Bennett had a long association with the National Academy of Design, and it is arguable that as its first keeper he might have left a watercolor or an aquatint to the organization. After all, despite the many administrative demands of his role at the Academy, Bennett continued to flourish as a topographic engraver right through his years of employment. If, then, he gave this watercolor to the Academy, why would he have chosen a clearly unfinished sheet?

The first and only record of the Academy's ownership of the watercolor appears in the publication *Constitution of the National Academy of Design, and Schedule of the Property* (New York: Sackett & Co., 1852) under the heading "Schedule of Property belonging to the National Academy of Design. Taken August 1st, 1852." The work is listed as "Water Colored Drawing, Unfinished, J. Bennett." Thus we know that by 1852 the signature on the recto was in place. Of the few watercolors by Bennett in other public collections in New York, only one is signed, and the hand bears little similarity to other of his autograph signatures.[1] The National Academy has several of Bennett's manuscript letters relating to his employment there. The autograph signatures in these letters, all in brown ink, share the same graceful script as the signature in *Figures in a Landscape*, but while the signatures on the letters are clearly by the same hand, the hand inscribing the watercolor varies slightly. It is, of course, possible that the signature was added by someone else at a later date as a record of authorship.

If we compare the National Academy's sheet to the few watercolors by Bennett in the collections of the New York Public Library, Metropolitan Museum of Art, and New-York Historical Society, the accomplished handling of transparent washes in muted tones and soft, feathery treatment of trees (see for example, *Niagara Falls: View of the American Fall, taken from Goat Island,* watercolor, acc. no. 1984.72, New-York Historical Society) do suggest certain affinities. The watercolors in the New-York Historical Society share the quiet, picturesque charm of the Academy's sheet. Other examples of Bennett's landscape watercolors, and indeed his aquatints, do not give figures the prominence they hold in *Figures in a Landscape*. There are very few comparative examples, however, by which to judge Bennett's figures in landscape imagery.

The unfinished nature of the National Academy's watercolor provides insight into the artist's working technique. The image is outlined in graphite, suggesting it might have been preparatory to an engraved illustration. The composition also appears to have been entirely laid out in graphite before the washes were applied. Bennett has, at least at this stage of execution, left the horizontal bands of wash translucent. Only the trees have been worked up with several layers of wash to effect the density of foliage. He has devoted considerable attention to the trees in the watercolor, even to the point of creating contrasting finishes through varnished and unvarnished areas. The tree at center is partially varnished, giving its unglazed area a deeper tonality. It is curious to consider the contrast of imagery between the fully described foliage and the unfinished figures. Though only rapidly sketched in graphite, the figures already convey the lassitude of a warm afternoon in this recreational setting.

Bennett generally made watercolors in preparation for aquatints. Equally skilled in watercolor and aquatint, he sometimes aquatinted his own images and sometimes left that process to other artists. To reproduce a wash drawing with many gradations of

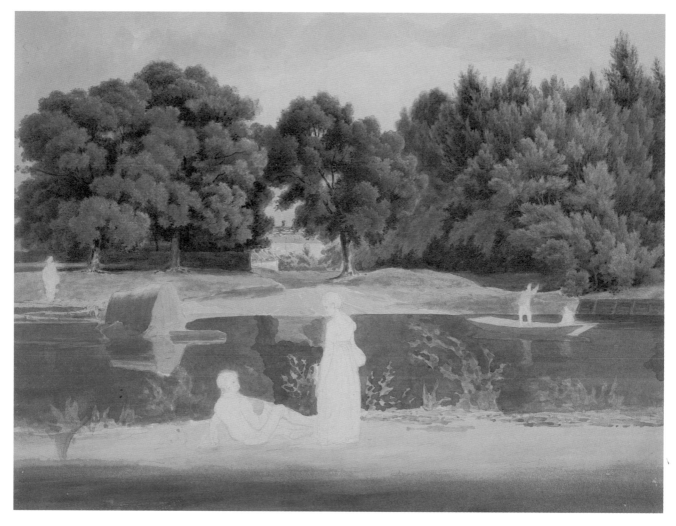

5

tone takes great skill and patience. Because the process itself is so complex, few aquatinters also learned how to draw interesting pictures.[2] William James Bennett was an exception to that rule. Although this unfinished watercolor does not present Bennett at his best, it has passages of proficiency and passages without resolution which, after all, are acceptable incongruities in an unfinished sheet.

1. The watercolor entitled *View of High Bridge and the Harlem River* in the Stokes Collection, New York Public Library (illustrated in New York 1988, p. 87) is inscribed: *W. J. Bennett from Nature 1844.* The signature is not in script, as was his custom, but in printed letters. It appears prominently in the image at the lower left.

2. For a further discussion of the aquatint process and its first American practitioners, see Mayor 1965, pp. 314–318.

Arnold W. Brunner

New York 1857 — New York 1925
ANA 1910, NA 1916

ARNOLD W. BRUNNER ranks among the foremost New York architects and city planners of his day. While his academic training and use of drawing were derived from traditional nineteenth-century practices, his buildings helped to shape the twentieth-century "urban landscape." He has been remembered more for his achievements in architecture than for his drawings and watercolors, which were a private pursuit of the 1880s and 1890s. After his death, Brunner's widow Emma Beatrice Kaufman Brunner gave his drawings to the Cooper Union for the Advancement of Science and Art so that the students might benefit from studying them. Some of these drawings now reside in the Cooper-Hewitt National Design Museum.[1]

In 1877, following early schooling in New York and Manchester, England, Brunner began studying the Beaux-Arts tradition of architecture at the Massachusetts Institute of Technology, which was then one of the few American universities offering an architecture program. After receiving his architecture degree in 1879, he worked for the New York architect George B. Post. From 1883 to 1885, Brunner traveled extensively in Europe, primarily in Italy and France, recording various sights in sketchbooks—architectural details, city and country views, studies of people, objects he saw in museums.

Back in New York by December 1885, Brunner established an architectural partnership with Thomas Tryon. Brunner & Tryon's first notable achievement was the Eleventh Street studio of the sculptor Daniel Chester French in 1888. As an American-born Jewish architect, Brunner was frequently commissioned to design New York synagogues, including Temple Beth-El on Fifth Avenue (1890–1891; demolished 1927) and the Spanish and Portuguese Synagogue (now called Congregation Shearith Israel) on Central Park West (1897).[2] Brunner, however, received his chief public building and civic planning commissions after 1898, when he established his own architectural firm. They include Mt. Sinai Hospital, New York (1898–1904; Brunner's buildings were demolished during later expansions); Columbia University's School of Mines (erected 1904, now called Adolph Lewisohn Hall);[3] the United States Post Office, Customs' House, and Court House in Cleveland (1901–1909); Lewisohn Stadium, College of the City of New York (erected 1915); Barnard Hall, Barnard College (erected 1917); governmental buildings in Toledo and Harrisburg; and the plan for Denison University in Granville, Ohio (1920s). In 1910, Brunner's proposal won the prestigious federal competition to design the building for the Department of State in Washington, but this project was never constructed.

Brunner played an active role on numerous professional and civic committees. In 1902 he was appointed a member of Cleveland's Board of Supervisors for Public Buildings and Grounds, becoming chairman in 1912. He also served on the city planning commissions for Baltimore, Denver, Rochester, and Albany. He was a longtime member of the American Institute of Architects, serving as president of the New York chapter in 1909–1910. In 1913 he was appointed a member of the American Academy of Arts and Letters, serving as its treasurer from 1914 until his death.

After Brunner's death, his legacy continued in the form of memorial awards established by the bequest of his widow. In 1938 the Architectural League of New York, where Brunner had served as president in 1903–1904, announced the Arnold W. Brunner Scholarship Fund (now administered by the New York chapter of the American Institute of Architects). The American Academy of Arts and Letters presents an annual Arnold W. Brunner Memorial Prize in Architecture.[4] These awards ensure that Brunner's name

lives on in today's New York architectural community, but few actually know the details of his professional achievements. Scholarly studies of Brunner's life and career are scant, and the role of drawing in his design process remains unexamined. His non-architectural drawings and watercolors of the 1880s and 1890s were obviously attempts by the young developing architect to examine the world around him. However, this heretofore overlooked aspect of his work deserves further critical attention in the context of drawing practice in late nineteenth-century America. MS

1. "Brunner Drawings" 1928. Another article, "Brunner's Works Placed" 1927, states that "a group of architectural drawings and watercolors" was given to Cooper Union. While 360 drawings (10 being architectural drawings, but most being travel sketchbook pages dating ca. 1883) given in 1927 came to be part of Cooper Union's collection (accessioned in 1948), the whereabouts of almost all of Brunner's architectural drawings is unknown.

2. Berger 1980, p. 164.

3. Some of Brunner's drawings for this building can be found in Columbia University's Avery Architectural and Fine Arts Library.

4. The first prize, issued in 1955, went to Gordon Bunshaft. Other award winners include Louis I. Kahn (1960), I. M. Pei (1961), Richard Meier (1972), Robert Venturi (1973), Michael Graves (1980), Frank O. Gehry (1983), James Ingo Freed (1987), Arata Isozaki (1988), and Renzo Piano (1994).

6

Lakeside Landscape, ca. 1890

Watercolor on paper; borders ruled in graphite

11⅞ x 9¼ inches (302 x 235 mm)

Signed in brown watercolor, lower left: *A. W. BRUNNER*

Cooper-Hewitt National Design Museum, Smithsonian Institution

Gift of Mrs. Arnold W. Brunner, 1948–47–19

The lack of specific information regarding where Brunner traveled and what prompted him to make occasional landscape watercolors leaves many unanswered questions. Was he self-taught in watercolor, or did he have lessons? Might he have been exposed to Victorian watercolors during his years at school in England? Apart from his vast European travels, did he regularly vacation in the countryside of the northeastern United States? Did he paint landscape watercolors in solitude—as a form of relaxation from his architectural practice and as a means to learn from nature's settings and forms? How aware was he of the work of artists of his own day?

Brunner's watercolors, such as this one, are frequently signed but rarely dated or identified. A posthumous article on Brunner noted that he had made trips to Nantucket, Bar Harbor, the St. Lawrence River region of Canada, and other parts of Quebec.[1] To date, however, the presumably North American lake depicted in this watercolor has not been identified.

While Brunner's pencil studies are usually tightly drawn and literally descriptive, his watercolors, like this undramatic but sparkling lakeside scene, somewhat exploit the medium's potential for broad, general representation. Compared, however, to the dazzling wash drawings and watercolors by Winslow Homer, Thomas Moran, and William Trost Richards (qq.v.), all of whom knew how to manipulate the aqueous colors with remarkably agile facility, Brunner's less fluid efforts would have to be classed as those of a skilled amateur. Instead of focusing on nature's details and textures, he constructed this generalized composition with discernable horizontal sweeps and vertical strokes of chromatic wash. His main purpose was to convey the site's open spaciousness. Perhaps, as an architect, his primary interest was the expansive quality of the landscape, for he deliberately chose to show that the scene extended beyond the sheet's edges, and did not include any compositional framing devices. He sought to convey an airy outdoor vista bathed in sunlight. Although we do not know if Brunner was aware of Impressionist art, his watercolor seems closer to that plein-air aesthetic than to the principles of landscape established by Hudson River school artists, who would have carefully articulated the setting's topographical features.

1. See clipping from *New York Herald Tribune* (dated by hand December 23, 192[7]) on Brunner microfiche, Arts Division, New York Public Library.

6

Frederic Edwin Church

Hartford 1826 — New York 1900
ANA 1848, NA 1849

THE PREEMINENT American landscape painter Frederic Edwin Church created extraordinary images of native and exotic scenery from the late 1840s to the late 1870s. Exhibitions of his great pictures *Niagara*, 1857 (Corcoran Gallery of Art, Washington), and *The Heart of the Andes*, 1859 (Metropolitan Museum of Art, New York), were sensational public events that generated widespread admiration for his technical virtuosity and uncanny power of observation.

Church's artistic talents were recognized early. In 1844, at age eighteen, he became the first pupil of Thomas Cole (q.v.), the Hudson River school founder and leading landscape painter. Staying with Cole in Catskill, New York, until 1846, Church began his lifelong practice of drawing outdoors directly from nature. He made detailed botanical studies throughout his career, as well as panoramic vistas — usually in graphite or oil, and, rarely, in ink. Cole recognized Church's skillful draftsmanship and encouraged his exploration of nature. After Cole's death, Church soon succeeded him as the unrivaled American master of naturalistic landscape.

In 1845 Church began exhibiting at the National Academy of Design. His first important success, *Hooker and Company Journeying through the Wilderness from Plymouth to Hartford in 1636* (Wadsworth Atheneum, Hartford), was shown there the following year. Church's consistent participation in the annual National Academy exhibitions until 1878 marked his sustained presence in New York art circles.

Having established his residence and studio in New York by 1848, Church made frequent sketching trips to the Berkshires in Massachusetts, to Vermont and New Hampshire, and to other rural and woodland areas of New England and New York State. In the summer of 1850, he visited the Maine coast and Mount Desert Island. Later, seeking even more remote wilderness areas, he traveled to rocky Grand Manan Island in Canada, again to Mount Desert Island, and to the Mount Katahdin region of Maine, which became a favorite spot for sketching over the next three decades. These trips always stimulated numerous drawings, oil sketches, and paintings.

The 1850s witnessed the full flowering of Church's artistic maturity. Inspired by the writings of the German naturalist Alexander von Humboldt and others, Church journeyed to Colombia and Ecuador in 1853 and 1857, visited Niagara in 1856 and 1858, and sailed to the edge of the Arctic Circle in 1859 . These travels resulted in the monumental paintings that are still regarded as iconic representations of the New World: its tropical paradise, grandest waterfall, and citadels of ice. Church's reputation soared, and his major paintings commanded unprecedented high prices.

In 1860 Church married Isabel M. Carnes and moved to Hudson, New York, although he maintained his Tenth Street studio in the city. There he produced a succession of landscapes: *The Icebergs*, 1861 (see no. 11), *Cotopaxi,* 1862 (Detroit Institute of Arts), *Chimborazo*, 1864 (see no. 10), *Rainy Season in the Tropics*, 1866 (see no. 12), among others. His life was jolted by the sudden deaths of his two young children in 1865. Shortly after, badly in need of a change of scenery, he and his wife traveled to Jamaica. There he made numerous studies of tropical scenes and atmospheric effects, his creative vigor renewed. In the fall of 1867 Church, his wife, and their third child embarked on an almost two-year odyssey in the Near East and Europe. The artist returned to New York in the summer of 1869 with hundreds of pencil drawings and oil sketches of the many sites he visited on his travels. From these he executed such masterpieces as *Jerusalem from the Mount of Olives*, 1870 (Nelson-Atkins Museum of Art, Kansas City), *The Parthenon*, 1871 (Metropolitan Museum of Art, New York), and *El Khasné, Petra*, 1874 (Olana State Historic Site, Hudson, New York).

In the 1870s, besides tending to a growing family (three more children were born), Church devoted most of his energy to designing and building (with architect Calvert Vaux) his grand villa, Olana. Completed in 1876, it commands a magnificent view of the Hudson River and the Catskills. Church pursued other endeavors as well. He was a founding trustee of the Metropolitan Museum of Art in 1870 and played a role in developing New York City's Central Park, as well as campaigning for a park around Niagara Falls.

His later years were marked by declining productivity and deteriorating health, although he still managed to make several trips to Mexico and Maine. At his death, his reputation as an artist was much diminished.

During Church's lifetime, most people were unaware of the vast quantities of drawings and oil sketches he made, primarily as source material for his

paintings. In 1917 the artist's fifth child, Louis Palmer Church, donated over 2,000 drawings and oil sketches to the Cooper Union Museum for the Arts of Decoration, now Cooper-Hewitt National Design Museum. The remaining 701 works from Church's studio are still at his former home, now Olana State Historic Site in Hudson, New York. Aside from his major paintings in public and private collections, these two collections constitute the prime repositories for investigating Church's art. MS

7
Niagara: View of the Canadian Falls and Goat Island, 1856

Graphite and white gouache on greenish-gray wove paper

11³/₁₆ x 17⅞ inches (285 x 455 mm)

Inscribed and dated in graphite, lower right: *2– cedar with red creeper / 3— Grape vine / Oct. 6th 1856.*

Cooper Union stamp 1, lower left and on verso.

Cooper-Hewitt National Design Museum, Smithsonian Institution

Gift of Louis P. Church, 1917–4–33c

8
Niagara River Gorge, 1856 or 1858

Graphite and white gouache on buff wove paper

10¾ x 18 inches (270 x 458 mm)

Inscribed in graphite at right: *slaty / yell / yell.* On verso, a rough graphite sketch of falls and tower.

Cooper Union stamp 1, lower left, and stamp 2 on verso, center.

Cooper-Hewitt National Design Museum, Smithsonian Institution

Gift of Louis P. Church, 1917–4–170

9
Niagara River Gorge, 1856 or 1858

Oil on cardboard

10⅝ x 16 inches (270 x 406 mm)

Cooper-Hewitt National Design Museum, Smithsonian Institution

Gift of Louis P. Church, 1917–4–168

7

During the 1800s thousands of tourists visited Niagara Falls, the most celebrated natural landmark in North America. Its immense torrents, mighty cataracts, and majestic beauty had been described and depicted since the seventeenth century. By the 1850s, numerous views of the falls had appeared in paintings, colored lithographs, engravings, book illustrations, advertisements, daguerreotypes, and stereo views.[1] As America's most ambitious landscape painter, Church could not resist the challenge of representing Niagara Falls in an astonishing new way. His interest in Niagara may also have been stimulated by reading volumes three and four of John Ruskin's *Modern Painters*, just published in 1856, which discussed the English artist J. M. W. Turner's vivid representations of the forces of flowing water.[2]

In mid-March, early July, and late September-early October of 1856, Church visited Niagara, each time making numerous studies in pencil and oil. He made another excursion in August and September of 1858.[3] Characteristically his practice was to draw aspects of the falls from various vantage points. In *Niagara: View of the Canadian (or Horseshoe) Falls and Goat Island* (no. 7), Church delineated shoreline vegetation to set off the distant view of the falls and rock faces,

and he further identified a few specific plants with a numbering system. He applied white gouache to convey the tumbling water, the spray rising from the base of the falls, and the foam on the surface of the Niagara River.

Another drawing and related oil sketch (nos. 8 and 9) show the same view on the Niagara River, where the water vigorously swirls into white water rapids. In the drawing, Church outlined the foliage and general topographical features of the rugged river bank. He shaded portions with regular parallel hatching. The real drama, however, was the churning and splashing water, heightened with white, which Church seems to have accentuated in his color version of the scene. The oil sketch shows how excellent his command of the medium was for conveying the water's unpredictable force. Many skillfully observed and rendered works like these provide a comprehensive visual record of his experience at Niagara, and constitute the raw material for making his great picture *Niagara* (Corcoran Gallery of Art, Washington). The painting was hailed as a sensational achievement when it was first exhibited in May 1857, and it immediately catapulted the thirty-one-year-old artist to widespread fame as the leading painter in the country.

8

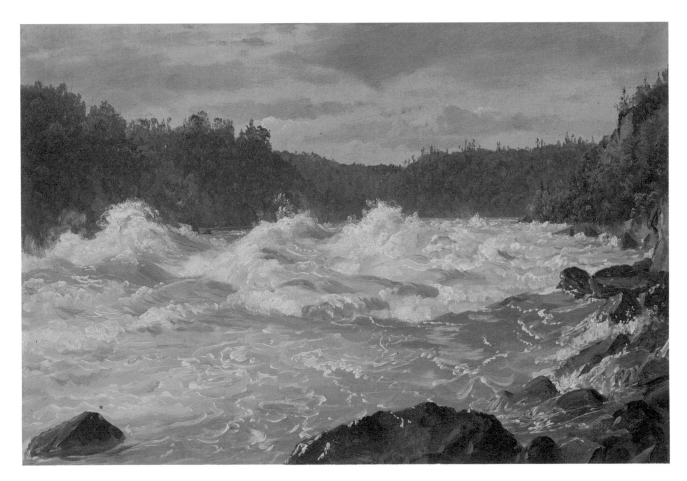

9

Church later returned to this popular subject with the paintings *Under Niagara*, 1862 (unlocated), and *Niagara from the American Side*, 1867 (National Gallery of Scotland, Edinburgh).

1. For thorough accounts of the importance of Niagara Falls as a subject for American landscape artists, see Washington 1985b and Adamson 1981. John Vanderlyn, John Trumbull, William James Bennett, George Catlin, Thomas Cole, and John F. Kensett had all made pictures of Niagara Falls prior to Church's pilgrimage to the site.

2. Huntington 1966, pp. 66–67.

3. The Cooper-Hewitt National Design Museum has over forty Church drawings and oil sketches of various vistas and detail studies of Niagara Falls and its vicinity. While some are dated with certainty to one of his 1856 trips, others are undated, and may date from his 1858 visit.

10

Mount Chimborazo and Guaranda, Ecuador, 1857

Oil over graphite on buff-colored paperboard

13⅝ x 21⅜ inches (345 x 536 mm)

Cooper-Hewitt National Design Museum, Smithsonian Institution

Gift of Louis P. Church, 1917–4–859

Seeking new American landscape subjects for his paintings, Church made two expeditions to South America—in 1853 and 1857. There he made hundreds of drawings and oil sketches, many of which are in the Cooper-Hewitt National Design Museum. Church's interest in the equatorial region came through his reading English editions of Alexander von Humboldt's *Cosmos: A Sketch of a Physical Description of the Universe* (1849) and passages from his *Personal Narrative of Travels to the Equinoctial Regions of the New Continent during the Years 1799–1804* (1829).[1] Humboldt's writings urged artists to explore the bountiful natural phenomena found in the tropics:

Are we not justified in hoping that landscape painting will flourish with a new and hitherto unknown brilliancy when artists of merit shall more frequently pass the narrow limits of the Mediterranean and when they shall be enabled, far in the interior of continents, in the humid mountain valleys of the tropical world, to seize, with the genuine freshness of a pure and youthful spirit, on the true image of the varied forms of nature?[2]

In Humboldt's day, Chimborazo was regarded as the world's highest peak, and the German naturalist's 1802 ascent to just short of its summit was still legendary in the 1850s. Apart from Humboldt's illustrations, this remote, extinct volcano had never been painted, so it was a chief destination of Church's 1857 journey. For ten days in early June he stayed at the town of Guaranda, about ten miles southwest of Chimborazo. From there he could obtain grand views of the mountain's summit whenever the clouds permitted.[3]

This image reveals much underdrawing in graphite: the sketchy outlines of Guaranda's buildings are visible at the bottom. Obviously, Church's primary interest was to capture the characteristic appearance of the mountain in late afternoon light, rather than detailing aspects of the Andean town. He painted only the upper portion in oil. At the top, the snow-capped peak stands out against patches of blue sky and cloud. Beneath, some foothills are sunlit, while other portions are in the cloud's shadow. The middle distance is enlivened by a patch of orange-yellow fields.

The numerous drawings and oil sketches Church had made on the 1857 trip served as important sources for all his subsequent tropical landscapes. His masterpiece, *The Heart of the Andes*, 1859 (Metropolitan Museum of Art, New York)—the painting that marked the pinnacle of his career—was the first in which he portrayed the lofty Chimborazo. The mountain appeared again in Church's 1864 landscape *Chimborazo* (Virginia Steele Scott Collection, Henry E. Huntington Library and Art Gallery, San Marino, California).

1. New York 1993, p. 14, n. 18.

2. Humboldt 1849 (2, p. 452), as quoted in New York 1993, pp. 15–16.

3. See New York 1993, pp. 23–26, and 59, n. 62. Kevin Avery's text provides a most thorough account of Church's South American trip and his study of Chimborazo. He identified, among the Cooper-Hewitt National Design Museum holdings, nine oil sketches of Chimborazo, along with twenty-two drawings done in Guaranda and its vicinity from June 3 to 14, 1857. The author is indebted to Kevin Avery for sharing his insights on Church and for his advice on these entries.

11

Floating Iceberg under Cloudy Skies, 1859

Oil over graphite on buff-colored paperboard

11⅞ x 20 inches (302 x 505 mm)

Cooper-Hewitt National Design Museum, Smithsonian Institution

Gift of Louis P. Church, 1917–4–305A

10

11

After making two expeditions to the Southern Hemisphere, Church turned to the grand scenery of the far North, particularly the icebergs in the North Atlantic. In mid-June 1859, he sailed from Boston to Halifax, then on to St. John's, Newfoundland, to explore the seas off the Newfoundland and Labrador coasts.[1] He was accompanied by the Rev. Louis L. Noble, the biographer of Thomas Cole, who later published a full account of the voyage in his book *After Icebergs with a Painter* (1861). Once beyond St. John's, where Church had chartered the schooner *Integrity*, numerous icebergs were regularly sighted. In spite of bouts of seasickness, both Church and Noble were spellbound by the phenomenal shapes of the glacial islands—which suggested to them enormous houses, cathedrals, castles, monumental marble ruins, snow-covered Andean or Alpine peaks—and by the amazing opalescent tints glinting off the ice.

During this almost month-long cruise, Church made numerous studies of icebergs in both pencil and oil. Fifty-nine of these can be found in the Cooper-Hewitt National Design Museum collection. In these works, Church's essential pictorial elements were the three states of water: liquid (sea), solid (ice), and gas (cloud). This oil sketch reveals how he manipulated oil pigment to render a craggy glacial mountain floating on fluid gray waves, formed by undulating brushstrokes. The ashen atmosphere above contrasts with the green water pooling in the iceberg's hollows. Church referred to these visual records of frozen color and form when he painted what was to become his most celebrated Arctic picture, *The Icebergs* (Dallas Museum of Fine Arts), which he completed by April 1861.

1. Church's interest in the Arctic region derived from a variety of sources: his friendship with the explorer Dr. Isaac Hayes, supplemented by his reading of Humboldt's *Cosmos* (1849) and Elisha Kent Kanes's *Arctic Explorations* (1856). Prior to his departure, Church had further familiarized himself with the subject by studying lithographs, engravings, and photographs of Arctic scenery, as well as books on polar geology and natural history. See Carr 1980 for a thorough account of American interest in the Arctic which prompted Church's journey and interest in icebergs.

12

Study for "Rainy Season in the Tropics," 1863

Graphite on paper, ruled with graphite and blue ink; on verso, two graphite elevation studies of a mansard-roofed house with details of plan, roof contour, and moldings; inscribed in pen and black ink (superimposed over part of image) in mirror writing: *Frederick / My dear Isabel*; in graphite, *My dear*

5³⁄₁₆ x 8³⁄₁₆ inches (133 x 207 mm)

Cooper Union stamp 1, lower left.

Cooper-Hewitt National Design Museum, Smithsonian Institution

Gift of Louis P. Church, 1917-4-771

This study, along with two preliminary sketches drawn on the back of a letter (dated January 15, 1863, to Church from his mother Eliza Janes Church), now in the collection of Olana State Historic Site, Hudson, New York, are the earliest preparatory drawings for the 1866 painting *Rainy Season in the Tropics* (see figs. 7 and 8). Gerald Carr has dated these drawings to 1863, rather than to between 1864 and 1866, when the painting was in process. According to Carr, the two Olana drawings must have been drawn shortly after Church received his mother's letter in mid-January

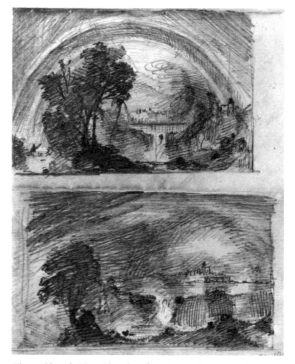

Fig. 7. Church, Two Sketches for "Rainy Season in the Tropics," *drawing, New York State Office of Parks, Recreation and Historic Preservation, Olana State Historic Site*

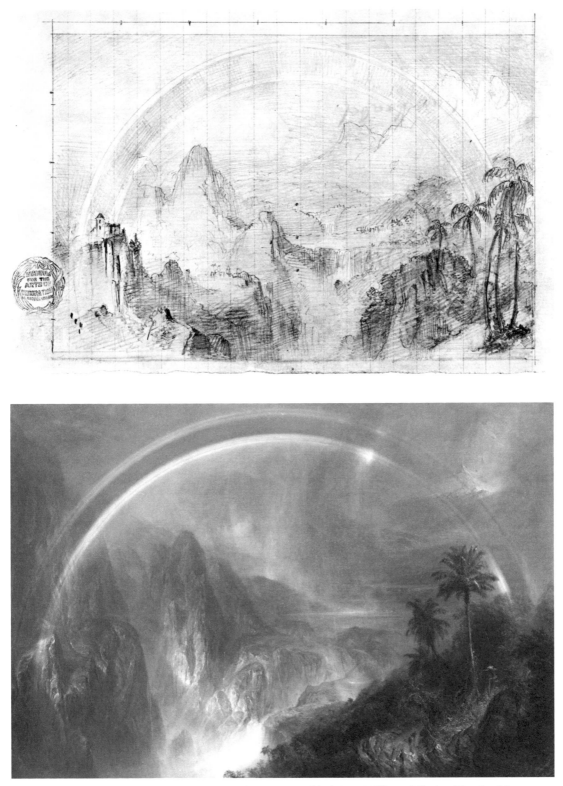

Fig. 8. Church, Rainy Season in the Tropics, *1866, oil on canvas, Mildred Anna Williams Collection, Fine Arts Museums of San Francisco (1970.9)*

1863. He probably did this more finished study by May 1863, when there was a public announcement about the tropical picture commissioned by Marshall O. Roberts, a successful shipping merchant and important Church patron.[1]

This dramatic panorama of towering peaks flanking a river gorge, with a church (or castle) perched atop a cliff at the left and a cluster of palm trees at the right, bridged by a prominent double rainbow, is similar in compositional formula to several of Church's South American landscape paintings.[2] While most of his graphite drawings are direct studies from nature, this is clearly a studio drawing, in which the artist imaginatively combined major landscape motifs into a sublime composition in preparation for the painting. Beneath faint strokes outlining the Andean terrain and equatorial foliage, Church drew a fine mesh of parallel shading lines to define the rocky mountain sides and areas of vegetation. The light atmospheric tones of the sky and the misty area between the two rainbows were also evenly shaded. Almost all the basic features of the painting were fully rehearsed in this drawing, which was ruled for scale transfer to the canvas.[3] In the final painting, however, Church eventually eliminated the building and accentuated the vaporous effects.

After Church's two trips to South America in 1853 and 1857, and to Jamaica in 1865, tropical subjects dominated his art, culminating with his 1877 painting *Morning in the Tropics* (National Gallery of Art, Washington), generally regarded as his last successful major work. Various Church scholars have pondered the symbolic meaning of *Rainy Season in the Tropics,* which was completed after the deaths of two Church children in 1865, his restorative trip to Jamaica that same year, and the conclusion of the Civil War.[4] The rainbow, symbol of God's benevolent promise to mankind, signals the passing of the storm and links the divided sides of the landscape, as well as earth and sky. The 1863 drawings, however, indicate that the rainbow was a part of the original conception,[5] which predates the personal and national events that affected Church's life. Thus, the post-Civil War significance generally attributed to this painting may be more than Church originally intended.

1. Both David C. Huntington (1966, pp. 56–57) and Elaine Evans Dee (Yonkers 1984, p. 63, no. 50) suggested that this drawing was done 1865–1866, after Church's Jamaica trip. For more recent information regarding the circumstances surrounding the creation of these drawings and the Marshall O. Roberts commission, see Carr 1994, pp. 285–287, no. 417.

2. In Washington 1989, p. 62, Franklin Kelly cites compositional similarities to *In the Tropics*, 1856 (Virginia Museum of Fine Arts, Richmond), and *View of Cotopaxi*, 1857 (Art Institute of Chicago). One could also cite similar geographic and compositional elements in *The Heart of the Andes*, 1859 (Metropolitan Museum of Art, New York), and *Cotopaxi*, 1862 (Detroit Institute of Arts).

3. Elaine Evans Dee noted that there is no other Church studio drawing in the Museum's collection that is ruled, as this one is, for enlargement (Yonkers 1984, p. 63, no. 50). She further remarked to the author (November 16, 1994) that a working drawing like this is usually among the last steps an artist makes before proceeding to work on the canvas. In her view, if Church began painting the picture in 1865, then possibly this drawing was made just prior to its commencement. The drawing's uniqueness in Church's oeuvre, however, might also substantiate a dating closer to the commission announcement, when presumably he intended to proceed more expeditiously to the painting stage, but, in this case, his progress was interrupted. The verso drawings do not clarify the matter. No one has firmly identified the architectural sketches, but Kevin Avery has proposed (in comments to author on December 2, 1994) that they may be early ideas for the house Church planned to build. The curious ink inscriptions (written in reverse) present the first names of the artist (misspelled) and his wife.

4. Most scholars have followed Huntington's interpretation (Huntington 1966, pp. 54–57). The painting's vision of sweeping New World glory was undoubtedly a factor in its selection for display in the 1867 Paris Exposition Universelle, and later at the National Academy of Design Winter Exhibition (1867–1868).

5. As Carr observed (Carr 1994, p. 286), the double rainbow appeared in Church's 1857 *Niagara* (Corcoran Gallery of Art, Washington), and he may have been consciously recalling in this drawing a dramatic feature derived from one of his most celebrated paintings.

13

Coconut Palm, Jamaica, 1865

Graphite on greenish-gray paper

10¾ x 8⅝ inches (275 x 220 mm)

Inscribed and dated in graphite, lower right: *The coil* [coir] *or wrapping greyish brown / yellow brown lights / Cocoanut* [sic] *Palm / Jamaica June 65.*

Cooper Union stamp 1, center.

Cooper-Hewitt National Design Museum, Smithsonian Institution

Gift of Louis P. Church, 1917–4–5

14

Coconut Palm, Jamaica, 1865

Graphite on greenish-gray paper

10¾ x 8⅝ inches (273 x 214 mm)

Inscribed and dated in graphite, lower left: *Cocoa Nut* [sic] *Palm / Jamaica June 65;* at lower right, *Portion of / root.*

Cooper Union stamp 1, center.

Cooper-Hewitt National Design Museum, Smithsonian Institution

Gift of Louis P. Church, 1917–4–6A

15

Palm Trees, Jamaica, 1865

Oil on tan paperboard

12 x 20 inches (303 x 507 mm)

Inscribed and dated in oil, lower left: *Jamaica / June 65*

Cooper-Hewitt National Design Museum, Smithsonian Institution

Gift of Louis P. Church, 1917–4–743C

16

Study of Tree Trunk, Parasite Vine, and Palm Plant, Jamaica, 1865

Graphite, white gouache on greenish-gray paper

17½ x 10¾ inches (446 x 275 mm)

Inscribed and dated in graphite, left center: *Jamaica / June 1865;* lower center, *Dead leaves / caught among the leavelets.*

Cooper Union stamp 1, center.

Cooper-Hewitt National Design Museum, Smithsonian Institution

Gift of Louis P. Church, 1917–4–11A

In late April 1865, Church and his wife departed for a five-month stay in Jamaica. In March their two young children had suddenly died of diphtheria. Both grief-stricken parents needed the solace and diversion a trip would provide. Humboldt's writings (see no. 10) convinced Church to view the fertile profusion of the tropical world as a present-day Garden of Eden. It was partly this spiritual association that lured Church and his wife to Jamaica during their period of mourning.[1] After settling in Bellevue near Kingston, Church immersed himself in sketching the luxuriant vegetation and tropical scenery, while Mrs. Church developed a passion for fern collecting.[2] The many detailed botanical studies of trees and plants the artist made in Jamaica, including these three pencil drawings and oil sketch, are among the finest he ever did.[3]

Church's practice of "portraying" specific trees and plants, by now well established, had initially derived from his early lessons with Thomas Cole (q.v.), who had advocated—in his 1835 "Essay on American Scenery" as well as in the example of his own drawings and paintings—the study of trees as crucial to understanding landscape. From Cole, Church also picked up the habit of inscribing his drawings with the tree's name, where it was observed, and the date. The works shown here exemplify Church's skill in delineating specific characteristics of each tree: varying textures, as well as forms and relationships of bark, trunk, branch, and leaf.[4] Church's scientific curiosity evinced in detailed botanical studies like these had been stimulated chiefly by his close reading of Humboldt. Humboldt had advised:

Coloured sketches, taken directly from nature, are the only means by which the artist, on his return, may reproduce the character of distant regions in the more elaborately finished pictures; and this object will be the more fully attained where the painter has, at the same time, drawn or painted directly from nature a large number of separate studies of the foliage of trees: of leafy, flowery, or fruit-bearing stems; of prostrate trunks. . . .[5]

In one *Coconut Palm* study (no. 13), Church focused on how the leaf fronds are attached to the trunk (leaving ringed scars after they fall off), while stringy roots dangle below. In the other study (no. 14), drawn on paper similar in color and size, he noted how the lower leaf fronds extend downward, above the branch stubs which circle the trunk. Perhaps he was trying to understand palm tree growth cycles, and maybe lurking in his mind was the symbolism of the palm as the Tree of Life.[6] In both drawings, he guided his pencil with remarkable assurance in out-

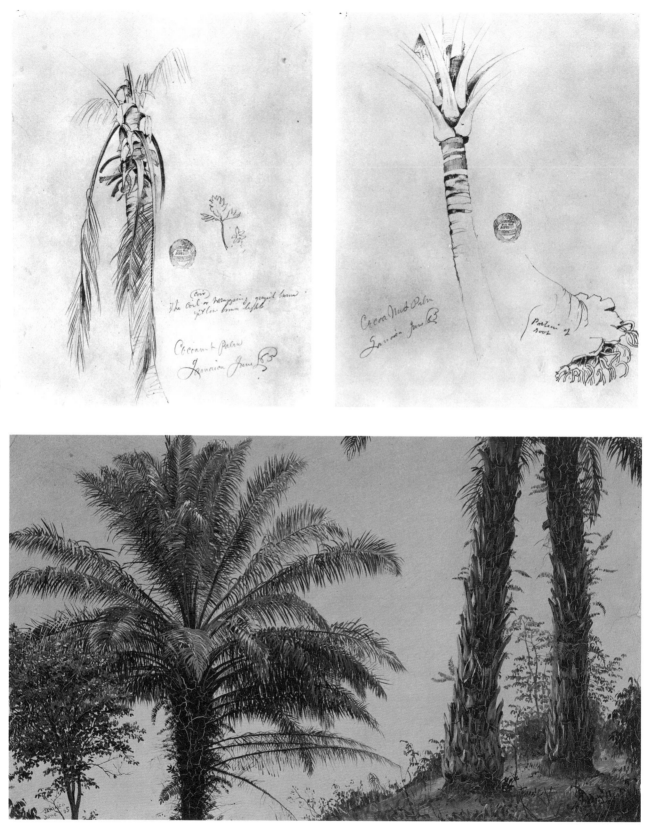

13

14

15

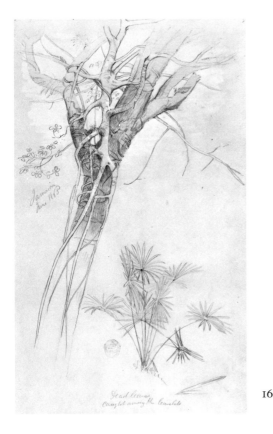

2. See Carr 1994, p. 291. Carr cites letters and the existence at Olana of one hundred fern and plant specimens, pressed between sheets of paper, as testimony to the seriousness of their botanical study.

3. More than a hundred drawings and oil sketches Church executed in Jamaica can be found in the Cooper-Hewitt National Design Museum.

4. Andrew Henderson of the New York Botanical Garden identified these as follows: *Cocos nusifera L.* (nos. 13 and 14); oil palm [*Elaeis* genus] (no. 15), though its appearance in Jamaica in the 1860s was unusual; *Ficus* and *Thrinax palm* (no. 16).

5. Humboldt 1849, p. 452, as quoted in Washington 1978, p. 23.

6. See Manthorne 1989, p. 13–14. The author appreciates Kevin Avery's suggestion of this idea.

7. The top of the palm tree at the right of *Rainy Season in the Tropics* (see no. 12, fig. 7) is very similar to that in this oil study (no. 15). Huntington 1966, p. 57, stated that every feature of *The Vale of St. Thomas, Jamaica* can be related to Church's Jamaica sketches.

16

17

Red Hills near Kingston, Jamaica, 1865

Oil on buff-colored paperboard

9¼ x 14½ inches (235 x 367 mm)

Inscribed in oil, lower right: F. E. CHURCH / JAMAICA /—65.

Cooper-Hewitt National Design Museum, Smithsonian Institution

Gift of Louis P. Church, 1917–4–385A

lining the palm tree's trunk and frond stems. He then shaded the tree with neat, concise parallel hatching. The draftsmanship convincingly conveys both the solidity of the palm's trunk and its feathery leaves. The oil study is painted in rich variations of green and brown (no. 15). In it, Church juxtaposed a glorious crown of palm fronds on one tree with a separate pair of coarse scaly trunks. In a large-format graphite study (no. 16), he carefully drew the sinuous tendrils of a parasite vine strangling a tree trunk beside a low-lying palm plant. The light-colored vine stands out against the graphite shading of the bark of the host tree, and white gouache suggests the sky. Church later referred to his Jamaican studies as he painted *Rainy Season in the Tropics,* 1866 (see no. 12, fig. 7), and *The Vale of St. Thomas, Jamaica*, 1867 (Wadsworth Atheneum, Hartford).[7]

1. See New York 1993, pp. 10–17, for a lucid analysis by Kevin Avery of Humboldt's theories and their impact on Church's travels to the Southern Hemisphere and on his art. Also see Huntington 1966, pp. 45–56, where the complexities of Church's motivations for going to Jamaica are discussed—including his need to rediscover nature's powers of renewal, which was thought to occur more rapidly in the tropics.

Cooper-Hewitt National Design Museum houses almost fifty Church oil sketches of the Jamaican landscape, many featuring atmospheric or cloud effects. *Red Hills near Kingston* is Church's most spectacular topographical study of the island's mountainous terrain. The view sweeps from the low-lying brush and trees in the foreground, across the cultivated valley plain, to the distant ridges being showered by storm clouds. In the foreground at the bottom, Church has skillfully depicted individual leaves and stems with minute touches of paint; in the central portion, he has brushed the pigment more broadly to render the lowland fields and the abruptly rising hills and ridges; brushstrokes visible at the top, where billowing clouds hover in the darkest parts of the sky at the upper left, indicate falling rain. By manipulating the oil pigment as he sketched on the spot, Church captured the subtle color variations of the scene's verdant vegetation.

This picture was probably done in May or June, before the Churches left the Kingston area for another part of the island.

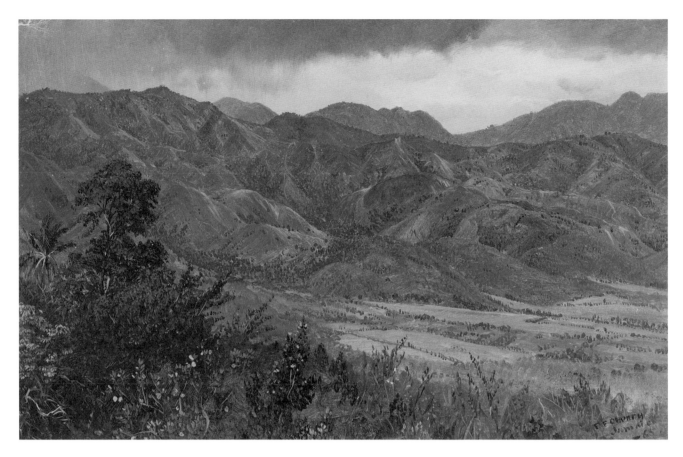

17

nice juxtaposition of

18

Valley of the Yemen, Palestine, 1868

Graphite and white gouache on pale green-gray paper

12⅛ x 17½ inches (308 x 445 mm)

Inscribed in graphite, left of lower center: *Valley of the / Yemen / Feb 20/68*

Cooper-Hewitt National Design Museum, Smithsonian Institution

Gift of Louis P. Church, 1917–4–376

Between November 1867 and June 1869, Church (with his wife, infant son, and mother-in-law) traveled throughout the Near East and Europe seeking inspiration from Old World cultures and scenery, particularly from important sites of ancient civilizations. In mid-January 1868, the family had temporarily settled in Beirut, and from there Church made excursions to various destinations in Lebanon, Palestine, Syria, and to what is now Jordan. The highlight of the entire trip was the month-long adventurous expedition via camel caravan to the ruined desert city of Petra, which Europeans had only rediscovered in

1812.[1] Between February 12 and 24, 1868, Church journeyed from Jerusalem southward to Petra, passing through the Valley of Yemen en route. Occasionally remarking on the biblical associations of the region, he documented what he saw in a detailed journal as well as in many pencil drawings and oil sketches.[2]

Church's journal entry described his first glimpse of the valley shown in this drawing:

After passing down a small gorge we came upon a level rock and proceeding to the edge there burst upon us one of the most stupendous views I have ever had the delight of witnessing. We gazed down into a tremendous valley, narrow but deep, at the bottom of which lay the silvery white bed of the torrents which yearly sweep the valleys. Gigantic mountains rose sublimely from the gorge. These mountains presented a very irregular frontage . . . broken into huge amphitheatric chasms and ravines. The mountains were terraced by majestic precipices and ledges . . . of flint and of a brown or purplish color. The main rock was of an exquisite golden brown with occasional whitish grey masses, vast slopes of debris . . . were piled up from the valley in the base of the precipices. . . . Many strange yet grand forms . . . with rounded fronts cut into horizontal seams by the layers of rock were gilded by the sun and looked like castles of enchantment. . . . I had time to take some more careful sketches and at dusk I returned to camp with a goodly number. . . .[3]

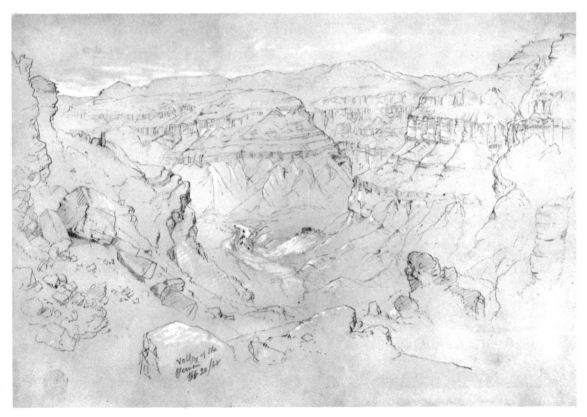

18

With very little shading, Church drew in painstaking outline the irregular canyon walls and strata, sculpted by centuries of erosion. He placed a few touches of white gouache for the highlights of the clouds in the sky, for the light reflections on the river that weaves through the valley floor, and to enliven some of the rock faces. While America's newly discovered canyon scenery would be popularized by Thomas Moran's paintings (see nos. 56, 57, 58) after 1871, this drawing shows Church's fascination with a panoramic view of a geologic terrain in a part of the world rarely seen by Americans. He did not learn until later that similarly configured canyons existed on his own continent. Remarkable for the artist's keen observation and scrupulous rendering on site, this study ranks among Church's more powerful graphic works.

1. Church traveled in the company of two missionary companions, the Rev. D. Stuart Dodge and a Mr. Fowler; a guide, Michail Hene, a cook, and three servants, two sheiks, eleven Bedouins, sixteen camels, and two horses. See Edmonds 1985, p. 82, for transcription of the entry for February 19 in Church's "Petra Diary," of the February 7 to March 9, 1868, journey, preserved at Olana State Historic Site. Carr 1994, p. 319, no. 466, further describes the format and contents of this diary.

2. Cooper-Hewitt National Design Museum has almost one hundred drawings and oil sketches Church made during this trip to Petra. Nine sketchbook drawings of geological strata and rock formations (page format 4¾ x 8 inches; 120 x 203 mm), executed primarily in graphite, are specifically identified with the inscription (in Church's hand) "El Yemen" (acc. nos. 1917-4-173, -174, -175, -176, -177, -178, -219, -456, -465). Some of these are also dated "Feb 20," while others are inscribed with notations for the color of the terrain. On February 21, 1868, Church drew the panorama of *The Valley of El Arabah* (1917-4-583), creating a compositional vista similar to this one of *Valley of the Yemen*. No oil paintings by Church of this valley are known to have been executed.

3. Yonkers 1984, p. 76, no. 59; Huntington 1966, p. 96; Edmonds 1985, p. 83. Transcriptions for this passage vary slightly in each publication. The author gratefully acknowledges Elaine Dee's checking her own transcription notes from the actual diary entry to assure the accuracy of the quote here.

19

Landscape with Ruined Temple (formerly *Landscape in Greece*), 1868 or 1869

Oil on tan paper

13 x 20 inches (330 x 510 mm)

Cooper-Hewitt National Design Museum, Smithsonian Institution

Gift of Louis P. Church, 1917-4-527

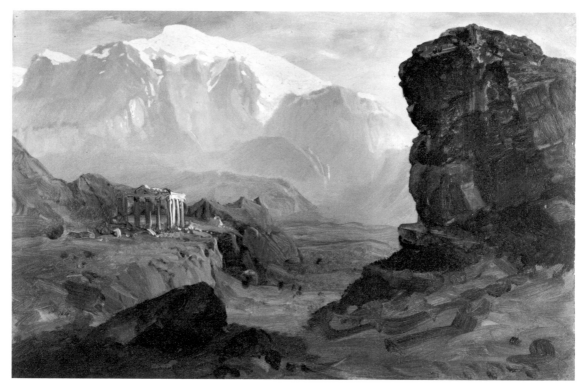

19

Church's view of a small ruined temple on a bluff in front of an immense snow-covered mountain is so vividly sketched in oil that it suggests the artist executed it on site. To date, however, neither scholars of the artist's work nor antiquity scholars have been able to identify this place. Gerald Carr commented that Church occasionally made oil sketch pastiches of various scenes derived from memory.[1] Perhaps he recalled aspects of mountainous landscapes and architectural ruins he saw during his 1867–1869 trip— either in the Near East, Cyprus, Rhodes, Turkey, Greece, Italy, Sicily, or even in the Alps—to invent this picturesque composition.

1. Carr in conversation with the author, November 8, 1994. Kevin Avery, in a note to author, December 2, 1994, corroborated the notion of this work possibly being a composite view.

20–31
Twelve Imaginary Landscapes,
ca. 1870–1873

Cooper-Hewitt National Design Museum, Smithsonian Institution

Gift of Louis P. Church, 1917–4–529 to –532, –534 to 540, –543

[Entry is written by MS and EH]

20
Imaginary Landscape with Ruined Tower and Bridge

Pen and black ink with rubbed graphite on paper

Image: 2 x 2^{13}/16 inches (51 x 71 mm)

Sheet: 2^7/16 x 3^5/16 inches (63 x 84 mm)

1917–4–529

21
Imaginary Landscape with Castle (Château la Batiaz, Martigny)

Pen and dark brown ink on paper

Image: 1^{15}/16 x 2½ inches (50 x 62 mm)

Sheet: 3⅜ x 4^5/16 inches (85 x 110 mm)

1917–4–530

22
Imaginary Landscape with Castle (Château la Batiaz, Martigny)

Pen and dark brown ink on paper

Image: 1^{13}/16 x 2^{11}/16 inches (48 x 69 mm)

Sheet: 3^7/16 x 4^3/16 inches (88 x 108 mm)

1917–4–531

23
Imaginary Landscape with Castle (Château la Batiaz, Martigny)

Pen and dark brown ink on paper

Image: 1^{15}/16 x 2^9/16 inches (50 x 69 mm)

Sheet: 3⅜ x 4^7/16 inches (86 x 113 mm)

1917–4–532

24
Imaginary Landscape with Waterfall

Pen and dark brown ink on paper

Image: 2^1/16 x 3 inches (53 x 76 mm)

Sheet: 3½ x 4⅜ inches (53 x 76 mm)

1917–4–534

25
Imaginary Landscape with Tower at Right

Pen and dark brown ink on paper. On verso, landscape study and inscriptions in graphite

Image: 1^{15}/16 x 2^{15}/16 inches (50 x 75 mm)

Sheet: 3½ x 4⅜ inches (90 x 111 mm)

1917–4–535

26
Imaginary Landscape with View of Lake

Pen and brown ink and wash on paper

Image: 1^{11}/16 x 2^9/16 inches (43 x 65 mm)

Sheet: 3^5/16 x 4^7/16 inches (85 x 112 mm)

1917–4–536

27

Imaginary River Landscape with Wooded Banks and Distant Tower

Pen and dark brown ink on paper

Image: 2³⁄₁₆ x 2⁷⁄₈ inches (56 x 73 mm)

Sheet: 3⁷⁄₁₆ x 4³⁄₈ inches (88 x 110 mm)

1917–4–537

28

Imaginary River Landscape with Tree in Foreground

Pen and dark brown ink on paper

Image: 2½ x 3 inches (55 x 76 mm)

Sheet: 3⁷⁄₁₆ x 4³⁄₈ inches (89 x 111 mm)

1917–4–538

29

Imaginary River Landscape with Boat at Left

Pen and dark brown ink on discolored off-white paper

Image: 1¹⁵⁄₁₆ x 2¹³⁄₁₆ inches (50 x 71 mm)

Sheet: 3⁵⁄₁₆ x 4³⁄₈ inches (84 x 111 mm)

1917–4–539

30

Imaginary Landscape with Palm Trees

Pen and dark brown ink on paper

Image: 2 x 2⁷⁄₈ inches (51 x 73 mm)

Sheet: 3⁹⁄₁₆ x 4⁷⁄₁₆ inches (90 x 113 mm)

1917–4–540

31

Imaginary Lake Landscape

Pen and dark brown ink and wash on paper

Image: 1¹³⁄₁₆ x 2¾ inches (47 x 70 mm)

Sheet: 3⅜ x 4³⁄₈ inches (86 x 111 mm)

1917–4–543

These twelve small drawings are unlike almost anything else in Church's oeuvre, either at the Cooper-

Hewitt National Design Museum or Olana State Historic Site. Although they entered the Museum's collection as part of the huge 1917 Louis P. Church gift of Frederic Edwin Church drawings and oil sketches, their attribution to Church was doubted because the group appears so uncharacteristic of him. Since the drawings are reminiscent in medium and style of Thomas Cole's compositions in ink, they have been attributed for a time to Cole (q.v.).[1] Closer examination reveals that Cole's technique for executing small-scale idealized views in ink differs from that displayed in the twelve drawings here. Cole usually drew with loosely flowing, almost calligraphic, outlines and tended to handle shading with loop-like strokes or with ink washes of varying densities (see nos. 32 and 33). These twelve drawings do not exhibit Cole's handling of tonal areas, which are more densely and insistently shaded with slanted crosshatching.[2] The technique seen here is more consistent with Church's hand than with Cole's.

As Church's teacher from June 1844 to 1846, Cole encouraged him to draw directly from nature—both landscape vistas and detail studies—to refine the skills necessary for rendering nature accurately. From Cole, Church also learned about the Old Master landscape tradition and how to draw with romantic chiaroscuro effects. David Huntington was among the first to recognize that two of these drawings reflect Cole's practice of making idealized compositions in pen and ink, but Huntington, while accepting them as Church's works, did not venture to date them firmly.[3]

Though the character of these drawings might suggest a dating close to the time of Church's associ-

Fig. 9. Church, Château la Batiaz, Martigny, Switzerland, *oil on paperboard, Cooper-Hewitt National Design Museum, Smithsonian Institution, 1917–4–345*

ation with Cole, they were probably done about 1870, following Church's tour of Europe and the Near East. Three of the drawings (1917–4–530, –531, –532) appear to represent the Château la Batiaz at Martigny, Switzerland, because of their similarity to an oil sketch Church did of this particular Swiss castle after August 1868 (fig. 9).[4] Since these three studies are not characteristic of the way Church sketched on site (see nos. 7, 13–14, 18), they might have been done later from the oil sketch, or from souvenir photographs Church purchased. As compositional exercises, the three château landscapes show how subtle tonal variations could suggest different times of the day or weather conditions, thus slightly altering the moody effect.

If the dating to around 1870 is accurate, the question remains why Church decided to make such drawings at this stage of his career. It could be that picturesque European scenes he saw reminded him of Cole's use of such views as a point of departure for idealized images. Yet there are no known Church paintings that derive from these drawings. Gerald Carr has proposed that Church made these three drawings, as well as the other imaginary landscapes, as teaching devices for Walter Launt Palmer and Lockwood de Forest, III, during one of their visits to Olana in 1871 or 1872.[5]

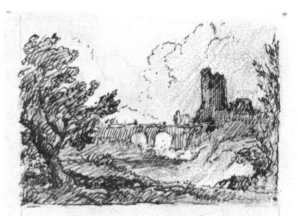

20

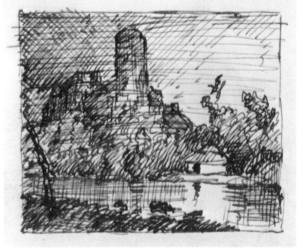

21

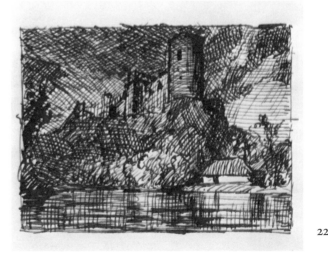

22

1. In all there are fifteen such drawings at Cooper-Hewitt National Design Museum and three at Olana (see Carr 1994, pp. 357–358, nos. 506–508). Elaine Evans Dee attributed the National Design Museum group to Cole because their compositions strongly recalled that artist's drawings and paintings of castles, towers, ruins, and idealized or classicized landscapes. (Dee 1982, pp. 13–14). Such drawings unquestionably attributed to Cole as *Compositional Sketches for Italian Landscapes* (1832) and *Tranquility* (ca. 1835–1840), both in the Detroit Institute of Arts (acc. nos. 39.566.33 and 39.30 respectively), as well as two Cole drawings in the National Academy of Design's collection (see nos. 32 and 33) exemplify Cole's artistic concerns and style of draftsmanship.

2. Observations noted by Ellwood Parry, III, in letters of May 17, and July 26, 1994, to Elizabeth Horwitz. Parry also identified the notations on the verso of 1917–4–535 as clearly in the handwriting of Church.

3. Huntington 1966, p. 35, figs. 13 and 14 (acc. nos. 1917–4–530 and –531, respectively) mentions these works in his discussion of the painting *New England Scenery*, 1851.

4. Carr 1994, pp. 357–358, nos. 506–508. Carr further noted that during Church's August 1868 visit to this Rhone River region of Switzerland, he made a drawing of the Château la Batiaz (Cooper-Hewitt National Design Museum, 1917–4–1182), and later the oil sketch (fig. 9), in addition to drawing other castles nearby. Carr dated the three idealized ink drawings, which are related to the château oil sketch and drawing, to ca. 1870–1873 on stylistic grounds.

5. Ibid., pp. 357–358, nos. 506–508.

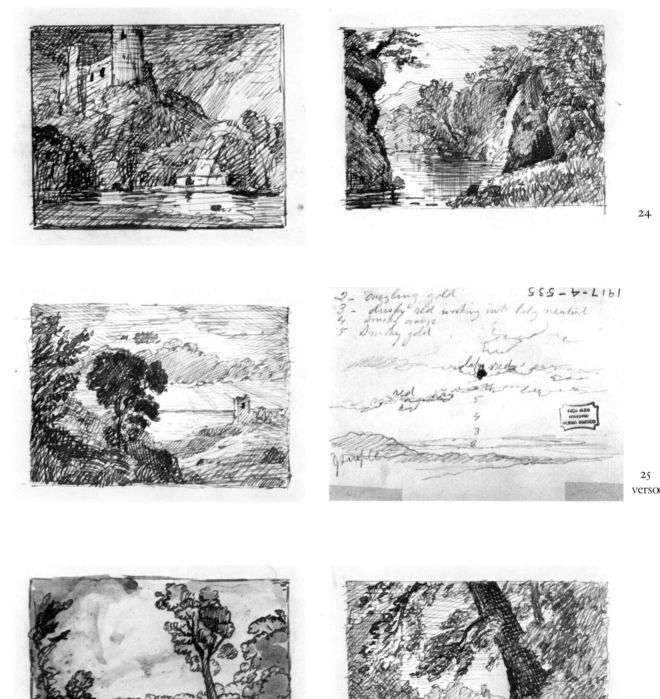

23

24

25

25
verso

26

27

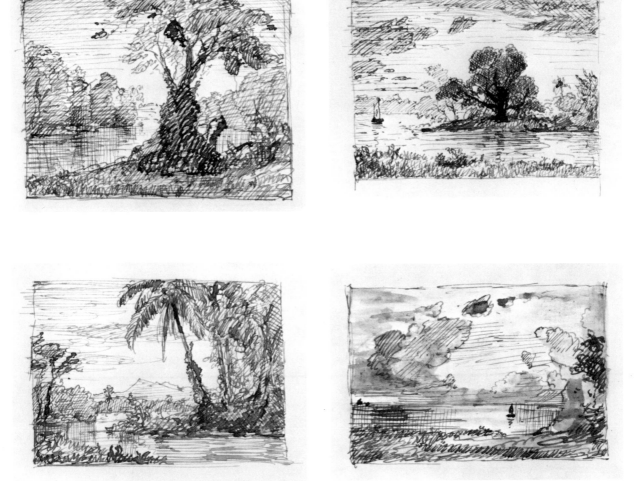

28

29

30

31

Thomas Cole

Bolton-le-Moor, Lancashire 1801 — Catskill,
 New York 1848
Founder NA 1826

THOMAS COLE was a self-taught artist whose prac-
tical experience in drawing came from early employ-
ment as a wood engraver for several textile manufac-
turing companies in his native England.[1] When he
was seventeen, he emigrated with his parents to the
United States. When his family settled for a time in
Steubenville, Ohio, Cole stayed in Philadelphia to
work for an engraving company. He was in
Steubenville himself, however, in 1819, when he be-

gan giving drawing and painting lessons at a school
operated by one of his sisters. He learned the funda-
mentals of oil painting from the artist John Stein,
who had recently arrived in Steubenville. Cole then
spent several years traveling around Ohio and Penn-
sylvania as an itinerant portraitist.

By the time Cole moved to New York in 1825, his
interests were turning from portraiture to landscape
painting. Among some of the possible reasons for this
include the inspiration he may have received from
landscapes by William Birch and Thomas Doughty
which he saw at the Pennsylvania Academy of the
Fine Arts; his reading and studying of published es-
says and books on the practical and theoretical aspects
of landscape painting; and his insecurity about draw-

ing the human figure, a talent needed for the successful execution of historical paintings or genre scenes.[2]

A turning point in Cole's career came when several of his landscapes were seen in New York by the artists John Trumbull, William Dunlap, and Asher B. Durand. While the accuracy of the often repeated story of Cole's discovery by these men has recently been challenged,[3] there can be no doubt that his decision to make sketching trips along the Hudson River and in the wilderness areas of New England—a practice he began in the summer of 1825—set a precedent that was to affect several generations of American artists. With the help of Dunlap, Durand, and others, he received commissions from significant American art collectors, including Luman Reed and Samuel Ward of New York, Robert Gilmor of Baltimore, and Daniel Wadsworth of Hartford.

Cole began exhibiting his landscapes in the annual exhibitions of the American Academy of the Fine Arts and the National Academy of Design in 1826, and was invited to become one of the founding members of the latter organization at its inception that same year. He participated in all but one of the National Academy's annual exhibitions from 1826 to 1848 and served as a member of the governing council from 1834 to 1838. Many of his major paintings were shown there, for example, *The Garden of Eden* (Amon Carter Museum, Fort Worth) and *Expulsion from the Garden of Eden* (Museum of Fine Arts, Boston) in 1827 and 1828, respectively; *View from Mount Holyoke, Northampton, Massachusetts, after a Thunder Storm* (*The Oxbow*) (Metropolitan Museum of Art, New York) in 1836; and *View of Schroon Mountain, Essex, Co., New York after a Storm* (Cleveland Museum of Art) in 1838.

While most of Cole's patrons, as well as the general public, seemed to prefer his views of identifiable American scenery, the artist sought to raise the level of landscape within the overall hierarchy of art by infusing it with historical references. To that end, he produced two great panoramic series: *The Course of Empire* of 1833–1836 (New-York Historical Society) and *The Voyage of Life* (two versions: 1840, Munson-Williams-Proctor Institute, Utica, New York; and 1842, National Gallery of Art, Washington). The first of these, which consists of five large paintings depicting the rise and fall of civilization, was inspired in part by Cole's European trip of 1829 to 1832. As he traveled through England, across the Continent, and especially through Italy, he was impressed—and de-

pressed—by the architectural remnants of classical and medieval times. *The Course of Empire* was the rather pessimistic result of these encounters; it was a commission for Luman Reed for his recently completed New York house.

The second great series, *The Voyage of Life*, was painted for Samuel Ward. In four large canvases, Cole dealt with the traditional theme of the "Ages of Man." Painted before and during his second European trip (1841–1842), the series contains traditional religious symbolism which Cole used to deliver a moralizing lesson and which was almost certainly an outgrowth of his own developing religiosity.[4] Before the paintings entered Ward's collection, they were exhibited in New York, Boston, and Philadelphia. The popularity of engraved versions helped to ensure the artist's renown for the rest of the century.

But Cole was not to see even the halfway point of the century; for early in 1848 he developed a problem with his lungs, probably pleurisy. His death in February of that year was an unexpected and tragic blow to the art world. The esteem in which he was held was expressed by the officers of the National Academy who called a special meeting of the membership to honor him. "Where shall we limit the loss sustained in common by the arts and by the country?" Asher B. Durand, president of the Academy, asked the gathered artists. "It was ever [Cole's] great aim," he remembered, "to elevate the standard of Landscape art and he has been eminently successful, he has advanced it far beyond the point at which he found it among us, and more than this he has demonstrated its high moral capabilities, which had been hitherto at best but incidentally and capriciously exerted."[5]

The Academy extended an invitation to William Cullen Bryant, the nation's leading romantic poet and a personal friend of Cole's, to deliver an oration in his honor, which Bryant did at the Church of the Messiah in New York in May. A memorial exhibition of Cole's paintings, organized immediately following his death, was held at the gallery of the American Art-Union.[6] DBD

1. The biographical facts of Cole's life have been gleaned from Parry 1988; and Washington 1994, pp. 23–111. The chronology of Cole's life compiled by Sharpe, ibid., pp. 161–68, was also useful. Furthermore, I wish to thank Professor William H. Gerdts, New York, for allowing me to use the extraordinary amount of material he has collected on Cole, which is part of his library.
2. Wallach, in Washington 1994, pp. 26–28.
3. Ibid., pp. 23–24.
4. On this point, see ibid., p. 101. William Cullen Bryant wrote

that Cole's religion "was without ostentation or austerity, not a thing by itself, but a sentiment blended and interwoven with all the actions of his daily life" (Bryant 1848, p. 36).

5. Minutes, February 18, 1848, National Academy of Design, Archives.

6. Ibid., May 8, 1848. Bryant's oration was subsequently published in pamphlet form, see Bryant 1848.

32
Landscape Sketch I

Pen and black ink on paper

4¼ x 5½ inches (108 x 140 mm)

Signed, in black ink, lower right: *TC*, with *ole* added in graphite

National Academy of Design [1980.42]

33
Landscape Sketch II

Pen and black ink on paper. On verso, three landscape studies

3⅝ x 7¹⁵⁄₁₆ inches (93 x 202)

Signed and dated in black ink on rock, right of center: *T. Cole / 1841*

Signed in graphite, upper right: *Thos Cole / (over)*

National Academy of Design [1980.43]

Thomas Cole's love for the actual experience of drawing was noted by his contemporaries and is evidenced by the large number of drawings by him that survive.[1] He began drawing from nature in 1823 while he was living with his family in Pennsylvania. Two years later, during his first historic trip up the Hudson River, he made a series of drawings that he numbered and carefully preserved for later use.[2] In the years that followed, he made hundreds more in the Adirondacks in upstate New York, the White Mountains of New Hampshire, along the Maine coast, and in Europe, notably in England, Switzerland, and Italy. At the same time, Cole mastered contemporary theories of landscape drawing which he read about in well-known books on the subject; made studies of paintings or engravings of paintings by other artists; and executed drawings from plaster casts of ancient sculpture.[3]

As was true for most landscape painters of the day, drawing was the first step in Cole's methodology. His production ranged from carefully finished, highly detailed studies of specific parts of nature—trees, for example—to small, quickly made notations of broad, panoramic views. These images then became part of the process that eventually led to the carefully constructed and composed paintings, finished in the studio, by which he made his living. For Cole, however,

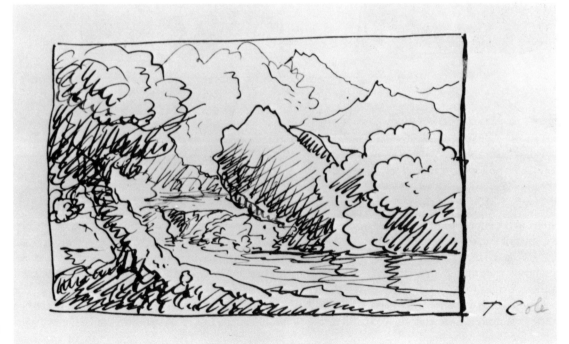

32

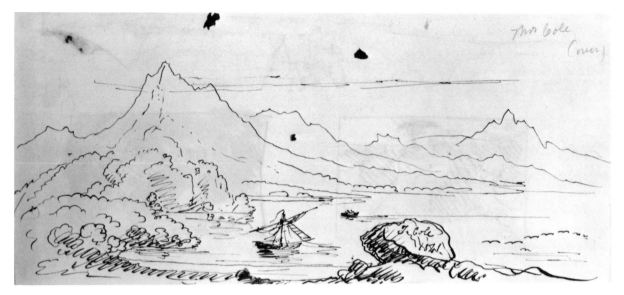

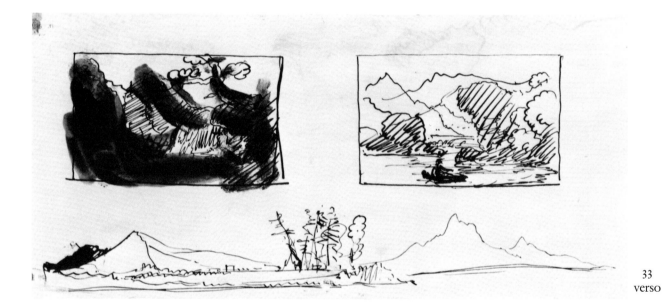

one step did not always immediately follow the other. "Have you not found?" he asked his friend Asher Durand, "—I have—that I never succeed in painting scenes, however beautiful, immediately on returning from them. I must wait for time to draw a veil over the common details, the unessential parts, which shall leave the great features, whether the beautiful or the sublime, dominant in the mind."[4]

The two drawings from the collection of the National Academy of Design which are shown here are examples of a type often executed by Cole and described by William Cullen Bryant as "the slightest notes of his subject, often unintelligible to others, but to him luminous remembrances from which he would afterwards reconstruct the landscape with surprising fidelity."[5] This is especially true of *Landscape*

Sketch I, which, despite its small size and the summary nature of its execution, mimics the compositional format of the classical landscape: a framing element placed at one or both sides of the composition, a winding stream or river moving into space, and a distant view of mountains.[6] Given the traditional manner of composition displayed here, it might be deduced that the drawing was not meant to represent a specific view but, instead, is truly a "composed" work; that is, it depicts a scene which comes from the artist's imagination.

On the other hand, *Landscape Sketch II*, which is dated 1841, is more specific and, at the same time, more panoramic than *Landscape Sketch I*, possibly an indication that it was made outdoors. Supporting this theory is the fact that the basic outline of the horizon in the image is repeated and extended in an even more panoramic drawing, one of three which appear on the verso of the same sheet. Even here, however, the drawing is not detailed enough to make the view's location securely identifiable, and neither it nor *Landscape Sketch I* can be linked to any known painting by Cole.[7]

Both drawings were evidently part of a collection of sketches by various artists compiled by Samuel F. B. Morse (1791–1872) and pasted by him into a scrapbook. While the exact provenance of the scrapbook is unclear, it was probably the same book that was the subject of an undated letter from Samuel Avery to Daniel Huntington now in the archives of the National Academy of Design. Avery stated that he had acquired a book of sketches from Dr. William F. Channing's daughter that had been "made by Prof. Morse & other N.A.s." While he did not say how the lady acquired the book, Avery theorized that "the sketches look as if they might have been done at business meetings of the Academy, at idle moments just to pass the time—and some one picked them up and thus saved them."[8] He hoped that someone would buy the collection and donate it to the Academy and, although no evidence of such a transaction has been found, that may be what happened. Since Avery himself was a frequent donor to the Academy, it seems more likely that it was he who gave the scrapbook to the collection.

Due to its archivally unstable condition, the scrapbook was dismantled in the late 1970s and the contents accessioned individually.

1. It has been estimated that as many as two thousand drawings by Cole survive (Yonkers 1982 p. 4). William Dunlap commented on the love of drawing which Cole developed early in life, and Cole himself told Dunlap that, when he was a child, "drawing occupied most of my leisure hours" (Dunlap 1834, 2, p. 353).

2. Yonkers 1982, p. 6; Felker 1992, pp. 60–93.

3. On these points, see Parry 1990, pp. 7–17. Cole evidently learned the "memorandum mode" of making sketches out-of-doors and annotating them with notes on color, etc., from William Oram's *Precepts and Observations of the Art of Colouring in Landscape Painting* (London, 1810).

4. Cole to Durand, January 4, 1848, quoted in Noble 1853, p. 248, and in Bryant 1848, p. 39.

5. Bryant 1848, pp. 38–39.

6. Although this drawing is undated, Parry has suggested that, due to similarities in style, it may date from the same time as *Landscape Sketch II*, that is, 1841 (Ellwood Parry, III, to Elizabeth Horwitz, Cooper-Hewitt National Design Museum, October 28, 1994). I wish to acknowledge the initial steps taken by Elizabeth Horwitz in researching the Academy's two drawings by Cole which included corresponding with Professor Parry.

7. The distinctive shape of the larger mountain which appears in the drawing is not unlike that of Chocorua Peak in New Hampshire, which appears in a number of other drawings by Cole now in the collection of the Detroit Institute of Arts. (Several of these are reproduced in Yonkers 1982, pp. 32–34.) However, although Cole was in New Hampshire in 1827, 1828, and 1839, it does not appear that he was there in 1841 (see Ruskin 1990, pp. 19–25). It seems more likely that the setting of the drawing is near Catskill, New York, where Cole moved permanently in 1836, or perhaps in Europe, to which he sailed in August 1841.

8. It has been suggested that the drawings originated at one or more meetings of the Sketch Club, an informal organization founded in New York in 1827 by Morse, Cole, and their friends, and which was a forerunner of the Century Association (see Helen Raye, in New York 1980, p. 34).

Samuel Colman

Portland, Maine 1832 — New York 1920
ANA 1854, NA 1862

"IT IS THE SINGULAR felicity of this artist" wrote George Sheldon of Samuel Colman, "that his tastes are so cosmopolitan, his sympathies so cultivated, and his experience so ripe, that, while friendly to the true in all schools, he is susceptible to the vagaries of none."[1]

This variety of artistic interest was imbued at an early age. Colman's family moved from Maine in the 1830s to New York, where his father's successful publishing business, described by Henry T. Tuckerman as "a unique depository of pictures" and "fine engravings," exposed the young Samuel to numerous artists and writers.[2] Raised in such a creative atmosphere, Samuel Colman matured early in taste and artistic ability, and by 1851 he was exhibiting at the National Academy. About this time, he purportedly studied

briefly with Asher B. Durand (1796–1886). Colman's paintings of upper New York State and the White Mountains of New Hampshire show a debt to Durand and to the Hudson River school in the choice of ideal landscape composition and interest in trees. These scenes won Colman praise, earning him election to the National Academy as an Associate in 1854; he rose to full Academician in 1862.

From 1860 to late 1861, Colman traveled in Europe and North Africa. Although he visited England, France, Italy, and Switzerland, he was particularly inspired by the exotic locales of Spain and Morocco, and throughout the next two decades he made many paintings of scenes there. He also produced architectural views, pastoral and coastal landscapes, and marines.[3] Testifying to Colman's early reputation is the invitation he received, along with such artists as Frederic Edwin Church (q.v.) and Albert Bierstadt (1830–1902), to contribute examples of his work to a portfolio of sketches (Century Association, New York) to be given to the poet and editor William Cullen Bryant in honor of his seventieth birthday in 1864.

In 1866, Colman was one of the principal founders of the American Society of Painters in Water Colors (later the American Water Color Society) and served as its first president until 1870. In that year he embarked on a trip to the Far West and Mexico which resulted in numerous watercolor and oil paintings of mountain and desert landscapes, some including pioneers and emigrant wagon trains.

Over the next two decades he traveled extensively, touring Europe a second time, from 1871 to 1875, passing through England, France, Italy, Holland, Algeria, Morocco, and Egypt; and again to the western United States and Mexico in the 1880s, and from 1898 to 1906.

When he returned from his travels, Colman vigorously resumed his activities in the New York art world. In 1877, he helped establish the Society of American Artists; by 1878, he had joined the New York Etching Club, exhibiting regularly until the mid-1880s. In the late 1870s, Colman also became involved in the decorative arts. In 1878, he joined Louis Comfort Tiffany's well-known interior design firm, Associated Artists. The firm's prestigious commissions included the redecoration of several rooms for President James Garfield in the White House and the Hartford residence of Mark Twain.[4] After Associated Artists disbanded in 1883, Colman continued his work in interior design, planning his house in New-

port, Rhode Island, which he embellished with objects from his own vast art collection. He collaborated with Tiffany in the early 1890s on the New York home of sugar merchant Henry Osborne Havemeyer. The Cooper-Hewitt National Design Museum has decorative designs by Colman that may relate to his interior design projects.[5] By the turn of the century, Colman had ceased exhibiting his work and turned his attention to writing. He published two volumes, *Nature's Harmonic Unity* (1912) and *Proportional Form* (1920), on the relationship of art and mathematics.

Throughout his life, Colman drew constantly from nature. The Cooper-Hewitt National Design Museum has many of his drawings—more than 170 sheets, most of them drawn on both sides—which were given by the artist's wife in 1939. Although the drawings range in date from 1854 to 1917, most date after 1870. Few of them have been published, and they await close study. Works in the collection consist of several types of drawings and watercolors: small travel sketches, larger outdoor studies, and oil sketches. The subjects of these drawings include numerous mountain landscapes, figures, genre scenes, harbors, tree and floral details, and animal studies. Rendered in a variety of techniques, the drawings reveal Colman's brilliant color and assertive, energetic line. EH

1. Sheldon 1882, pp. 154–155.
2. Tuckerman 1867, p. 559.
3. Archetypical paintings during the 1860s and 1870s include *Genesee Valley* (National Academy of Design) and *Storm King on the Hudson* (National Museum of American Art, Smithsonian Institution, Washington).
4. Faude 1975 provides a detailed analysis of Colman and Associated Artists. Colman's other partners at Associated Artists were Lockwood de Forest, III, and Candace Wheeler.
5. The Cooper-Hewitt National Design Museum has, for example, *Floral Circular Ornaments* (1939–85–76).

34
Sea Girt, New Jersey, 1878

Pen and black ink, watercolor, white gouache over traces of graphite on tan oriental paper.

13½ x 19¾ inches (345 x 500 mm)

Inscribed and dated in pen and black ink, middle left: *Sea Girt. Cedars / Sep 11 1878*; lower left: *Sea Girt Sept 11 1878*

Cooper-Hewitt National Design Museum, Smithsonian Institution

Gift of Mrs. Samuel Colman, 1939–85–7

Sea Girt, by 1878 a newly established resort town on the New Jersey shore, appears in only one other, smaller Colman drawing in the Cooper-Hewitt National Design Museum (fig. 10), executed in the days just before this work, and, in an undated watercolor painting *Near Sea Girt, New Jersey*.[1] Colman's activities prior to his Sea Girt trip offer little insight as to why he went there. In August 1878, he was in Keene Valley in New York's Adirondack Mountains with his friend and fellow artist James David Smillie (1833–1909).[2]

Colman's visit to Sea Girt may have been inspired by the general artistic interest in coastal landscapes. Shore scenes became increasingly popular during the 1860s and 1870s, including the New Jersey shore, treated by William Trost Richards and Winslow Homer (qq.v.). The interest continued into the late 1870s and early 1880s with the proliferation of a specialized type of coastal landscape featuring cedar trees on lonely shores, such as is found in the present drawing.[3]

Although no other drawings or paintings by Colman of Sea Girt can be identified, he made at least two etchings of deserted coastal scenery: *Coast of Mount Desert* (Maine) of 1877 and *Pacific Coast, California* of 1878–1879.[4] Both prints and this drawing reveal his interest in how the powerful effects of wind and water alter topography. The drawing shows how lashing gusts of sea wind have bent the cedar branches into their misshapen state as well as the beach erosion caused by pounding water and wind. Later Colman made other wild coastal scenes, such as the watercolor *Point Lobos, Monterey, California*, 1888.[5]

This study and the earlier Sea Girt sheet of September 9 (fig. 10) offer insight into Colman's method of drawing outdoors. On the recto of his preliminary sketch of the 9th, he summarily noted features of the cedars and the sandy beach; he depicted the cedar tree and low shrub-like vegetation in more detail on the verso dated September 10. Copious light and color notations inscribed throughout the earlier double-sided sketch were translated in broad watercolor

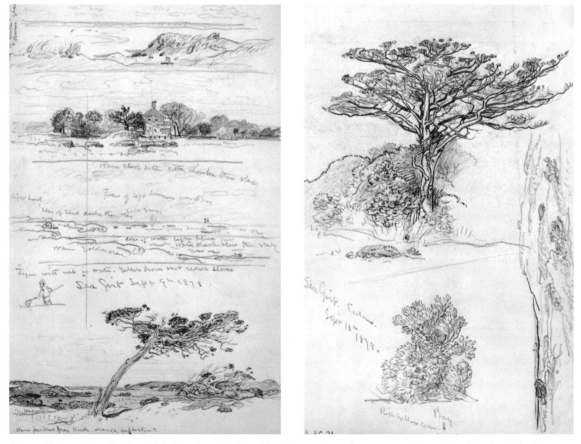

Fig. 10. Colman, Four Studies of the Beach at Sea Girt, New Jersey, *September 9, 1878, and (verso)* Studies of a Cedar Tree, a Low Shrub and the Beach at Sea Girt, New Jersey, *September 10, 1878, drawings, Cooper-Hewitt National Design Museum, Smithsonian Institution, 1939–85–31*

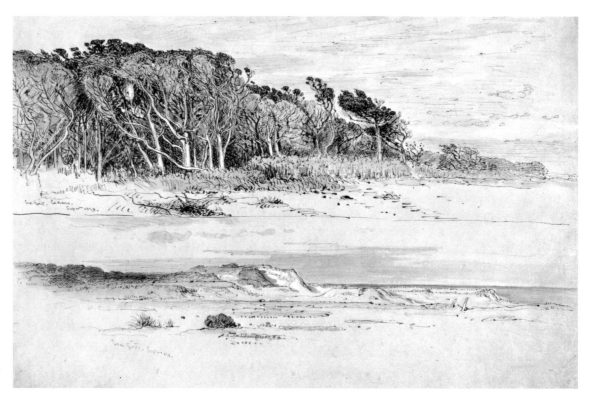

34

washes and strokes of white gouache on the later study. As his support for this study, Colman used unpainted tan oriental paper which imparts an even tonality to the image and a sense of pictorial finish.

From this drawing, one can imagine that Colman intended to join the top and bottom landscapes as a single panoramic scene—progressing from the dense linear mesh of clustering trees and grass to the few wispy lines suggesting land's end.

1. The watercolor, which may have been the work mentioned in the 1882–1883 American Water Color Society exhibition catalogue (no. 135), is now with Berry-Hill Galleries, New York. It measures 8⅞ x 17¾ inches (226 x 451 mm). Although this beach view with figures is somewhat similar in topography to the Cooper-Hewitt National Design Museum study, the precise relationship between the watercolor and the drawing is unclear and needs closer analysis. The author is indebted to Kevin Avery for suggesting this watercolor's connections to the Museum's drawing.

2. Smillie Diaries, roll 2850. Smillie's entry for August 9, 1878, noted that Colman was in the Keene Valley. Later entries during that month record their various activities.

3. Ferber 1980b, pp. 244–248.

4. Both etchings are part of the artist's estate, Salander-O'Reilly Galleries, New York.

5. *Point Lobos, Monterey California*, 10 x 10¾ inches, signed and dated, lower left, *Sam Colman/88*. The watercolor is reproduced in New York 1983b, no. 28.

35
Oak Wood, Montauk, New York, 1880

Graphite, pen and brown ink, watercolor, white gouache on gray-green paper. On verso, *Study of Oak Wood* in graphite, pen and black and brown ink, wash, watercolor, white gouache on gray-green paper

10¾ x 15⅜ inches (276 x 390 mm)

Inscribed and dated in graphite, lower left: *Oak Wood. Montauk. Sept 8th 1880*. On verso, in graphite, partially retraced in brown ink, lower left: *Montauk Sept 8th 1880*

Cooper-Hewitt National Design Museum, Smithsonian Institution

Gift of Mrs. Samuel Colman, 1939–85–4

This drawing, along with the image on the reverse, is one of only two sheets by Colman in the Cooper-Hewitt National Design Museum depicting Montauk, at the eastern terminus of Long Island.[1] Although the dates of this and subsequent trips to Montauk are poorly documented, other works by Colman show that he visited eastern Long Island in the late 1870s, the early 1880s, and in 1889.[2] During these visits, he produced picturesque views of the flat countryside, the farmyards, and the rustic windmills.

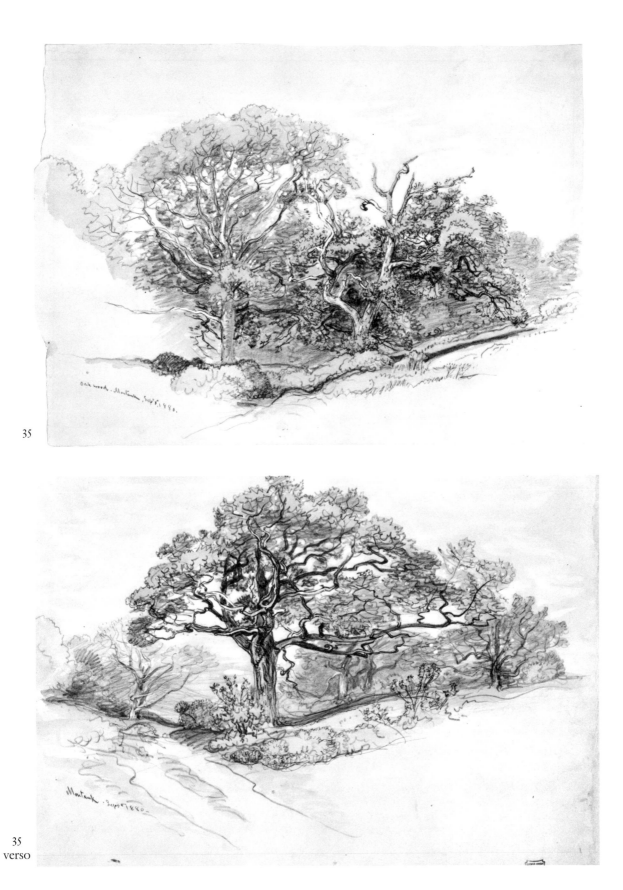

35

35
verso

For these works Colman was praised for his "judge-ment and lightness of hand" and for the "quiet senti-ment" he had captured.[3]

During the late 1870s, other artists such as R. Swain Gifford (1840–1905) and Winslow Homer (q.v.) visited Montauk to paint the peaceful landscape and relaxed rural life. Colman's attraction to Mon-tauk may have arisen from his affiliation with the New York Etching Club. Members Thomas Moran (q.v.) and his wife Mary Nimmo Moran (1842–1922) made prints of various Long Island scenes, and, by 1878, they had settled near Montauk, in East Hamp-ton.[4] A more plausible reason for Colman's visit to Long Island, however, was the presence of Lock-wood de Forest, III (1850–1932), one of his Associ-ated Artists partners, who maintained a studio in Montauk during the 1880s.

Colman liked to sketch outdoors throughout his career and frequently executed spontaneous, on-the-spot studies of trees in graphite.[5] He had a particular fondness for trees, which he continued to depict for the rest of his career (see no. 34). The Cooper-Hewitt National Design Museum has approximately forty tree studies Colman made on his trips to the western United States, the Hudson River valley, and else-where in New York and New England. He drew these either in sketchbooks or on large individual sheets. He very often used both sides of the paper, as he did here, and usually annotated his drawings with the place and date of execution. In *Oak Wood, Montauk*, Colman contrasted a mature upright tree in full glory on the left with a leafless tree with contorted limbs that has been ravaged by the elements. Using graphite to delineate the trees' trunks and branches, he rapidly shaded in between them to suggest dense lower fo-liage. For the leafy tufts at the treetops, he employed a broken, serrated outline.

The whiplash line characteristic of this drawing is typical of Colman's dynamic drawing style. As a fol-lower of the Hudson River school drawing tradition, he used line to describe the appearance of nature and to suggest the underlying natural forces that molded it. The almost unruly lines of this drawing not only denote the winding, attenuated forms of the trees, but also connote the wind shaking the branches. As Colman himself stated:

one of the most desirable features . . . is to give as much as possible the quick lines an artist makes with pen or pencil that represent or stand for what he sees in nature. For al-though there are no lines to be seen in reality, still they stand for the movement in figure, cloud, and mountain,

and suggest to the quick imagination more than the finished picture. This is the reason why artists and persons cultivated in art take so much pleasure in simple sketches.[6]

1. The related drawing is inscribed "*Montauk, Sept. 1880*" and is executed in graphite on brown laid paper, measuring 9¾ x 12⅜ inches (247 x 315 mm). Cooper-Hewitt National Design Museum, 1939–85–77.
2. Colman made a substantial number of etchings and drawings of eastern Long Island, beginning around 1877 with a group of etch-ings including *Old Mill, East Hampton* and *Barnyard at East Hamp-ton*. Another etching, *Old Mill at Wainscott, Long Island*, was made about 1883. Cooper-Hewitt National Design Museum has about fif-teen drawings of East Hampton scenery dating from 1877 to 1889 (1939–85–94). Kennedy Galleries, New York, has other East Hamp-ton studies.
3. *New York Times*, February 14, 1881, p. 5.
4. For a longer discussion of the artistic community of East Hampton, see East Hampton 1969 and East Hampton 1976, passim.
5. Cooper-Hewitt National Design Museum has a graphite drawing of an oak tree from 1854 (1939–85–54) and a pen and ink sketch from 1917 (1939–85–29A).
6. Samuel Colman quoted in Koehler 1880, p. 387.

Owen G. Hanks

Troy, New York ca. 1820 — New York 1863

OWEN G. HANKS is variously described as a bank note engraver, pictorial engraver, or line engraver of portraits and landscapes. The chronology of his life is difficult to reconstruct, given the scarce and conflict-ing documentation on him.[1] He was probably related to Jarvis F. Hanks and James A. Hanks, portrait painters active in New York from 1828 to 1833.[2] He may also have been a brother of Frederick Hanks, an engraver working with David R. Harrison in New York from 1844 to 1846. Though it has been stated that Owen Hanks first appeared in the New York city directory in 1846, another source notes his presence in New York from 1838 when he was employed by the bank note engraving firm of Rawdon, Wright & Hatch. In February 1841, he registered in the antique class at the National Academy. From 1848 to 1855, Hanks was a member of the bank note engraving firm of Wellstood, Benson & Hanks, of which he was a founding partner.[3] For the next few years, he worked as an independent engraver. He later engraved picto-rial vignettes, figures, and eagles for the American Bank Note Company.

To better understand the career of Owen Hanks, and indeed the presence of his watercolor in this ex-

hibition, it is worthwhile to briefly consider the tradition of bank note engraving in New York, its genesis, and its engravers. According to David McNeely Stauffer, the scarcity of metallic money among the early colonists in America encouraged the introduction of paper currency, which in time created the first serious demand for the work of copperplate engravers.[4] Asher B. Durand, John W. Casilear, and John Frederick Kensett all got their start in the bank note engraving business. After 1800, the engraving profession was greatly diversified with the increasing demand for illustrations in American periodicals and reprints of British publications.

It is by way of the noteworthy bank note and pictorial engravers James Smillie (1807–1885) and his son James David Smillie (1833–1909) that Owen Hanks came to be represented in the collection of the National Academy of Design.[5] In 1841, James Smillie was invited to become a partner in the firm of Rawdon, Wright & Hatch, where Hanks was presumably already employed.[6] Smillie was specifically appointed to superintend production. By 1842 they described themselves as pictorial engravers. It stands to reason that if Owen Hanks was employed by Rawdon, Wright & Hanks in 1841 he would have had early training in pictorial engraving, perhaps from Smillie himself.[7] As Smillie was recognized as the preeminent line engraver of his day, this would have been a fortuitous association for the young Hanks. James David Smillie joined his father's company at an early age and there he produced pictorial vignettes and drawings for bank notes. Young Smillie later turned his attention to painting in oil and watercolor. He was a founder and president of the American Society of Painters in Water Colors in 1866.

Owen Hanks's landscape watercolor was given to the National Academy as part of the James David Smillie Gift in 1902. This history of ownership further supports the theory that Hanks worked alongside one or both of the Smillies in one engraving company or another and that their mutual admiration led to the inclusion of this watercolor in the Smillie family collection. Owen G. Hanks died in New York on October 27, 1863, at the age of forty-three. He was buried in Hudson, New York.[8]

DA

1. The author is indebted to Roberta Waddell, curator of prints at the New York Public Library, for research assistance toward the preparation of this entry.

2. Altman 1938.

3. Altman 1938 indicates that Owen Hanks was present in New York from 1846 (p.118), while Groce and Wallace 1957 (p. 289) documents his employment with the bank note engraving firm of Rawdon, Wright & Hatch beginning in 1838. In 1852 the Wellstood firm became Wellstood, Hanks, Hay & Whiting and in 1855, Wellstood, Hay & Whiting. In 1858 it merged with other companies to form the American Bank Note Company.

4. Stauffer 1907, 1, p.xxi.

5. As Owen Hanks was not a member of the National Academy of Design, it stands to reason that he would not have contributed to its collection. The Academy's collection was initiated and developed to represent its membership, and thus it has accumulated its American art collection almost exclusively through the gifts of its members, gifts known as diploma works.

6. Altman 1938, p. 262.

7. Five pictorial engravings in the Print Room of the New York Public Library give further confirmation of a collaboration between Owen Hanks and James Smillie. Drawn by James Smillie and engraved by Owen Hanks, these loose sheets were originally bound as plates in two publications by Nehemiah Cleaveland, *Mount Auburn Illustrated* (New York, 1847) and *Greenwood Illustrated* (New York, 1847).

8. Hanks's death is recorded in the *New York Evening Post* and *New York Herald*, October 28, 1863.

36
Landscape with Birch Tree, 1859

Watercolor with traces of graphite on paper, arched at top

4¾ x 3⁹⁄₁₆ inches (121 x 91 mm)

Initialed in graphite, presumably by artist, in monogram on verso, lower center edge: *OGH* and dated there: *1859*; signed in
graphite on verso, center: *O. G. Hanks*; inscribed in graphite on verso, lower center: *Est. J. D. Smillie N. A.*

National Academy of Design

Gift of James David Smillie, 1902 [1981.630]

In the course of his career as a bank note engraver, Owen Hanks was employed by at least two companies that also specialized in pictorial engravings—Rawdon, Wright & Hatch and the American Bank Note Company. This exquisite, small landscape in watercolor was probably made as a preparatory study for a pictorial engraving. Its perfectly balanced, highly finished composition of delicately drawn foliage conforms in scale and design to the demands of a vignette illustration. Trimming the sheet to arch the top was a popular device in the 1860s, and often used by artists for illustrational purposes. In the present watercolor, there are traces of graphite outlining the edge of the arching top, another indication of its intended use for an engraved plate.

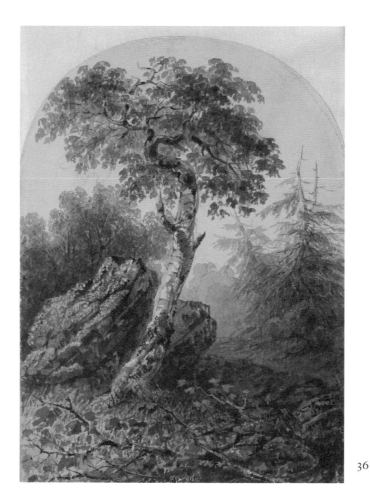

36

Hanks's technical mastery of this richly detailed landscape on such a small scale clearly owes a debt to his rigorous training in bank note work, where assignments ranged from engraving a standing figure of George Washington to decorating a tobacco revenue stamp.[1] While there is some documentation describing Hanks's activity in bank note engraving, there appears to be no documentation whatsoever to describe his production of engravings for book illustration or their related watercolors. We know from the exhibition records of the National Academy of Design that he pursued landscape painting in watercolor to some degree. He exhibited several landscapes in annual exhibitions intermittently from 1854 to 1863. In the latter year, he showed bank note vignettes along with a landscape.[2] His sureness of touch in this small watercolored vignette is clear evidence of his skills as a draftsman and a sign as well of his ease working in the medium.

Although the artist Owen Hanks remains somewhat of a mystery to us, the existence of his watercolor in the National Academy collections is clearly traceable to the the beneficence of James David Smillie. The gift enriched the Academy's holdings of drawings and shed new light on the Smillie circle of artists and friends.

1. Altman 1938, p. 118.

2. For a record of Hanks's submissions to the National Academy of Design annual exhibitions, see Cowdrey 1943, I, p. 208, and Naylor 1973, I, p. 391.

William Stanley Haseltine

Philadelphia 1835 — Rome 1900

ANA 1860, NA 1861

WILLIAM STANLEY HASELTINE ranks as one of America's preeminent landscape draftsmen of the second half of the nineteenth century.[1] He was the son of Elizabeth Shinn, from a prominent Philadephia family, and John Haseltine, a well-to-do Philadelphia merchant. Artistic ability seems to have been inherited as well as encouraged in Haseltine's family: his mother was an amateur landscape painter, and his four brothers also went on to careers in the art world. As a teenager, both before and after college, he studied drawing and painting in Philadelphia under the expatriate Darmstadt painter Paul Weber (1823–1916), at the same time as William Trost Richards (q.v.). After attending the University of Pennsylvania and graduating from Harvard College in 1854, Haseltine convinced his father to let him study painting in Europe, and he departed for Düsseldorf in 1855.[2]

There, according to Helen Haseltine Plowden, his daughter and biographer, he worked in the studio of Andreas Achenbach (1815–1910), the most influential landscape painter in Düsseldorf at this time.[3] He never formally enrolled as a student at the Düsseldorf Academy and he simply may have studied Achenbach's drawings and paintings informally as well as those of other landscape painters who taught at the academy.[4] From the Düsseldorf style of landscape draftsmanship, Haseltine absorbed the practice of using loose washes over a graphite underdrawing on tinted papers, along with using an X-shaped compositional structure. In Düsseldorf, he also met fellow American artists Emanuel Leutze (1816–1868), Worthington Whittredge (1820–1810), and Albert Bierstadt (1830–1902), who became his lifelong friends and with whom he went on sketching trips before moving on to Rome in 1857.

His drawings of the late 1850s, depicting mountain views or scenes of the Roman Campagna are generally of two varieties: graphite and gray wash (sometimes with white gouache heightening) on brown or green tinted papers; or gray wash (often with chartreuse, yellow, and brown watercolor) on off-white paper. In both types, Haseltine placed landscape elements in the middle of the sheet, leaving two or three margins free, often using the lower margin to make color and light notations. He continued to rely on intersecting diagonals as the method of organizing landscape elements—mountains, trees, rocks, ruins—and light and dark contrasts to further enliven scenes.

After traveling two years through Switzerland, Germany, Austria, and Italy, where he sketched and painted views of the European countryside and the Italian coast, Haseltine returned to the United States in the summer or fall of 1858. The next year he set up a studio in New York's Tenth Street Studio Building, where returning Düsseldorf friends Leutze, Whittredge, and Sanford R. Gifford (1823–1880), as well as other prominent American painters, including Frederic Edwin Church (q.v.), also had studios. For the next seven years, Haseltine sketched in New York State, along the coastline of Rhode Island's Narragansett Bay, at Nahant (outside of Boston), and on Maine's Mount Desert Island. His spare drawings of rocks, sea, and sky and the paintings based on them, which were exhibited at the Pennsylvania Academy of the Fine Arts and the National Academy of Design, are some of his most compelling works and established his reputation. Until 1865, he exhibited regularly at the National Academy yearly exhibitions.

Haseltine's wash and watercolor drawings of this time served to train his eye for composition as much as they served as preparatory studies for oil paintings. They are asymmetrically balanced, with coastal rocks filling one corner of a sheet, offset by large areas of sea and sky. Generally, outer margins remain free as in the earlier drawings. The light is clear and dispassionate, permitting careful scrutiny of nature's geologic formations. Like Church and other artists of the time, Haseltine was influenced by scientific theorists of the 1850s, particularly Louis Agassiz, whom he probably knew, and whose theory of glacial land formation encouraged viewing nature not so much as the demonstration of God's handiwork, but as the accidental result of geologic history.[5]

While the Rhode Island and Nahant pictures received praise in the early 1860s for their objective "filial study of nature...and capital rock drawing," critics grew bored with them by the mid-1860s and accused the artist of lacking versatility.[6] As a result of a series of devastating assaults by the press and greater financial independence following his marriage to the wealthy Helen Marshall after the death of his first wife, Haseltine moved to Europe in 1866. There, he could satisfy a growing clientele of wealthy American and European visitors with mementos of famous tourist sites. After a year in Paris, he moved to Rome,

and by 1874, he and his family had settled in a lavish apartment in the Palazzo Altieri, where they became active in the social life of the Italian and expatriate Anglo-American art community. Haseltine remained in Rome essentially for the rest of his life, with the exception of four documented visits to the United States in 1873–1874, 1893, 1895–1896, and 1899. He continued to exhibit at the National Academy of Design, though not as frequently as in the 1860s, and his work was included in the 1876 Philadelphia Centennial Exhibition.

Haseltine captured the soft light of Rome and the Campagna, combining it with his detailed manner. His pictures of Capri, Sicily, Venice, and Castel Fusano juxtaposed sharply focused passages in the foreground or middle ground with atmospherically rendered areas of sea and sky.[7] He was particularly partial to those mutable moments of the day—dusk, sunset, or early dawn—when light and color are most evanescent. Haseltine's fascination with the changing quality of light and color, as well as the growing interest in watercolor in the United States (from the mid-1860s) and in Italy (from the mid-1870s), encouraged him to use this medium more frequently for finished works. Nearly half of his extant work after 1870 is in watercolor. The portability of watercolor equipment and the quick-drying drawings made it easier for him to work on his frequent summer travels in Europe. Enhancing the chromatic qualities of these middle and late works was the blue to blue-gray "Turner-paper" that Haseltine preferred at this time. Using graphite underdrawing for trees, boats, and ruins, he built up the rest of his images in bright colors of gouache. His fluid application of opaque paint gave these works the appearance of pastels with which they were meant to compete.

In Haseltine's drawings from 1895, particularly those of Traunstein, Bavaria, rich chromatism, loose handling, and broken color (influenced by Impressionist pictures) coexisted with a more precise description of landscape elements placed in the middle ground.[8] While these late works can at times be overly pretty, it cannot be denied that Haseltine throughout his career, both in the United States and Europe, displayed the talent of a masterful composer. His beautifully balanced landscapes conveyed the vision, if not the reality, of a beneficent and harmonious natural world.

One year after Haseltine died, a memorial exhibition of his work opened at the Palazzo Altieri. The paintings and drawings remaining in his studio were divided upon the death of his widow among three children, Helen Haseltine Plowden, the sculptor Herbert Haseltine, and Princess Mildred Stanley Rospigliosi. Herbert's portion descended to his two children, Marshall Haseltine and Contessa Helen Haseltine Toggenburg, and Princess Rospigliosi's inheritance was dispersed during World War II.[9] Dedicated to reestablishing her father's reputation in the United States, Helen Plowden published a biography and organized exhibitions of Haseltine drawings and paintings all over the country. Between 1936 and 1970 she distributed the majority of her inheritance through sale or donation to American museums.

Mrs. Plowden's relationship with the National Design Museum and the National Academy started in 1953 when she donated one drawing of Capri to the Cooper Union Museum (now the Cooper-Hewitt National Design Museum) and a drawing and painting of the same subject to the Academy (see nos. 38–39). In 1957–1958, a show organized by Mrs. Plowden and Haseltine's Boston dealer, Doll & Richards, traveled to nine United States venues including the Cooper Union Museum and the National Academy of Design. Three years later, Mrs. Plowden asked the National Academy to assist her in distributing close to one hundred paintings and drawings to interested art institutions and libraries all over the country. The largest portion of the National Design Museum's Haseltine material came in 1969 with the gift of around seventy drawings and watercolors. While a portion of the Plowden and Herbert Haseltine estates remains in Europe with the artist's descendants, Cooper-Hewitt National Design Museum holds the largest and richest repository in the United States of Haseltine's work—numbering nearly eighty drawings and watercolors dating from all phases of his career.

GSD

1. I am grateful to Andrea Henderson Fahnestock for editing, making suggestions, and graciously sharing her research on Haseltine. Plowden 1947 is the starting point for any biographical account of the artist. San Francisco 1992, with essays by Marc Simpson, Andrea Henderson, and Sally Mills, provides new information and critical assessments of Haseltine's work and career.

2. In an 1855 letter in which Haseltine begs his father to approve foreign study, the young artist cites three or four young men who were going abroad to study, "Two of these, who are very poor—and one of them no older than I am—are going to Europe this summer by subscription" (Plowden 1947, p. 33). These two men could well have been William Trost Richards and his friend Alexander Lawrie, who were planning to leave for Europe together in July or August. Richards's trip was supported by funds gathered in part by the Rev. William Henry Furness, see Ferber 1980b, p. 44.

3. Plowden 1947, p. 42.

4. Andrea Henderson has suggested the influence of Johann Wilhelm Schirmer (1807–1863) who started the landscape course at the Düsseldorf Academy and was Achenbach's teacher when he was a student there. Schirmer had left Düsseldorf for Karlsruhe by the time Haseltine arrived, but he certainly could have seen Schirmer's drawings in Düsseldorf. For discussion of Haseltine and Schirmer, see Henderson, in San Francisco 1992, p. 47, n. 7; p. 156.

5. Marc Simpson, ibid., pp. 17–18; Wilmerding 1994, pp. 108–109.

6. "Brooklyn Artist's Reception," cited in San Francisco 1992, p. 165.

7. Henderson 1993, p. 157.

8. Henderson, in San Francisco 1992, pp. 39–41.

9. I am indebted to Sandra Feldman and Lane Sparkman of Hirschl & Adler Galleries, New York, for information on the disposition of the Haseltine estate. The Plowden gift files at the National Academy of Design and the National Design Museum provide a detailed account of the distribution of the Plowden works.

37
Mountains near Meiringen, Switzerland, 1856

Pen and black ink, wash, white gouache, graphite on tan paper

17⅜ x 23¹¹⁄₁₆ inches (447 x 577 mm)

Inscribed and dated in wash, lower left: *Meyringen*; in graphite: *56*

Cooper-Hewitt National Design Museum, Smithsonian Institution

Gift of Mrs. Roger H. Plowden (Mrs. Helen Haseltine Plowden), 1969–121–50

While based in Düsseldorf, Haseltine and his friends Emanuel Leutze, Worthington Whittredge, and Albert Bierstadt took two summer sketching trips, in 1856 and 1857, along the Rhine, into Switzerland and

37

northern Italy. In a September 3, 1856, letter to his mother, Haseltine enthusiastically described his first encounter with the landscape around Meiringen, a resort town in the Haslital in the Bernese Oberland.

The valley in which Meyringen is situated is very impressive; it is surrounded by high mountains from which eight or ten waterfalls, some two thousand feet high descend into the valley. . . . The scenery is extremely wild; in some parts we had to look down for some two hundred feet over fearful precipices to catch a glimpse of the waterfall.[1]

According to his daughter, the artist preferred the scenery of Switzerland—"Nature in her more virile garb"—to the softer hazy Rhine landscape, and he came away from the two Swiss trips with a portfolio "bulging with sketches."[2] This drawing, and other surviving drawings of Switzerland from these trips in the Cooper-Hewitt National Design Museum, reveal Haseltine's animated response to the dramatic Swiss scenery. Working in graphite, he sketched the mountainscape contours and then built up the composition in a series of monochromatic, freely applied washes, going from light to dark. To ensure crisp edges, he reinforced the contours in graphite and applied dark wash to add linear definition to the trees. He also added a layer of dark wash across the middle ground, thereby drawing the viewer into the picture. The brown paper, which Haseltine was partial to in his early years, accentuates the final contrasting splash of white gouache indicating snow on top of the distant mountains.

This early work of Haseltine's testifies to his knowledge of the wash drawings of the Düsseldorf landscape and seascape artist Andreas Achenbach and perhaps those of Johann Wilhelm Schirmer.[3] Plowden particularly stressed Haseltine's connection with Achenbach, who taught him how to compose— "discovering and framing-in pictures in the landscape." From Achenbach he also obtained "a clear conception of how contrasts of values, lights, distances, could form themselves into one harmonious whole." This approach to landscape composition, where "the center of attraction [is] intended to draw the eye of the beholder to it, gathering up all the other points of the picture to itself," is apparent as well in Haseltine's oil on paper mountainscapes of Switzerland from 1856. In these works, individual trees, rocks, and hills, set against distant mountains, tend to merge into one large mass without any clear spatial or planar differentiation between them—and are all subordinated "into one harmonious whole."[4]

1. Plowden 1947, pp. 48–49. Meiringen was a popular sketching place for nineteenth-century artists. William Trost Richards (q.v.) also worked there eleven years after Haseltine, in 1867, as indicated by three dated drawings (1953–179–51–53) in the National Design Museum.

2. Ibid., pp. 46–47

3. On Achenbach and Schirmer see Atlanta 1972, pp. 36, 39. Achenbach's *Mountainous Landscape*, 1840s, in black crayon (Kunstmuseum Düsseldorf), shows a compositional arrangement similar to the Meiringen drawing with the same contraction of foreground and background without any spatial indications between. Schirmer's wash drawing on green-tinted paper, *Landscape* (Kunsthalle Bremen), demonstrates the fluid drawing and the zigzag shorthand for describing outlines of foliage. A *Mountainous Landscape*, watercolor over graphite (Staatsgalerie Stuttgart), shows mountains painted in wash similar to those in the Haseltine drawing. Schirmer drawings in the Nasjonalgalleriet, Oslo, resemble other Haseltine studies executed at this time.

4. Quotes are from Plowden 1947, p. 44 and 37.

5. See for example, *Mountain Scenery, Switzerland* (William Benton Museum of Art, University of Connecticut, Storrs); and *Schwyz near Brunnen* (St. Louis Art Museum), reproduced in San Francisco 1992, plates 2 and 3.

38
Capri, 1858

Brush and gray wash, pen and black ink over graphite on tan paper, laid down

18⅛ x 23⅛ inches (462 x 587 mm)

Inscribed and dated in gray wash, lower left corner: *Capri / 1858*; in graphite, lower right corner: *highest light in foreground*

National Academy of Design

Gift of Helen Haseltine Plowden, 1953 [1980.48]

39
Capri, Southern Coast and the Faraglioni, ca. 1865

Brush and gray wash, and possibly charcoal over graphite on paper

15⅙ x 21⅜ inches (381 x 543 mm)

Signed in wash, lower left: *Wm S. Haseltine*; inscribed in graphite, on rocks, center right: *red[d]ish grey / yellow*

Cooper-Hewitt National Design Museum, Smithsonian Institution

Gift of Mrs. Roger H. Plowden (Mrs. Helen Haseltine Plowden) 1953–155–1

For a nineteenth-century American painter seeking the sublime in nature, the island of Capri, with its jagged limestone cliffs plunging precipitously down

38

to the sea, offered some of the wildest and most fantastic scenery.[1] The four-square-mile retreat at the southern end of the Bay of Naples, "where Nature has placed terror and beauty side by side," was one of Haseltine's favorite painting sites.[2] He visited the island at least five times—in 1858, 1865, 1868, 1870, and 1871, and possibly in 1891 as well[3]—creating numerous on-site graphite and wash drawings as well as oil sketches that he later used as points of departure for many oil paintings.[4]

The National Academy of Design drawing may have functioned as a preparatory study for the finished painting in Washington's National Gallery of Art, *Natural Arch at Capri*, 1871, which shows the same distant coast of Sorrento in the background. The Cooper-Hewitt National Design Museum drawing was used as a preparatory study for an 1867 painting, *Isle of Capri* (fig. 11).[5] This painting, known only

from the black and white auction catalogue photograph, is slightly wider than the related drawing, allowing the entire rock to be seen at the painting's right edge, and it shows less sky and slight modifications of the foreground rocks. In other respects, it seems to follow the National Design Museum drawing almost exactly.

The National Academy and the National Design Museum drawings viewed together provide some clues about the evolution of Haseltine's compositional handling. For the earlier Academy sketch, he found a spot on the eastern side of the island, looking out over several rocky outcroppings in the foreground, across the bay toward the Sorrentine peninsula in the distance. Evolving the compositional formula that he would use throughout the next decade, whether capturing the coast of New England or Italy, Haseltine here juxtaposed the diagonal lines of the

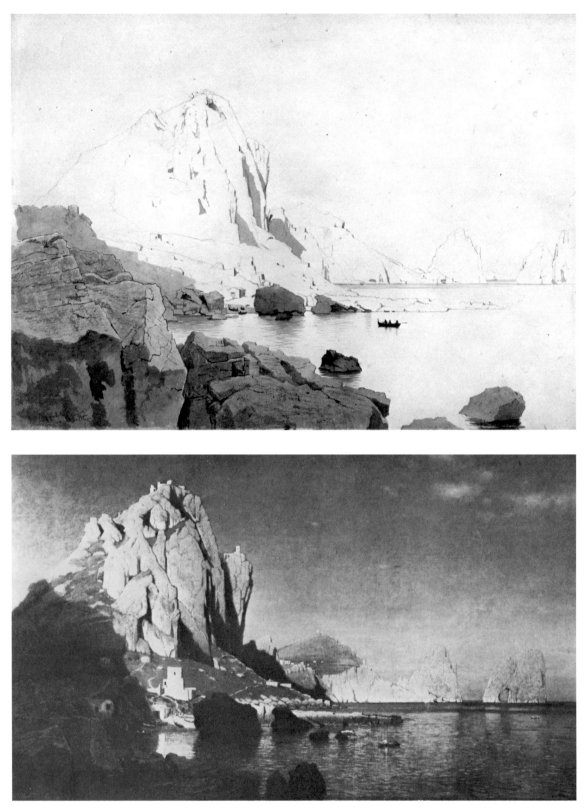

39

Fig. 11. Haseltine, Isle of Capri, *1867, oil on canvas, unknown location*

rocks on the surface with a planar description of three-dimensional space. His application of wash on the rocks in alternating patterns of dark and light helps to define spatial layers and outlines the areas where the sunlight coming from the upper left bathes the rocks in the foreground.

Dating approximately eight years later than the Academy sketch, the National Design Museum's drawing shows the rocky outcroppings in precisely articulated foreground, middle ground, and background planes.[6] The vantage point here is on Capri's southern coast, close to one of the island's ports, the Marina Piccola, looking eastward toward the headland known as Punta di Tragara and the curious rocky, needle-like islets, the Faraglioni. Awesome nature dwarfs everything made by humanity. Beneath tower-like promontories topped with ancient ruins, three fisherman in a boat row toward one of the small beaches of the Marina Piccola, where three other boats are pulled up on the sand. Two tiny figures standing on the end of a natural jetty gaze toward the "rocky obelisks" in the distance, between which one glimpses a ship sailing southward.[7] The scene is drawn economically with tonal washes over graphite, allowing the white paper to express the brilliant sunlight which illuminates the scene.

This view closely corresponds to a description of the Marina Piccola by the poet Bayard Taylor from 1868:

Here the island shelves down rapidly between two near precipices . . . the vast, glittering sea basked in the sun. At the bottom we found three fishers' houses stuck among the rocks, more like rough natural accretions than the work of human hands; a dozen boats hauled up on the stones in a cove about forty feet in diameter. . . . Silence and savage solitude mark the spot. Eastward, the Faraglioni rise in the gray-red inaccessible cones; the ramparts of the Castello make sharp crenelated zigzags on the sky, a thousand feet above one's head.[8]

Haseltine in these studies captures the eternal "silence and savage solitude" of Capri.[9]

1. In addition to Haseltine, American artists who painted views of Capri include: Worthington Whittredge, Sanford R. Gifford, Charles Temple Dix, Charles Caryl Coleman, and Elihu Vedder. See Boston 1992, p. 293.

2. Taylor 1868, p. 740.

3. Henderson, in San Francisco 1992, p. 42.

4. Haseltine exhibited paintings of Capri throughout the 1860s and 1870s and into the 1880s, see San Francisco 1992, pp. 163 ff. Andrea Henderson records 28 paintings and 10 works on paper of Capri. One of these pictures, *Sunrise at Capri*, 1880–1900, is in the National Academy of Design. For discussion of the Capri paintings, see Henderson, ibid., pp. 42–43.

5. Ibid., p. 42. Henderson also shared the information on the painting *Isle of Capri*, in C.G. Sloan & Company, Washington, *Public Auction*, September 20–23, 1979, sale 715, p. 159, lot 2150 (31½ x 55 inches).

6. Haseltine's visit to Capri in 1865 was reported in the *Round Table*, September 9: "Charles Dix and Hazeltine are refreshing themselves and filling their portfolios with marine effects and coast scenery on the Isle of Capri. The last news of importance from them is that on the Fourth of July they gave a fete to the entire population of the island. It is reported to have been something quite extraordinary and to have cost—including fireworks, wine, banquets, etc.—nearly twenty francs," quoted in San Francisco 1992, p. 173.

7. Gregorovius, p. 47. When Haseltine first settled in Rome in 1857, he lived in the same building as Gregorovius.

8. Taylor 1868, pp. 745–746.

9. Additional unidentified views in the Cooper-Hewitt National Design Museum probably depict Capri: 1969–121–24; 1969–121–33; 1969–121–66.

40

Canal Scene near Bruges, Belgium, 1875–1880*

Point of brush, gray, blue-gray and black washes, white gouache, graphite and possibly charcoal on blue-gray paper laid down on illustration board

15⅛ x 22⅛ inches (382 x 563 mm)

Inscribed in graphite, lower left: *Bruges*; initialed in red crayon, lower left: *WSH*

Cooper-Hewitt National Design Museum, Smithsonian Institution

Gift of Mrs. Roger H. Plowden (Mrs. Helen Haseltine Plowden), 1958–20–1

According to Helen Haseltine Plowden, her father executed this view of the outskirts of Bruges in thirty minutes while waiting for a train.[1] Whether or not this story is apocryphal, the drawing gives the impression that it was dashed off on the spot in a few minutes. It is early in the morning, the moon is still high in the sky, and a heavy fog lies upon the rural countryside. A canal cuts through the flat farmland from the right foreground into the left middle ground and back again into the distance at the right. Tall trees border the edge of the canal, their full foliage screening two farmhouses. The air is heavy and the mood serene.

Haseltine described this intimate and solitary experience of nature with the most limited of means. (It is possible that the drawing is unfinished, either deliberately or by happenstance.) On blue paper he sketched the composition quickly in graphite and then blocked in all the foliage with tones of gray

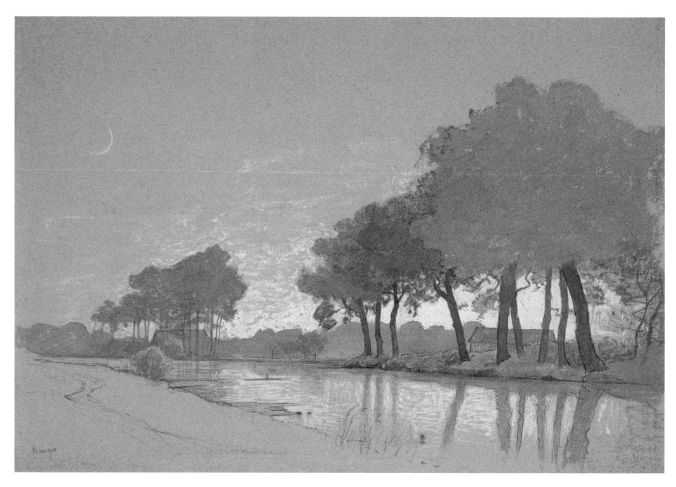

40

gouache. The slender trunks are colored in darker wash over graphite shading and a darker wash suggests the tree contours, canal banks and grasses, and reflections in the water. To indicate the distant town and trees, he applied blue watercolor. Finally, he brushed some white gouache above and in between the trees to suggest the early morning fog and the crescent moon. White gouache also indicates the moving water in which the graceful trees are reflected.

In contrast to Haseltine's early wash drawings of the 1860s, characterized by emphatic contours, strict planar definition of space, clear white light, and stasis, this study suggests color, freedom, fluency, softer focus, and movement—all common to the artist's drawings of the 1870s and 1880s. The clarity of white paper has given way to greater colorism starting with the support itself—a blue textured paper which Haseltine used almost exclusively for his watercolors at this time. There are no hard, angular edges here as in his 1860s drawings of rocks and coast in Narragansett, Nahant, or Italy. The stream, the tree trunks, the river banks—everything undulates—and the masses of foliage hover like clouds. Even the white gouache has been applied in quick fluent strokes, conveying the movement of the stream and the shimmering quality of the light in this early morning scene.

By the early 1870s, Haseltine was responding to criticism of his earlier paintings, which were deemed retrogressive and "hard," as well as to changes in taste at this time which called for poetry and mood over geological and topographical accuracy. An appreciation of the artist's new manner was expressed by a critic visiting Haseltine's New York studio in 1874:

With later studies has come, in addition to the knowledge [of] what to see, the still finer intuition of what the artist should *not* see. The sharp, intense perception born of October days in the bracing atmosphere of the New England coast, has been tempered by long and languorous afternoons in the soft air. . . . His painting now shows a wise warmth of tone, a subtle gradation of color, and a poetic feeling in conception and composition which were only hinted at in his earlier efforts. His touch has grown more . . . free, his handling broader and his atmosphere more vaporous and soft.[2]

In his late gouaches and watercolors, Haseltine was also reacting to contemporary Italian plein-air paintings as well as to the broken color and bright palette of Impressionist pictures, perhaps those of Claude Monet, whom, according to Plowden, he knew and

greatly admired. Many of the high-keyed watercolors and gouache drawings on blue paper of the late 1870s and 1880s (portraying the pine woods around Cannes, the shores of Lake Geneva, the mountains of Switzerland, the cities in Spain, or the woods of Traunstein in Bavaria (as well as other places Haseltine visited in his frequent travels through Europe) can look very much like hardened versions of Impressionist pastels.[3]

1. Helen Plowden to Richard Wunder, August 12, 1958, in National Design Museum property files. Apparently, Haseltine was known to work quickly. "An artist-friend of his said once: 'It embarrasses me to go out sketching with Haseltine; he is usually halfway through a sketch before I have *even started* mine. . . .'" Quoted in Plowden 1947, p. 154.
2. Unidentified clipping in Plowden gift files, National Academy of Design.
3. See, for example, San Francisco 1992, plates 62 and 64–68.

Winslow Homer

Boston 1836 — Prout's Neck, Maine 1910
ANA 1864, NA 1865

THOUGH WINSLOW HOMER spent his first forty-six years in the urban environments of Boston and New York, his artistic production was grounded in the countryside. His love of sports and life outdoors drew him to the landscape of upstate New York and the New England coast, which became the subjects of his work. Born in Boston to a middle-class family, he grew up in Cambridge, Massachusetts. Having demonstrated a precocious talent for drawing, Homer was apprenticed in the Boston lithography firm of J. H. Bufford, where he designed sheet music covers and learned the rudiments of commercial lithography and wood engraving. At age twenty-one, he became a freelance illustrator. His scenes of everyday life in Boston and rural life in New England appeared in *Ballou's Pictorial Drawing-Room Companion* and *Harper's Weekly*.

In 1859, Homer moved to New York where he worked as a freelance illustrator. Shortly after arriving, he began several months of night classes in life drawing at the National Academy and took a few painting lessons. Otherwise, his art studies were entirely self-directed. After the Civil War started, *Harper's Weekly* sent Homer to report on the battlefront as an artist-correspondent. Working in black

and white chalk or graphite and wash, he sketched scenes of daily life in the Virgina military camps. From these sketches he composed formal illustrations that were later engraved in wood block by other artists. His experience as a reporter taught him how to observe and record essential forms and movements swiftly and accurately. The Civil War also provided subjects for his earliest oil paintings.

Until he was forty, Homer supported himself as an illustrator for such popular periodicals as *Appleton's Journal*, *Every Saturday*, *Galaxy*, *Hearth and Home*, and *Harper's Weekly*. Beginning in 1863 he exhibited paintings at the National Academy of Design on a regular basis until 1888. After becoming an Academician in 1865, he went to Paris where two of his paintings were exhibited at the 1867 Exposition Universelle. Nothing is documented about what he saw during his ten-month stay there. He may have visited the Manet and Courbet exhibitions, however, and probably also saw works by the Barbizon painters.

On his return to New York in the fall of 1867, Homer concentrated on portraying the leisurely life of the country in peacetime. His drawings depict men, woman, and children at such fashionable resorts as Long Branch, New Jersey, the White Mountains of New Hampshire, the Adirondack Mountains of New York, or the coastal town of Gloucester, Massachusetts. These works are characterized by emphatic contours and sharply demarcated patches of light and dark. Being economical and practical, he often used the same compositions with only slight variations for watercolors, oil paintings, and illustrations. By 1875, he was able to give up his work as an illustrator and focus entirely on his watercolors and oil paintings, which were selling well enough to provide him with a regular income.

Applying himself to the serious study of watercolor, Homer made great advances in his painting during the 1870s.[1] The medium perfectly suited his interest in working outdoors directly from nature, enabling him to capture the sunlight on fields and streams, the shadows in the woods, or the flickering light on seaside waters. Based on trips to Gloucester, a visit to Virginia, and several to Houghton Farm in upstate New York, he produced several series of remarkable watercolors of women and children in outdoor settings. While he employed flat washes, precise outlines, and opaque gouache highlights in his early watercolors, those toward the end of the decade are distinguished by fluid transparent washes, a rich bold

palette, and sparkling bright light. At the exhibitions of the American Society of Painters in Water Colors these works were considered original but "eccentric."[2] The commonplace subject matter aroused the ire of some critics, including Henry James who, while he could not help being intrigued by Homer's work, detested his "bald, blue skies, his big, dreary vacant lots of meadows, his freckled straight-haired Yankee urchins, his flat-breasted maidens . . . ; [Homer] has resolutely treated them as if they were . . . every inch as good as Capri."[3] Others found the spontaneous brushwork "careless," and his bright colors unrealistic. By 1880 in Gloucester, Homer was creating his most advanced watercolors thus far—marine studies that displayed a new coloristic power inspired by the color theories of Ogden Rood. Homer's new painting techniques included bleeding colors on soaked paper and scraping the paper to create highlights.

In 1880, when his reputation had reached a high peak, Homer left New York for England. He settled in Cullercoats, an artist's colony and fishing village near Tynemouth in Northumberland. This trip proved to be the turning point in his career. There he abandoned optimistic idyllic views of women and children to concentrate on people whose lives were uncertain–bound by the random power of the sea. In portraying the men and women of this fishing port, engaged in their daily tasks and struggling against nature for survival, he found archetypes for humanity in general. Upon his return in 1882, he left New York to make his permanent home in Prout's Neck, Maine, a rocky outcropping on the Atlantic, where he could work in isolation. Here he began the most productive period of his career. A series of major oil paintings, *The Life Line* and *The Herring Net* (preparatory drawings for both are in the National Design Museum's collection), and *Eight Bells*, all portray the dramatic conflict of humanity wrestling with the sea.

As a respite from severe Maine winters, Homer frequently traveled to the Bahamas or to Florida, where he combined fishing with painting and drawing. Stimulated by the intense light and color of the Caribbean, he created some of his most luminous watercolors depicting Bahamian natives and the seaside tropical landscape. The Bahamas also inspired one of his most famous paintings, *The Gulf Stream*, 1899 (Metropolitan Museum of Art, New York), for which a preparatory watercolor exists at the National Design Museum. Summers and falls were sometimes spent in the Adirondacks and, from the mid-1890s, in

Quebec. After 1890, Homer ceased his narrative depictions of the human struggle against nature and produced pure seascapes where the conflict became metaphorical. The compelling power of these late works secured his standing as one of the great American artists of all time.

When Homer died in 1910, he left a large group of drawings, paintings, and prints in his Prout's Neck studio. Some of the material was sold in the 1911 sale of the estate, but other work remained unsold. About three hundred drawings were at one point destroyed by mice. The artist's brother, Charles Savage Homer, Jr., was acquainted with Eleanor and Sarah Hewitt, the founders of the Cooper Union Museum for the Decorative Arts. Charles Homer also knew the painter Eliot Clark—later president of the National Academy of Design—who was acting as the agent for the Hewitt sisters, helping to build the drawing collection for use as study material at the Cooper Union Woman's Art School. Homer's brother was encouraged to donate the studio contents to Cooper Union for this purpose, which he did in 1912. In subsequent years, this Homer collection was enlarged through the gift of important drawings from Charles W. Gould, a New York lawyer, who was a trustee of Cooper Union and a friend of the artist. The holdings comprise the largest group of works by Homer in any private or public collection, consisting of 272 drawings, 22 oil paintings, 1 oil sketch, 14 watercolors, as well as wood engravings and etchings.[4] Documenting most of the artist's career, these works cover the full range of subject matter and all the major sites where Homer painted.　　　　　GSD

1. See Cooper, in Washington and New Haven 1986, pp. 20–79.
2. Ibid., p. 24
3. James 1875, quoted in Spassky 1985, p. 432.
4. On the Homer collection at the Museum, see Hathaway 1936, pp. 53–63; New York 1972, pp. 3–4; and Dee 1975, pp. 44–47.

41
Shepherdess Resting under a Tree, 1878

Graphite and white gouache on gray-green paper

5¹³⁄₁₆ x 8⁹⁄₁₆ inches (133 x 218 mm)

Initialed and dated in graphite, lower right: *W H 1878*; inscribed in graphite on verso, left edge: *4*

Cooper Union stamp 1, lower right corner

Cooper-Hewitt National Design Museum, Smithsonian Institution

Gift of Charles Savage Homer, Jr., 1912-12-88

42
Waverly Oaks, 1878*

Graphite and white gouache on gray-green paper

5¹³⁄₁₆ x 8¹⁄₁₆ inches (148 x 205 mm)

Signed in graphite, lower right corner: *Homer*; inscribed in graphite, center verso: *Waverly Oaks*; in black crayon, left edge: *$15* crossed out in ink; in graphite: *no. 14*; *$[10 erased]*

Cooper Union stamp 1, lower left verso

Cooper-Hewitt National Design Museum, Smithsonian Institution

Gift of Charles Savage Homer, Jr., 1912-12-87

"We have rarely seen anything more pure and gentle than the little American girl . . . half hidden away under the dark shade of trees, with her sheep at her side." So wrote critic Susan N. Carter about a related Homer watercolor in the American Society of Painters in Water Colors exhibition of February 1879.[1] This display included twenty-three watercolors and gouaches Homer executed in the summer and fall of 1878 at Houghton Farm, in Mountainville, New York. Located in the rolling hills of Orange County, this property was purchased in 1876 as a summer home by Lawson Valentine, a prosperous manufacturer of paint and varnish. The chief chemist for the Valentine Company was Winslow Homer's brother, Charles Savage Homer, Jr. He and Winslow, along with other Valentine friends, were frequent houseguests at the farm in the following years.[2] The rural life and rolling hills inspired Homer to create a large number of drawings, watercolors, and oil paintings depicting children playing on the farm and young people engaged in chores. The exhibited drawing belongs to a group showing young girls in smocks and

sunbonnets, or in pseudo-eighteenth-century shepherdess dress, lying in hillside pastures, resting in the shade, or tending sheep.[3]

Many Homer scholars consider these bucolic shepherdess scenes overtly sentimental and contrived compared to the rest of Homer's oeuvre, which was so consciously based on naturalism.[4] This "aberration" in his work may have been due to the Philadelphia Centennial Exhibition of 1876 which inspired a revival of early American imagery. There was a general wave of nostalgia in the wake of the Civil War for an agrarian past that was fast being replaced by an industrial society.[5] American artists, including Homer, responded to this yearning with pictures of farm scenes and rural life that embodied the enduring American values of individualism and hard work.[6]

Though Homer concentrated much of his energy on the formal aesthetic problems of his artwork, he nevertheless was acutely conscious of his clientele and at times would tailor his subject matter to suit the market. He and his colleagues knew the French tradition of "peasant genre," as represented in the work of Jean François Millet and Jules Breton, whose paintings were exhibited and collected in the United States and discussed in the press. Homer adapted the French images to American taste and experience.[7]

Winslow Homer's interest in the shepherdess theme seems to date back to 1877 when he and eleven other artists, including Francis Hopkinson Smith (q.v.) organized the Tile Club. They met weekly to socialize and paint tiles, in response to the current fad for painted bric-a-brac. Homer produced several tile designs using the shepherdess motif—the most famous of which was a fireplace surround called *Pastorale*, made for the West Townsend, Massachusetts, house of his brother, Charles.[8] Perhaps with this fireplace project in mind, Homer brought a shepherdess costume up to Houghton Farm when he visited there in the summer of 1878.[9] Several young girls posed for him in this costume or in everyday farm dress, including the children of Valentine's houseguests.[10]

Aside from the narrative content of these pictures, Homer certainly used his studies and watercolors to explore the formal problems of his art—compositional arrangements, the figure-ground relationships, value contrasts, and different media effects. Taking advantage of the farm topography, he investigated the relationship of figures and animals in an active, diagonally arranged landscape.[11] In the drawing, the young girl's figure runs parallel to the slope of the hill.

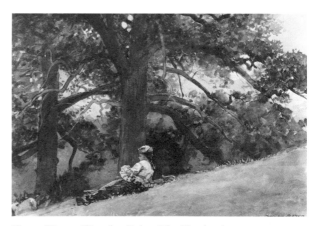

Fig. 12. Homer, Waverley Oaks—The Shepherdess, *1878, watercolor, private collection*

Her body, just breaking the contour of the hill, is balanced by the vertical tree trunk. Another National Design Museum study, which appears to be preparatory to this drawing, shows sheep grazing on a steep hillside beneath a tree with low-hanging branches similar to the tree in the *Shepherdess Resting*.[12]

Nature without figures also interested Homer at this time. *Waverly Oaks*, executed probably in the spring of 1878, during one of his visits to Cambridge, shows an anthropomorphic majestic oak whose lively branches fill the entire sheet like a patriarch embracing his children.[13] Both *Waverly Oaks* and *Shepherdess Resting under a Tree* allowed him to study the effective use of value contrasts. Exploiting the French imported green-tinted paper, he drew his subjects in a soft dark graphite and then applied a highly contrasting white gouache to express the sky and sunlight coming through the branches, creating dappled patterns of light and dark that enhance the visual interest of the paper surface.[14]

Homer considered both these drawings as independent artworks in their own right. *Waverly Oaks*, for example, has prices inscribed on the verso. He may also, however, have used them in preparation for another work. *Shepherdess Resting under a Tree* provided the compositional arrangement of figure, landscape, and animals for a watercolor now in a private collection, *Waverley Oaks—The Shepherdess*, signed and dated 1878 (fig. 12).[15] This watercolor also shows a young girl tending sheep, lying on a hill sloping down to the left, only she is wearing a shepherdess costume and her back is to the viewer. The depiction of the tree in *Waverly Oaks* seems to have been one of

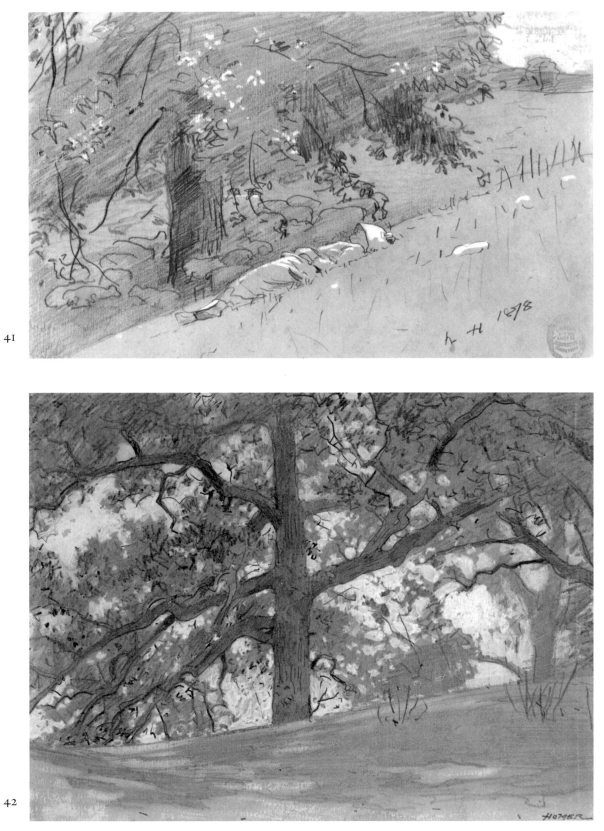

41

42

the points of reference for the trees in the watercolor, which are similarly seen from below and arch out to both sides of the picture.[16]

If Homer deliberately directed his 1878 and 1879 production for public consumption, he succeeded in this goal. Thereafter, his reputation in the American art world was established.

1. Carter 1879, p. 94. The "study" she referred to was no. 227, *Watching Sheep*. In addition to writing art criticism, Susan N. Carter was director of the Woman's Art School of Cooper Union until 1897, see New York and Washington 1989, p. 2.

2. Linda Ayres, in Princeton and Hartford 1990, pp. 19–26.

3. No scholar has yet published the entire Houghton Farm oeuvre since many of the drawings and watercolors are in private collections. Cooper-Hewitt National Design Museum has nearly thirty drawings depicting Houghton Farm scenes.

4. Hendricks 1979, p. 138, has been most condemning, referring to these works as the "sheep-shepherd-shepherdess glut."

5. Cooper, in Washington and New Haven 1986, p. 54.

6. Hills 1987, p. 62.

7. Helen Cooper and others scholars have pointed to the connection between the work of Millet, Breton, and Homer, see Cooper, in Washington and New Haven 1986, p. 52; p. 64, n. 5.

8. Hendricks 1979, p. 133, p. 137, p. 128, figs. 192 and 193.

9. Cooper, in Washington and New Haven 1986, p. 60.

10. One of his sitters was the daughter of a poor family by the name of Babcock who lived near the farm, see Hendricks 1979, p. 138.

11. David Tatham, in Syracuse 1979, unpaginated.

12. Gift of Charles Savage Homer, Jr., 1912-12-54. According to Linda Ayres, in Princeton and Hartford 1990, p. 21, Valentine purchased Southdown sheep as well as Jersey cows and horses especially for Houghton Farm.

13. The portrayal of the tree in *Waverly Oaks*, was probably inspired by prints after Barbizon paintings. Waverly Oaks was a stand of oak trees in the Waverly (also spelled Waverley) section of Belmont, Massachusetts, named for the Waverley Land Company which developed this border area of Belmont and the neighboring town of Waltham. The oak trees, supposedly over two hundred years old, adjoined Beaver Brook, a mill, and a pond which formed a popular recreation spot. In 1894, the thirty-acre Waverly Oaks area was taken over by the Massachusetts District Commission as the Waverly Oaks Reservation. Today the area is part of the Beaver Brook Reservation, and, unfortunately, the last oak died in the early 1950s. See Betts 1974 and Betts 1985. I am indebted to Belmont Historical Society member Martin L. Cohen who brought this information to my attention.

14. For a thorough discussion of the technique, media, and paper of *Waverly Oaks*, see Provost 1993, pp. 35–46.

15. This watercolor was recently published by Henry Adams, misdated 1873; he refers to it in a discussion of Homer's sexuality. See Adams 1990, pp. 244–252. I thank Abigail Booth Gerdts for drawing my attention to this article.

16. New York 1986, p. 27, no. 25.

43
Fisherman in Quebec, 1895*

Black, gray wash, white gouache over charcoal on gray-green paper

12 x 19¹⁵⁄₁₆ inches (305 x 506 mm)

Initialed in black wash, lower right corner: *W. H.*

Cooper Union stamp 2, center verso

Cooper-Hewitt National Design Museum, Smithsonian Institution

Gift of Charles Savage Homer, Jr., 1912-12-89

Fly fishing was a recreational hobby that Homer knew intimately. He had fished since he was a child in Boston. As an adult, he became adept at fly fishing when the sport was still relatively unknown in the United States.[1] From the late 1860s to the end of his life, a good portion of his free time was spent fishing in the White Mountains and the Adirondacks as well as the Caribbean and Canada. He also produced many brilliant, luminous watercolors of these locations.

In company with his brother, Charles, Homer visited the province of Quebec for the first time in 1893. Their destination was the Tourilli Fish and Game Club, thirty miles north of Quebec City in the Laurentian Mountains. This exclusive club of socially prominent sportsmen from New York, Boston, and Canada owned over 355 square miles of wilderness on Lake Tourilli near the town of St. Raymond.[2] Living in the main clubhouse at first, the brothers surveyed the fishing possibilities. The best fishing on the Saguenay River and in Lake St. John was accessible by railroad to the town of Roberval (on the southwestern side of Lake St. John) or via canoe from the town of Chicoutimi on the treacherous upper Saguenay River to Lake St. John. The brothers made the difficult canoe trip of around thirty miles several times—paddling against the current in turbulent, churning waters.

Though Homer seems to have spent the first trip with his brother exclusively fishing for trout and ouananiche (land-locked salmon particular to this area), on subsequent visits, in 1895, 1897, and 1902, he pursued both sport and work, executing approximately forty-eight watercolors as well as graphite drawings.[3] Concentrating on four sites, he drew and painted fishing scenes of Lake Tourilli, Lake St. John, the rapids at Great Discharge—where the waters of Lake

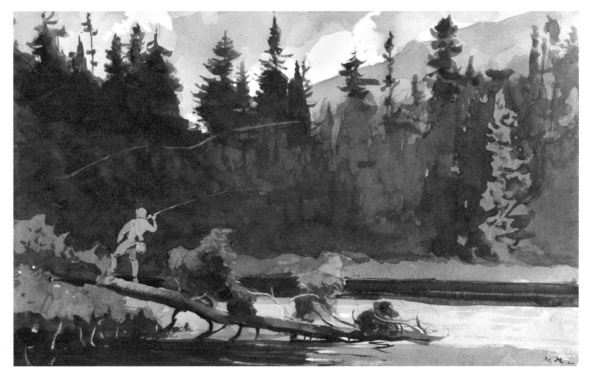

43

St. John surge into the upper Saguenay River—and the wild, rock-filled gorges of the river itself.

For the 1895 trip Homer decided to paint a series of watercolors in monochrome, to see if he could use only graded tones of black wash and white gouache to approximate the effects achieved by varying color hues. The Canadian wilderness, with its stark and primitive character, was ideally suited to black and white renderings. Beginning his artistic career as an illustrator, Homer was particularly attuned to working in monochrome. His oft-quoted statement about using chiaroscuro is worth repeating here in this context:

I have never tried to do anything but get the true relationship of values; that is, the values of dark and light and the values of color. It is wonderful how much depends upon the relationship of black and white. Why, do you know, a black and white, if properly balanced, suggests color. The construction, the balancing of the parts is everything.[4]

According to Helen Cooper, Homer did at least eleven monochrome watercolors in 1895, all executed on gray-green paper.[5] These include scenes of Quebec City and its surroundings, presumably executed on his way up to the fishing expedition: *The Plains of Abraham* (formerly Hirschl & Adler Galleries, New York), and *Wolf's Cove* (Bowdoin College Museum of Art, Maine), a trading outpost along the St. Lawrence River. Also using monochrome, he painted at least two versions of the log cabin that he and his brother had built in 1895 at the extreme boundry of the Tourilli fishing club property.

Fisherman in Quebec belongs to a small group of several monochromes showing scenes of fishermen in lake settings, either on Lake Tourelli or Lake St. John.[6] Together, they demonstrate Homer's complete mastery of watercolor's technical possibilities. This drawing shows a young man fly fishing in a lake or river bordered by a dense forest of fir trees. The sky is overcast and it appears to be late afternoon. Standing presumably on an uprooted tree lying in the water, he is in the midst of a backcast—raising his rod in the air behind him, causing the fine silk line to roll out in a wave above his head. Over his shoulder, he wears a creel basket to hold trout or salmon that are caught, probably on wet ferns to keep them cold. The air is still and the mood generally serene.[7]

Homer carefully orchestrated the development of this composition. His sophisticated technique, which required careful planning, suggests it was painted indoors from earlier on-site sketches.[8] After laying out

the basic compositional lines in a summary charcoal underdrawing, he worked up the scene in a careful sequence of washes, proceeding from the lightest to the darkest values. Using the paper itself as a light tone, he laid in a variety of graded transparent gray washes—medium-light, medium, medium-dark—in vigorous broad horizontal strips stretching across the entire sheet, conveying the water, the uprooted tree, the dense forest, and the mountain behind. In his mature style, Homer exploited "accidental effects." This is exemplified in his painting of the forest, where he laid black wash over an underlayer of medium gray wash and then dropped puddles of water on top of the wash which he then dabbed with an absorbent medium. The technique created a series of distinct round rings marking the outside edges of the puddles, producing the impression of tree branches emerging from the dense undergrowth. With a few brief strokes of gray gouache (black wash mixed with opaque white) he superimposed on the trees a fisherman whose rod and line loop in a graceful arc over his head and back toward the water in front of him. Homer applied the lightest tone of white gouache in irregular shapes above and in between the treetops to achieve the patches of bright light coming through the cloud-filled sky. Finally, with quick calligraphic shorthand strokes of white gouache, he noted highlights on the water, the fallen tree, and the undergrowth. A masterful closing pinpoint of gouache created the spot of light reflecting off the metallic fishing reel. Through this combination of broad wash strokes, soakings, and calligraphic strokes, Homer was able to convey the scene and to express mood—the serenity of a man in harmony with the majestic surrounding wilderness.[9] The poetic, sparkling artistry of this watercolor and others of this series are among the great accomplishments of his career.[10]

1. Cantwell 1972, p. 70.

2. See ibid., p. 71, for a more detailed account of the fishing club's facilities.

3. Cooper, in Washington and New Haven 1986, p. 198. See also Teitelbaum 1987, pp. 37–47, the first catalogue of Homer's Canadian watercolors.

4. Beatty in Goodrich 1944, p. 220.

5. Cooper, in Washington and New Haven 1986, pp. 200–202. Lloyd Goodrich, in New York 1987, p. 11, says there are twelve.

6. According to Goodrich 1944, p. 147, most of the monochromes were done at Lake Tourilli, while Cooper, in Washington and New Haven 1986, p. 202, places them on Lake St. John. Included in this group are *Two Men in a Canoe*, 1895 (Portland Museum of Art, Maine); *Three Men in a Canoe*, 1895 (collection of Mrs. Wellington Henderson); *Canoe on a Canadian Lake*, 1895 (private collection).

7. Though most of Homer's Canadian watercolors convey the tension of humanity fighting the natural elements, this is one of a few watercolors where the relationship appears to be a harmonious one.

8. Examples of such on-site sketches from Homer's Canadian trips are in the Cooper-Hewitt National Design Museum. This group of eighteen drawings on sketchbook and lined notebook pages depicts men fishing or canoeing in the lakes and rapids. Included is a preparatory study on the back of an envelope for the watercolor *Casting*, 1897 (Mead Art Museum, Amherst, Massachusetts).

9. See Cooke 1961, pp. 184–190, for a discussion of Homer's late watercolor style. I also wish to thank Konstanze Bachmann, National Design Museum paper conservator, for reviewing the technical working process of this watercolor with me.

10. Homer was particularly pleased with his Canadian watercolors, and he asked high prices for them—from $100 to $400. They were exhibited in 1895 at the St. Botolph's Club, Boston; in 1898 at M. Knoedler & Co., New York; and in 1899 at Doll & Richards, Boston. See Cooper, in Washington and New Haven 1986, pp. 206–207.

Daniel Huntington

New York 1816 — New York 1906
ANA 1839, NA 1840

DANIEL HUNTINGTON, best known as a painter of portraits and history paintings, was a central figure in the New York art world from 1850 until his death. His long presidency of the National Academy of Design (1863–1869; 1877–1890) attests not only to his administrative skills but also to the power and prestige he enjoyed. He also served as president of the Century Association (1879–1895) and vice-president of the Metropolitan Museum of Art (1871–1874; 1876–1903). In 1867, American art critic Henry T. Tuckerman wrote of him:

Few of our painters have exhibited greater versatility of talent or more broad and pure artistic sympathies. In other times and under different circumstances, Huntington would have become a religious painter, in which branch, by study and sentiment, he was specially fitted to excel; devoted to portraiture by the practical exigencies of his era and country, he has yet delineated scenery and executed genre pictures with eminent success.[1]

Huntington began his career at Hamilton College where he took lessons with portrait painter Charles Loring Elliot (1812–1868). By 1835, the young artist was in New York studying painting, first with Samuel F. B. Morse (1791–1872) and later with Henry Inman (1801–1846). In 1840, he departed on the first of several trips to Europe (1842–1845, 1852, 1853, 1857–1858,

1882–1883) in search of new subjects and stylistic approaches.

Soon after his return, Huntington painted *Mercy's Dream*, 1841 and *Christiana and Her Family Passing through the Valley of the Shadow of Death*, 1844 (both Pennsylvania Academy of the Fine Arts, Philadelphia), which were highly praised and brought him great success. The paintings reveal his very academic style and proclivity for moralizing themes which he inherited from his teacher, Samuel F. B. Morse. In addition to these subjects, a retrospective exhibition of Huntington's work in 1850 displayed history, genre, and landscape scenes. Indeed, by this time, his landscapes were popular, causing one critic to hail him as "second only to [Thomas] Cole," potentially "one of the greatest landscape painters."[2] During the 1850s, however, Huntington turned increasingly to portraiture, receiving most of his commissions from friends, family, and business associates.

While clearly specializing in portraits and the human figure—nearly 1,000 of his 1,200 total paintings are portraits—Huntington revealed in his drawings a dedication to landscape. Almost half of the Cooper-Hewitt National Design Museum's nearly 800 Huntington drawings (and many in the National Academy's 80 sketchbooks) depict landscape and nature studies. Yet surprisingly little scholarship has been devoted to these works, to how they were used, or even why Huntington made them.[3]

There are a greater number of landscape drawings than landscape paintings,[4] suggesting that the landscape drawings were made as ends in themselves and out of personal interest.[5] For Huntington, landscape drawing provided a stimulating alternative and a necessary escape from portraiture. Indeed, most of his landscape drawings were done for recreational pleasure. In 1858, a critic in the *Crayon* observed, Huntington's "landscapes seem to be more the pastime of leisure hours than of steady, laborious purpose."[6] Each summer from 1836 onwards, the artist left the city and retreated to favorite sites in upstate New York and New England.[7] In addition to these locales, many drawings are of mountains, lakes, and meadows he saw on his European travels.

Daniel Huntington's landscape drawings—both panoramas and detail studies—derive from direct observations of nature, carefully translated onto paper in a realistic manner. His drawings were readily inscribed with notes on color, light, and other descriptive information, including personal anecdotal data

that occurred as he executed them. His preferred medium for drawing was graphite, frequently used with either white chalk or white gouache for light or atmosphere. While he typically selected cream-colored, white, or tan paper as his drawing surface, gray-green or other pale-colored papers were occasional[ly] used to enhance such naturalistic qualities as rushing water.

Huntington's landscape drawings can only serve to confirm the assessment of a critic writing in the *Crayon* in 1858 who perceived that "Huntington was born a landscape painter, and it is to be regretted that the pictures he paints in this high department of Art are not more frequent."[8] EH

1. Tuckerman 1867, p. 21.

2. *New-York Daily Mirror*, July 18, 1840, p. 30.

3. Greenhouse 1987 is a comprehensive survey of Daniel Huntington's sketchbooks at the National Academy; it is unpublished and is on deposit at the Academy.

4. Although Huntington painted relatively few independent landscape paintings, it is significant that he included nature views and landscape details in many of his portraits and history paintings.

5. Greenhouse 1987, p. 1.

6. Quoted from New York 1980, p. 42. It is important to note that this comment refers to Huntington's landscape paintings, not his drawings.

7. In addition to those in the collections of the Cooper-Hewitt National Design Museum and the National Academy of Design, there are several Huntington sketchbooks which include drawings of New York and New England landscapes: one at the Metropolitan Museum of Art, New York, and three at the New-York Historical Society.

8. Quoted in New York 1980, p. 42.

44

Chocorua from Hill to Right of Albany Road, 1854

Graphite and white chalk on brown paper

11½ x 15¾ inches (292 x 400 mm)

Inscribed and dated in graphite, bottom left margin: *Chicorua* [sic] — *from hill to right of / Albany road Sep 12 54*; below: *wine & picnic[s?] with Hoyt*

Cooper-Hewitt National Design Museum, Smithsonian Institution

Bequest of Erskine Hewitt, 1942–50–222

Huntington frequently visited the White Mountains of New Hampshire between 1847 and 1892.[1] He is known to have stayed in the town of Jackson, where

Chicorua – from hill to right of Albany road. [Sept. 12. 54.]

44

he shared a studio with Samuel Colman (q.v.) and other Academy artists in the mid-1850s, as well as in the artistic community of North Conway (see no. 45). Although Thomas Cole (q.v.) had traveled to the White Mountains as early as 1827, referring to the mountainous region as "the Switzerland of the United States,"[2] the White Mountains did not truly receive widespread attention until mid-century, when the railroad could more quickly deliver both artist and tourist.

Huntington was particularly fascinated with Mount Chocorua. He executed at least forty views of the peak (now in the Cooper-Hewitt National Design Museum) over the four subsequent decades, sketching the mountain from various different vantages. He also painted the mountain and its lake sometime before 1861 (New-York Historical Society).[3] Although not identical in composition, this drawing may relate to that work.

In the drawing, Huntington seems to be chiefly interested in creating a scene of pastoral splendor. The broadly conceived topography, flattened and pushed close to the picture plane by means of an even line, conveys the sense of beauty that made Chocorua, and the White Mountains in general, such an attraction to landscape painters. Indeed, as Thomas Starr King wrote in 1860, "many of the most competent artists who have made faithful studies during summer vacations in New Hampshire, award superiority to Chocorua for picturesqueness."[4] Huntington's fidelity to visual data was tempered by classical notions of pictorial balance and other formal concerns which tend to give the drawings a self-consciously composed appearance. The rocks in the foreground of *Chocorua from Hill to Right of Albany, Road*, for instance, function more as framing devices than records of natural fact and provide containment to the broad vista.

As a reminder of the circumstances surrounding the making of the drawing, Huntington inscribed this sheet with mention of the "wine and picnic" he shared "with Hoyt," in addition to noting the location and date of execution. The identity of Hoyt is not sure. The name may refer to either the landscape painter Albert Gallatin Hoit (1809–1856), whose name is variously spelled, or, the portrait painter William B. Hoit (active ca. 1840–1876), whose name Huntington inscribed on another sketch.[5] Huntington would have known both men from White Mountain artist circles.

45

1. Greenhouse 1987, under 1986.15.36. The Cooper-Hewitt National Design Museum has approximately 150 sketches by Huntington of the White Mountain region.
2. Cole quoted in New York 1980, p. 32.
3. According to the entry in Koke et al. 1982, cat. no. 1376, pp. 185–187, this painting may be the same one exhibited at the National Academy in 1858, no. 61, as *Mill-Pond at Chocorua*.
4. King 1860, p. 12.
5. Huntington's drawing 1942–50–218 in the Cooper-Hewitt National Design Museum is inscribed with the name William B. Hoit.

45

Study of a Hemlock, North Conway, New Hampshire, 1855

Graphite on paper

14⅛ x 9¹⁵⁄₁₆ inches (352 x 253 mm)

Inscribed and dated in graphite, lower right: *trunk purplish grey / with some light grey & green moss - / & lighter brownish touches on / lights of bark; near view of trunk / not seen in sketch* [?] *below hill*; *ground. Hemlock on hillside / back of Mr. Willies / North Conway Aug 6 55*; *near view of leafage*

Cooper-Hewitt National Design Museum, Smithsonian Institution

Bequest of Erskine Hewitt, 1942–50–39

In this sheet, Huntington examined the hemlock tree and its parts with the scrutiny of a botanist. To further specificity, he enlarged details and added lengthy descriptive notes. He rendered light, color, and textural values through a combination of parallel, zigzag, and curving pencil strokes that convey the distinctiveness of sharp needles as well as the roughness of heavy bark. His highly accurate natural representation epitomizes Hudson River school practice, where direct observation of the details of nature was essential to understanding all the elements of landscape. Indeed, *Study of a Hemlock* illustrates perfectly the

advice given by Asher B. Durand (1796–1886), one of the leading exponents of the school, who advocated when drawing a tree:

observe particularly wherein it differs from those of other species; in the first place, the termination of its foliage . . . whether pointed or rounded, drooping or springing upward &c., &c.; next mark the character of its trunk and branches, the manner in which the latter shoot off from the parent stem, their direction, curves and angles. Every kind of tree has its traits of individuality.[1]

Huntington would have learned this practice from his teacher, Samuel F. B. Morse, who advocated the importance of such individualized studies.

Although Huntington executed other tree studies, none in the collection of the Cooper-Hewitt National Design Museum is so detailed as this drawing. The precise characterization and masterful handling seen here make this drawing one of the artist's most spectacular studies.

1. Durand 1855, p. 34.

46

Bash-Bish Falls, South Egremont, Massachusetts, 1859

Graphite and white chalk on gray paper

14¹¹/₁₆ x 10⁷/₁₆ inches (373 x 264 mm)

Inscribed and dated in graphite, lower right: *Bash-Bish /
July 18 59*

Cooper-Hewitt National Design Museum, Smithsonian
Institution

Bequest of Erskine Hewitt, 1942–50–202

46

Although the Cooper-Hewitt National Design Mu-
seum has no other Huntington drawings specifically
identified as Bash-Bish Falls, which is in the Berkshire
Mountains, a sketchbook drawing at the National
Academy indicates that the artist returned to the
vicinity in 1861.[1] Depictions of cascading waterfalls
were not new to Huntington, who sketched several
well-known waterfalls in Vermont as well as other ar-
eas of New Hampshire throughout his career.[2]

The idea to visit and record Bash-Bish Falls may
have come from Huntington's friend and colleague
John Frederick Kensett (1816–1872) who painted no
less than five views of the falls during the 1850s.[3] Un-
doubtedly, Huntington was curious to see the sheer
power and grandeur of the falls which were hidden
deep within a forest interior. Throughout the 1850s,
the site attracted other tourists, including landscape
artists Sanford R. Gifford (1823–1880) and Homer
Dodge Martin (1836–1897), whose 1859 painting cap-
tures the massive boulders and wild cascades that
made Bash-Bish Falls so popular.[4] And, as late as 1861,
Asher B. Durand also painted a dramatic view of the
falls (Century Association, New York).

Huntington's inclusion of four picnickers recasts
the scene from sublime wilderness to tamed outdoor
retreat, replete with genre detail. These tourists, who
may be the artist's friends or even family members,
find in nature a compatible recreational environment
for their leisurely refreshment and summer meal.
And, though Huntington's reverence for nature is ev-
idenced by the careful articulation of landscape fea-
tures, his habit of portraying man is also apparent.

4. Sanford R. Gifford made sketches during July 1854. Homer
Dodge Martin's painting of 1859 is now in the Albany Institute of
History & Art. See Pittsfield 1990, pp. 43–47, for a longer discussion
on the topic of Bash-Bish Falls.

1. Greenhouse 1987, under 1986.15.18.
2. In the Cooper-Hewitt National Design Museum's collection,
other Huntington drawings of waterfalls include Berlin Falls, New
Hampshire, in 1862 (1942–50–763) and Bolton Falls, Vermont, in
1864 (1942–50–766).
3. New York 1987a, p. 152; for instance, see Kensett's painting
Bash-Bish Falls of 1855 (National Academy of Design).

Charles Cromwell Ingham

Dublin 1796 — New York 1863
Founder NA 1826

CHARLES CROMWELL INGHAM began his formal art training at the Dublin Society's school and with William Cumming, a leading Dublin portrait painter. By 1815, he was producing and exhibiting history paintings and portraits, evidently with a certain amount of success. His precise reasons for leaving Ireland are not clear, but it is known that in 1816 he arrived in New York. The historian William Dunlap, writing in 1834, noted that Ingham had attracted attention from the moment he landed on these shores and "has continued to paint in this city, from the time of his arrival to this day, with constant employment and uniform improvement."[1]

Ingham was a member of and frequent exhibitor at the American Academy of the Fine Arts; but more significantly, he was a founding member of the National Academy of Design in 1825. In fact, he was among the most active early members of the National Academy, serving on the governing council beginning in 1827 and, for many years, as a member of the Committee of Arrangements which had the responsibility of hanging the annual exhibitions. Ingham was a consistent participant in these exhibitions, showing paintings at the Academy in every year but two between 1826 and 1863, the year of his death. The esteem in which he was held by his fellow Academicians is indicated by the fact that, in 1861, following the resignation of Asher B. Durand from the presidency of the Academy, the position was offered to Ingham. Due to age and infirmity, however, he declined the honor.

On a more personal level, Ingham was widely acknowledged for the generosity which he showed other artists. In 1837, for example, he actively solicited contributions for commissioning a portrait from Samuel F. B. Morse following Morse's failure to receive a major commission from the federal government. Later that same year, Ingham offered his own front parlor to Thomas Cole (q.v.) for an exhibition of his works, thereby affording the younger artist the opportunity to display the results of his talent to friends and interested parties.[2]

As is readily apparent from his exhibition record, Ingham's success in the United States was based almost solely on his talents as a portraitist. In fact, with Henry Inman, he was one of the most popular portrait artists of his day and had among his sitters the Marquis de Lafayette, Edwin Forrest, De Witt Clinton, and Catherine Sedgwick. He was well known for the high degree of finish and finely polished surfaces of his canvases, for which he was almost always praised by contemporary critics, at least in the earlier decades of his career. In 1826, for example, a writer for the *New-York Mirror* lauded his portrait of Lafayette, shown that year at the Academy's first annual exhibition, as "splendidly painted . . . with an attention to nature and a laborious finish, which may rival any production of the pencil." Two years later, Ingham's popular portrait of a young woman, romantically called *The White Plume*, was noted for its "glassy brightness," which, one writer believed, could be interpreted as "an expression of thought, a light of soul, that the pencil has seldom succeeded in mimicking so closely."[3] A number of other works also bear fanciful titles, for example, *The Flower Girl*, 1846 (Metropolitan Museum of Art, New York), which depicts a young woman carrying a basket overflowing with blossoms and a potted plant which she offers to the viewer. By including these props, Ingham overlaid the portrait with genre characteristics, thereby enlivening the figure, engaging his audience, and making the overall work more interesting.

This tendency also speaks of an interest in subject matter which transcends the boundaries of portraiture. As previously mentioned, Ingham had exhibited paintings in Ireland with subjects taken from history or literature, and he continued this practice, at least occasionally, after his arrival in this country. In 1816, for example, he showed *The Death of Cleopatra* at the American Academy of the Fine Arts, and in 1832 he showed *The Bard Singing "The Isles of Greece," before Haidee and Juan* at the National Academy. He is also known to have painted at least one still life (private collection, New York), and, in 1838, two paintings— *Youth Leaning on a Horse* and *Pic-Nic Party in Orange County, Fishkill*—which may have been genre scenes, were shown at the Stuyvesant Institute in New York.[4] During the 1830s, Ingham exhibited several landscapes at the National Academy, including a view of the Hudson River near Fishkill. In 1837, a work called simply *Landscape* was in the Academy's annual exhibition, and, two years later, the artist's best-known painting in this category, *Great Adirondack Pass, Painted on the Spot* (Adirondack Museum, Blue Mountain Lake, New York), was shown. Two other landscapes by Ingham, *Trap Dyke at Avalanche Lake*

and *View of the Indian Pass*, were engraved and published, probably in the 1840s or 50s, by Bufford's Lithography Company in New York.

Evidently, Ingham began painting landscapes only in the 1820s or early 1830s, almost certainly as a direct result of his affiliation with landscapists such as Thomas Cole and Asher B. Durand. But the pursuit was evidently difficult for Ingham, as he suggested in a letter he wrote to Cole in 1833:

I think it impossible to look at a landscape and paint it so as to be pleased with the picture, that is if the painter has any eyes. I have not been as industrious as you have. I have painted only half a picture (a landscape) and am not a bit better pleased with myself. I find it exceedingly difficult to get the colour of the distance. I sat at a window and painted the view before me, but have failed in giving colour. I have painted it like a miniature, every tree on the horizon, eight miles off, I have painted every house and bush, so that the picture will give pleasure to myself as a memorial or a map, but little pleasure to anybody else.[5]

Whatever Ingham's talents as a landscape painter might have been, they were not enough to give him, in any sense, a second career. And he probably could have used one by the 1850s when public taste was already quickly shifting away from portraiture to native landscape painting. The rise of photography, coupled with the dominance of the Hudson River school, was partly to blame for the change. Meanwhile, Ingham's health began to fail. By the early 1860s he was producing and exhibiting less consistently. He died at his home in New York at the end of 1863.　　DBD

1. Strickland 1913, p. 541; Dunlap 1834, 1, pp. 41–43, quote from p. 43.

2. Ingham to Cole, March 20, 1837, and July 10, 1837, Cole Papers (ACL-1).

3. *New-York Mirror* 3, June 3, 1826, p. 358, and 5, May 24, 1828, p. 366.

4. Cowdrey 1943, 1, p. 200; Rutledge 1945, p. 106; Yarnall and Gerdts 1986, 3, pp. 1871–1873. Examples of the lithographs are in the Print Room, New York Public Library.

5. Ingham to Cole, October 24, 1833, Cole Papers (ACL-1).

47
Sketchbook, 1820–1836 *

137 drawings on 79 leaves of paper (11 blank); 9 gouache and/or watercolor; 58 ink; 41 graphite; 6 graphite and ink; an autograph album bound in cardboard covers

Exhibited drawing: *Catskill Mountain House*

Graphite on paper

8 x 6½ inches (203 x 165 mm)

Inscribed, lower center: *sketched on the spot*

National Academy of Design

Gift of Gardiner Stewart, 1899 [1981.755]

Despite Ingham's primary occupation as a painter of portraits, this sketchbook is evidence that he was an artist with a wide range of interests. The book is signed and dated twice. The inscription "Charles C. Ingham's / Sketch Book / Portrait Painter New York / 1820" appears at one end of the book and "Charles C. Ingham's / Portrait Painter / Sketch Book / 1832" appears at the other. This would seem to imply that Ingham used the book at two different times in his career, first in 1820 and then turning it over in 1832 he began it again.

The 1820 section begins not with drawings but with a number of poems, copied from published sources, by writers such as Lord Byron and James Thomson. These are followed by a series of architectural drawings, most of which appear to be of a single building, a manor house in the Italianate or Gothic Revival style. Elevations, floor plans, and interior views, some enhanced with watercolor, are included, as are several drawings for devices meant to improve lighting and the circulation of air in the building. This series of architectural and engineering studies is interrupted only once, with a page of notations on pigments.

The 1832 section of the sketchbook contains drawings of a more varied nature. Several figure studies, evidently copied from other paintings, probably historical works, and at least one drawing based on a sculpture are here, as are about a dozen highly finished portrait drawings, some of which have been enhanced with watercolor and wash. Although the precise subjects of most of these cannot be identified, one is very close in composition to Ingham's painted portrait of Amelia Palmer, 1830 (Metropolitan Museum of Art, New York). Evidently, Ingham used this section of the sketchbook for keeping a visual record of his full-size, finished, painted portraits, that of Amelia Palmer being one.

47

More germane to the current exhibition are several landscape drawings which are part of the sketchbook. These include a view of Hoboken, "sketched on the spot," and one of Kaaterskill Falls. A third view, this one of the Catskill Mountain House, is illustrated here and, like the view of Hoboken, was sketched on the spot. With its magnificent Hudson River view, the Mountain House was the hotel of choice for visitors to the Catskill Mountains in New York State from the year of its opening in 1826 until the early 1900s.[1] It was located near Kaaterskill Falls and Kaaterskill Clove, favorite haunts of tourists as well as of the painters of the Hudson River school. The hotel itself is featured in paintings by Thomas Cole, Jasper Cropsey, and Sanford R. Gifford, among others.

Ingham's view is the traditional one: from or near the road which approached the hotel from below, looking up toward the building, which he frames against the mountain. In his drawing, Ingham only sketches in the vegetation and the shape of the mountain itself, while he gives his full attention to the architecture of the hotel, defining its whole as well as its parts—pediment, columns, windows—in finer detail. In front of the hotel, he places a tiny figure, standing in a typically romantic attitude, gazing toward the distant Hudson River, and presumably contemplating its beauty. Ingham appears to have been more confident in rendering the architecture than he was the landscape. The careful linearity of the drawing of the building is in keeping with the fine academic manner in which he painted portraits.

1. Van Zandt 1966.

Samuel Isham

New York 1855 — East Hampton, New York 1914
ANA 1900, NA 1906

ALTHOUGH HIS WORK as a painter was Samuel Isham's primary focus, he is remembered today for his significant contributions to the history of American art both as author and critic.[1] In 1905, he published *The History of American Painting*, a pioneering study of major and minor artists in a virtually uncharted field of scholarship. As an artist himself, Isham's authorship carried an implicit measure of credibility among readers, and his subjects were often his friends.

One of several children of Julia Burhans and William Bradley Isham, Samuel Isham was born to considerable wealth, his father having prospered as a financier and leather merchant. Educated at Phillips Academy in Andover, Massachusetts, and at Yale University, Isham first studied art at Yale in the drawing class of John Henry Niemeyer (1839–1932).[2] Niemeyer, whose family had come to the United States from Bremen, Germany, had spent four years at the Ecole des Beaux-Arts in Paris before assuming his post as drawing instructor at Yale. After the young Isham graduated in 1875, he went off to Paris to further his drawing studies with Louis de la Chevreuse, the former teacher of Niemeyer.

After three years of study and travel abroad, Isham returned to New York to pursue a law degree at Columbia University. Graduating in 1880, he joined the law firm of Lord, Day, and Lord. During the course of the next few years, he suffered partial deafness, a disability which certainly aggravated his gentle temperament and ultimately may have influenced his decision to give up the law. He then resumed his training as an artist and returned to Paris to enroll at the Académie Julian.[3] There Isham studied under two doctrinaire academic painters, Jules-Joseph Lefebvre and Gustave Boulanger. Along with this formal studio instruction working from the model, Isham must have been drawn to the countryside surrounding Paris. To vary his routine, he also made plein-air studies of scenery. Several drawings, apparently made during this second Paris trip, were given to the National Academy of Design and now form part of this exhibition. Isham's paintings did not go unnoticed in Paris. He exhibited three oil paintings, two portraits and a genre scene, in the Salons of 1888 and 1889.[4]

Back in the United States in 1887, now a professional artist, Isham took up quarters in the Sherwood Studio Building on West 57th Street, joining several other foreign-trained American artists there. He began exhibiting regularly in New York, both at the National Academy of Design and its rival organization, the Society of American Artists. Intermittently for the next twenty years, Isham contributed paintings — mostly portraits — to the Academy's annual exhibitions.[5] He was elected to the Society of American Artists in 1891, and later served as its treasurer from 1894 until 1906 (when it merged with the National Academy of Design). He also joined the New York Water Color Club in 1891, another venue to showcase his recent production.

Despite the frequent exhibition of his work in New York and in other cities around the United States, Isham never had many sales. According to Robert Bardin, the artist assigned such prohibitive prices to his paintings and watercolors, relative to those of more prominent contemporaries, that he may have priced himself out of the market. Isham's independent wealth released him of the need to earn a solid income from selling pictures.[6]

Accolades continued to come Isham's way right through the last decade of his life. He was elected to membership in the National Academy of Design in 1900, and for the next nine years he lectured at the Academy's Schools on the subject of "Art Schools of the Old World."[7] Yale awarded him an honorary degree in 1901, and, in 1904, he won a silver medal at the Universal Exposition in St. Louis.

Before writing his ambitious critical study of American art, Isham published an essay on Gustave Courbet in 1896 as part of John C. Van Dyke's *Modern French Masters* (London, 1896). He pronounced Courbet the most influential artist of modern painting, though he derided that artist's "lack of grace and dignity of subject." Isham continued to lecture and publish short essays in his final years, until a month before he died. His last critical work described Japanese wood-block prints, of which he had a sizable collection. Following his death, his sister Julia gave two hundred of these Japanese prints to the Metropolitan Museum of Art in her brother's memory. She also donated the paintings found in his studio — some thirty-five canvases — to various museums throughout the country.

The National Academy of Design has a collection of forty-one drawings and watercolors by Samuel

Isham acquired as a bequest from his estate. The subjects of these sketches run the gamut from strictly academic exercises—after plaster casts, *écorché* studies, and life drawings of male nudes—to plein-air nature studies of plants and trees. Many of the drawings were presented to the Academy in a portfolio having an interior label inscribed as follows: "Gift from the estate of / Samuel Isham N.A. / 26 Sketches / Work of Samuel Isham." The portfolio, which remains at the National Academy, also bears the printed commercial stamp of the Paris art supply shop where it was bought: "Leo Berville / Tableaux Couleurs fines / Encadrement." Many of the drawings loosely gathered in the portfolio are dated to the summer months of 1884. Given that Isham was in Europe at this time, studying in antique and life drawing classes at the Académie Julian and otherwise traveling on the Continent (one of the watercolors, dated May 23, is a view of Florence), it is likely that the entire collection of sheets found in the portfolio date from his second period of French study in the early 1880s. Indeed, five of the six landscape studies selected for this exhibition are dated 1884.

One might wonder how an artist who lived such a rich and exemplary life in the arts in New York as a painter, critic, lecturer, and administrator could have been so fully eclipsed, essentially forgotten in the course of time. One explanation lies in an assessment of his painted oeuvre. Isham's strict adherence to academic training, literal descriptions of his subjects, and an outmoded aesthetic were antithetical to the emerging modernist style.　　　　DA

1. The author is greatly indebted to Robert Bardin for his invaluable research on the elusive history of Samuel Isham. Without his willingness to share this documentation, it would have been virtually impossible to piece together Isham's chronology.

2. Niemeyer had been raised in Cincinnati and was employed as a sign painter in Indianapolis before moving to New York in 1860, Bardin 1985, p. 2.

3. The Académie Julian was founded in 1868 by Rodolphe Julian. Though the training was rigorous, the curriculum was more democratic than that of the Ecole des Beaux-Arts. The Académie Julian required no entrance exams and welcomed foreign students, many of whom were American. By 1885, it was the largest art school in Paris.

4. Bardin 1985, p. 3.

5. For Isham's submissions to annual exhibitions at the National Academy of Design, see Naylor 1973, 1, pp. 488–489.

6. Bardin 1985, p. 5. When Isham's father William Bradley Isham died in 1909, he left close to a million dollars to each of his three sons and two daughters.

7. Until the 1990s, the National Academy of Design required newly elected members to give a portrait likeness of themselves to the organization on election. This could be a self-portrait or a self-image by another artist. Isham's submission was painted by his fellow Academician and friend Kenyon Cox. Reciprocally, Cox invited Isham to paint his so-called diploma piece, now in the Academy.

48
Gnarled Tree, 1884

Graphite on paper

9¹⁄₁₆ x 5⁹⁄₁₆ inches (230 x 142 mm)

Initialed and dated in graphite, lower right: *Mch 1ˢᵗ 84 / S I*; inscribed in graphite on verso, lower left: *Gift from the Estate of Samuel Isham N. A.*

National Academy of Design

Gift from the Estate of Samuel Isham [1981.47]

Isham drew this rather grotesque tree in the late winter of 1884 on one of his sketching excursions outside Paris. The artist must have been attracted to the trunk's massing of round heads as well as its protrusions and cavities, the result of a pruning process know as pollarding. Pollarding, more common in Europe than in North America, is the practice of cutting back the tops of young trees, thus allowing branches to grow only from the apexes of the shortened trunks.

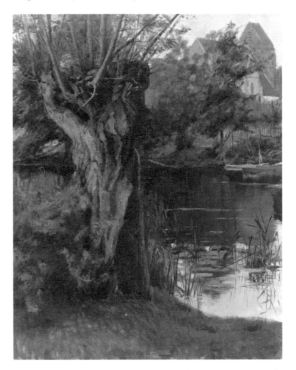

Fig. 13. Isham, Landscape in France, *oil on canvas, National Academy of Design, 1985–59*

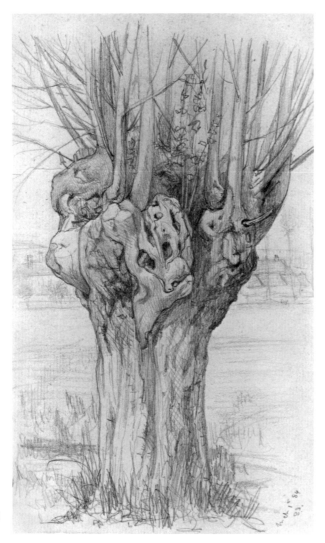

48

The National Academy of Design has a landscape in oil by Samuel Isham which bears an old, pollarded tree very similar to the one delineated here (fig. 13). Though the painting is undated, its stretcher has the stamp of a Paris supplier, and its similarity to several landscape drawings in the National Academy collection suggests that the painting also dates from Isham's second period of study in France. His usual preference for figure painting over landscape gives us another reason to believe that this anomalous landscape was painted in France around the time he was sketching en plein air.

49
Late Winter Landscape, 1884

Charcoal on paper

15½ x 21⅛ inches (394 x 536 mm)

Initialed and dated in graphite, lower left: *S I / Mch 2 84*; inscribed in graphite on verso, lower left: *Gift from the estate of / Samuel Isham N. A.*

National Academy of Design

Gift from the Estate of Samuel Isham [1981.79]

Though differing in media and overall composition, this dark charcoal drawing has much in common with the previous sheet. In fact, it was sketched a day later. Isham has broadened his view, now rendering several pollarded trees in an otherwise barren landscape. Only the cultivated pathway which divides the gently ascending hill hints at a human presence. The obelisk-like tree in the foreground again foretells the symbolist imagery of Odilon Redon, its shouts of small, naked branches strangely similar to Redon's charcoal drawing *Cactus Man* in the Woodner Family Collection.[1] The strong graphic presence of this stark landscape also calls to mind the early charcoal studies of Vincent van Gogh, whose work Isham may have known. If pollarding trees was a measure of rejuvenation, the pruned examples in this drawing leave a contrary impression of decay.

1. For a reproduction of *Cactus Man*, see Washington 1988.

Trees pruned as such are often found on cultivated land alongside a river. The harvested branches are then used to make baskets to transport the crops.

Pollarded trees—generally oak, beech, linden, or willow—produce quite bizarre specimens, as evidenced by this sketched example. Pruning trees is, of course, a restorative process. Cutting back a tree's branches, in a sense, restores its youth. Many pollarded trees live for centuries, often with hollow trunks. Through tightly drawn, shaded lines, Isham has taken great pains to precisely render the contours and recesses of the trunk's permutations in the present sheet. The tree's globular protrusions have an anthropomorphic quality suggesting human skulls, an analogy which calls to mind the later symbolist head studies in charcoal of Odilon Redon.

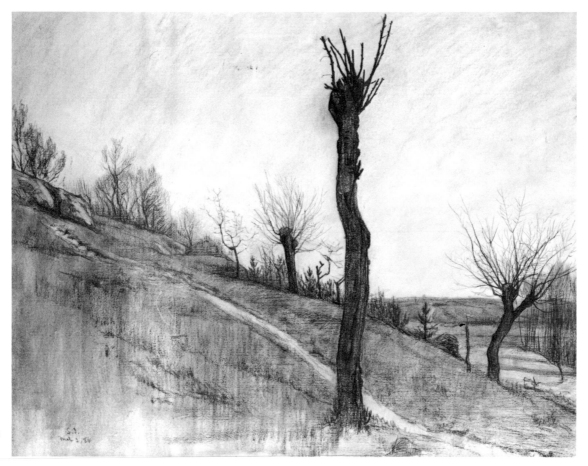

49

50
Tree Study, 1884

Graphite on gray paper

21⅜ x 17½ inches (543 x 438 mm)

Dated in graphite, lower right center: *July 12, 84*; inscribed in graphite, lower left: *Gift from estate of / Samuel Isham N. A.*

National Academy of Design

Gift from the Estate of Samuel Isham [1981.52]

This precisely drawn study of a tree, silhouetted on gray paper, is instructive for its lack of finish. Isham has detailed certain areas to completion, leaving others unresolved. The dense mass of veiny branches at the upper left contrasts markedly with the softly shaded foliage at the center. The tree becomes a metaphor for growth and regeneration, its spindly outer branches replaced by fresh leafage. The absence of the artist's customary initials implies his own recognition of its unfinished state. For Isham, this nature study was simply an exercise in rendering the complex configuration of limbs and branches afforded by this graceful old tree.

51
A Thicket of Trees in Foliage, 1884

Graphite on tan paper

15½ x 21 1/16 inches (393 x 535 mm)

Initialed and dated in graphite, lower left: *Aug 2. '84 / S I*; inscribed in graphite on verso, lower left: *Gift from estate of / Samuel Isham N. A.*

National Academy of Design

Gift from the Estate of Samuel Isham [1981.57]

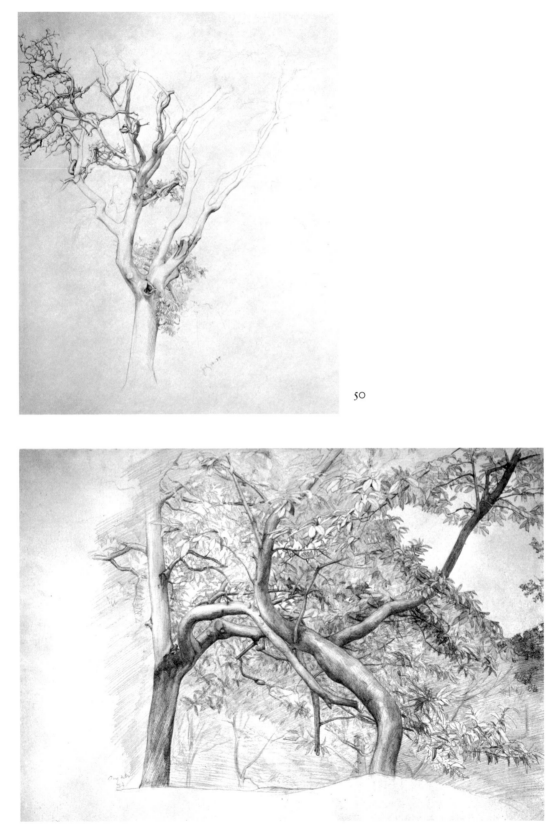

50

51

Drawn just several weeks after the previous un-finished study of a single tree, this drawing describes a thicket of trees in late summer. Here Isham has pre-cisely individualized two interlocking aged trees, their broken limbs a reminder of nature's own prun-ing cycle. Elsewhere in this densely foliated land-scape, trees are only suggested by a broad shading of diagonal and horizontal lines surrounding the central configuration of boughs. The drawing is as much a sketch of spatial masses and voids as it is a study of in-dividualized trees against an abstraction of thicket fo-liage. The heavy massing of leaves is interrupted at the upper right where parting branches separate to al-low the sun to penetrate. Isham has cleverly crafted this airy void, creating a counterpoint to the dense tree growth at the lower left. This is surely another ex-ample of Isham's plein-air draftsmanship, this time a very carefully worked exploration of the intermin-gling of old leafy trees in a thicket, probably discov-ered one warm summer afternoon.

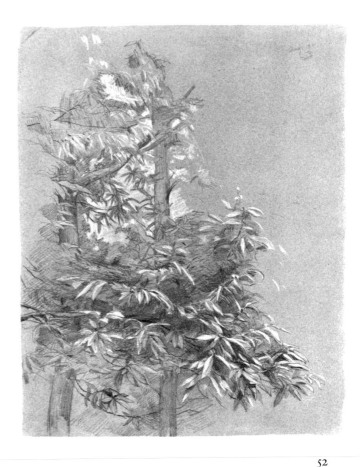

52

52
Trees in Foliage, 1884

Graphite and white chalk on blue paper

17⅞ x 14½ inches (454 x 369 mm)

Initialed and dated in graphite, upper right: *Aug. 11, 8[4?] / SI* in a circle; inscribed in graphite on verso, lower left: *Gift from estate of / Samuel Isham N. A.*

National Academy of Design

Gift from the Estate of Samuel Isham [1981.51]

Although this drawing's inscribed date is not fully legible, assigning it to Isham's production in the sum-mer of 1884 seems reasonable. The previous drawing, dated August 2, 1884, is similar in many ways. The present sheet is a rather graceful study of a bank of finely sketched, leafy trees in which Isham has also used his customary hatching of diagonal lines and broad shading to suggest an impenetrable massing of branches and foliage beyond. Here he has introduced white chalk, both to give form to the foliage in the near ground and to suggest recessive space. It is clear from this drawing that he has first delineated the leafy bowers in graphite and then overlaid white chalk to flesh out the forms. In the upper areas of the sheet, chalk is omitted from the leaves and used instead to suggest the distant view. The chalk shading in the dis-tance, all the more arresting for its application on col-ored paper, gives the impression of an open sky be-yond the forest. Isham has experimented with differ-ent drawing media in this sketch to present an elegant massing of light airy leaves and a visual counter-point—the deep forest and infinite sky.

53
Landscape Sketches

Graphite on folded, blue-gray paper. On verso, graphite, watercolor and gouache

Folded sheet 19 x 12⅜ inches (483 x 314 mm)

National Academy of Design

Gift from the Estate of Samuel Isham [1981.49]

This is the only unsigned, undated drawing by Isham in the present exhibition. Given its cast—several quick exercises in structuring a landscape composi-

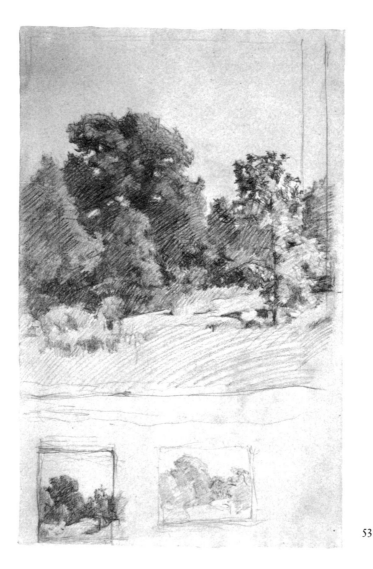

53

tion—it is probable that the sheet was sketched in the studio from memory. Thus Isham felt no compunction to note the date of execution. He likely dated those drawings sketched in the countryside in order to later remember his itinerary—the drawings serving as a visual diary of his travels.

The recto of this folded sheet has three landscape studies: a full-size, central image of trees in a meadow and, below, two vignette sketches of the same landscape. Making broad diagonal lines of graphite in varying tonalities, Isham used his pencil to develop a landscape composition. The sheet gives the impression of rapid execution as the artist shifted from one scale to the next. Along with this tonal investigation, Isham was testing the perimeters of his composition. In the vignette at the lower left and the larger sketch

above, he has worked out the horizontal expanse of trees and shrubs. In both, the foliage reaches beyond the vertical dimension established by the artist's pencil. These sketches are clearly exercises in structuring a composition, probably preliminary to a painted landscape.

The verso of this folded sheet bears a small sketch in graphite, watercolor, and gouache. Isham has rapidly shaded in the coniferous trees in graphite and then overlaid, in the near ground, several tall foxgloves, first outlined in graphite and then delicately colored in watercolor and gouache. Even the perimeters of this small, unfinished verso sketch suggest a rectangular composition, another indication of Isham's structuring impulse in the four studies on this blue-gray folded sheet.

Thomas Moran

Bolton, Lancashire 1837 — Santa Barbara 1926
ANA 1881, NA 1884

MANY OF THOMAS MORAN's landscapes played a significant role in documenting and promoting the exploration of the American West in the late nineteenth century. From an early career as an illustrator and watercolorist, he would become celebrated for his remarkable views of the West's most spectacular wilderness areas.

Moran, who was born in an urban industrialized part of England, emigrated at age seven with his family to the United States. During his years growing up in Philadelphia, the young artist's talents were encouraged, as were those of his artistically inclined three brothers. In 1853, Moran became an apprentice in the wood-engraving firm of Scattergood and Telfer. The demanding and precise technique required for wood engraving helped him develop his abilities for careful observation and detailed rendering. This training launched Moran on a career from which he could earn a modest living by supplying drawings and watercolors for illustrations. He later shared a studio with his elder brother, Edward (1829–1901), who taught him the rudiments of painting. Both budding artists were encouraged by the Irish-born Philadelphia artist James Hamilton (1819–1878), who advised them to follow the artistic example of J. M. W. Turner.

During this time, Moran was regularly sketching in the countryside around Philadelphia. In the summer of 1860, he made his first trip to a remote wilderness—the "Pictured Rocks" of Lake Superior, a natural sight that exceeded his expectations.

In 1861, Moran, with Edward, traveled to England in order to directly study Turner's paintings (which they had only previously known through a few watercolors and *Liber Studiorum* prints). They also visited various picturesque places in England and Scotland. After returning to Philadelphia from another trip to England in 1862, Moran married Mary Nimmo (1842–1899), who later became an accomplished etcher. Together, they made the grand tour of Europe, visiting England, France, and Italy, in 1866 and 1867. By 1870, Moran was pursuing a comfortable career as a landscape painter, supplementing his income by teaching and accepting occasional commissions for book or magazine illustrations in order to support his wife and growing family (Paul Nimmo, born 1864; Mary Scott, born 1867 or 1868; and Ruth Bedford, born 1870). After 1872, they lived in or near New York; in 1884, they established their summer home and studio in East Hampton, Long Island. Long Island's placid marsh and coastal scenery inspired Moran to create numerous paintings, drawings, watercolors, and etchings (which he had taken up in 1878).

In 1870 Moran received a commission which drastically influenced the future direction of his career. Even though he had never been west of Michigan, *Scribner's Monthly* asked him to provide illustrations (based on crude expedition sketches) for two articles by Nathaniel P. Langford, "The Wonders of the Yellowstone."[1] This assignment so aroused his interest that in the summer of 1871, at age thirty-four, Moran financed his own way west to join Ferdinand V. Hayden's U.S. Geological Survey of Yellowstone as expedition artist. It is a tribute to his adventurous spirit and resilience that, in spite of his greenhorn inexperience in handling the hardships of overland travel in uncharted terrain and the rigors of camp life, he would become one of the most successful artist-explorers. During that summer, Moran made abundant field studies and watercolors of "Yellowstone's wonders." As his daughter Ruth would later recount: "To him it was all grandeur, beauty, color and light—nothing of man at all, but nature, virgin, unspoiled and lovely. In the Yellowstone country he found fairylike color and form that his dreams could not rival."[2] Hayden used Moran's pictures to provide congressmen with their first glimpse of the Yellowstone region. Its scenery further inspired the artist to make his first great painting, *The Grand Canyon of the Yellowstone* (1872), which catapulted him to national prominence shortly after it was purchased by the United States government and unveiled when Congress designated Yellowstone the first national park. Yellowstone's landscape furnished Moran with a busy two years' worth of more commissions. He exhibited a group of finished watercolors—not his field sketches—of Yellowstone subjects at Goupil's Gallery in New York in the fall of 1872. Moran became so associated with Yellowstone images that he acquired the nickname T. Yellowstone Moran. He even incorporated a Y with his initials *TM* as his monogram signature.[3]

Between 1872 and 1892, Moran made seven more major trips west, two with government expeditions:

California (1872); Colorado River canyons in Utah and Arizona, culminating at the Grand Canyon (1873); Rocky Mountains, Colorado, to seek out the Mountain of the Holy Cross (1874); Donner Pass and Lake Tahoe, Nevada, Utah, Idaho, and the Tetons (1879); Colorado and New Mexico (1881); returning from Cuba and Mexico through the states (1883); and a grand tour that included the Grand Canyon and Arizona, the Rocky Mountains in Colorado, Wyoming, and his second and final visit to Yellowstone (1892). These two decades were the artist's most prolific period, and each trip generated portfolios filled with sketches, which, in turn, triggered a flurry of studio activity. Moran's major paintings, *Chasm of the Colorado* (1873–1874), also purchased by Congress, and *Mountain of the Holy Cross* (1875), which received a gold medal at the 1876 Centennial Exposition, assured him a place as the primary western landscape artist just when national interest in the American West was at its most intense. His drawings and watercolors are vivid documents from a nationalistic episode of frontier exploration, but they are also praiseworthy works of art. His contribution to this chapter in America's history was commemorated by two natural landmarks bearing his name: Mount Moran, of the Teton Range, and Moran Point in the Grand Canyon. With all this national attention, it is a bit surprising that Moran was not elected a member of the National Academy until 1881.[4]

Apart from his treks west, Moran also traveled elsewhere, and new sights always generated a cache of sketches. In 1881 he received commissions which prompted a visit to Niagara Falls, as well as a ride along the Baltimore and Ohio Railroad's eastern route through Virginia, West Virginia, and Ohio, to Chicago. He then continued on to Denver and the Rockies (see no. 60). In 1882 Moran and his family sailed for England, where he revisited Bolton, his birthplace. A local gallery there honored him with an exhibition of a hundred watercolors and twenty-two oils. During his stay in London, he met John Ruskin, an early champion of Turner's art and one of Britain's chief theorists on art and nature. In 1886, Moran sold a number of paintings to fund his first trip to Venice, where he created Turneresque views. Whenever the artist was not traveling, he spent his summers in East Hampton contentedly pursuing artistic activity amidst family and artist friends. In 1892, following his extended summer trip through the Southwest, Colorado, and Wyoming, he had a large retrospective exhibition at the Denver Art League. After 1892, Moran remained active as an artist and traveler, often using his railroad contacts to obtain free passage west. After the death of his wife in 1899, he went on frequent prolonged journeys accompanied by his daughter Ruth. Between 1901 and 1910, they regularly visited the Grand Canyon, which now had hotel comfort, unlike the rugged camping the artist had endured on his first visit. He began to spend winters in California. In 1916 he moved to Santa Barbara, where he spent the last decade of his life, apart from occasional summers back in East Hampton.

In 1917 the artist gave eighty-three drawings and watercolors (along with a few prints) to the founders of the Cooper Union Museum so that they would be available for students to study. This important body of work reveals Moran's brilliant color sense, his ability to faithfully grasp nature's power, and his masterful technical handling—whether forceful or delicate, whatever was appropriate to the subject. Motivated by a deep love of beautiful scenery, Moran also knew how to be enterprising in creating landscapes that would please others. MS

1. Clark 1980, pp. 11–12.

2. Ibid., p. 21

3. Ibid., p. 20

4. He first exhibited at the National Academy in 1866, then in 1872 and 1875. From 1877 to 1900, he annually submitted paintings to its exhibitions. After 1873, he also regularly exhibited at the annual exhibitions of the American Water Color Society, where he was also a member.

54
Half Dome, Yosemite, 1872

Black ink wash over graphite on tan paper

7½ x 5¼ inches (191 x 133 mm)

Signed in black ink, lower right: *TYMORAN.* [TYM configured as the artist's monogram]; inscribed and dated in black ink, from lower left to lower center: *South Dome Yosemite. 1872.* *(16)*

Cooper-Hewitt National Design Museum, Smithsonian Institution

Gift of Thomas Moran, 1917–17–15

Is there something else there?

55
Half Dome, Yosemite, 1873

Watercolor, white gouache over graphite on blue-gray paper

14½ x 10⅜ inches (369 x 265 mm)

Signed and inscribed in graphite and dated in black ink, lower right: *South Dome T. Moran. 1873*; initialed (with monogram) and dated in black ink, location in graphite, lower left: *TYM. 1873 Yosemite.*

Cooper Union stamp 1, lower right.

Cooper-Hewitt National Design Museum, Smithsonian Institution

Gift of Thomas Moran, 1917–17–32

In late August 1872, just over a year after Moran's first western journey to Yellowstone, the artist and his wife set out by train for Yosemite, which had been designated a California state recreation area in 1864. Prior to seeing this scenic mountainous region, Moran had been commissioned to illustrate an article by Isaac H. Bromley, "The Wonders of the West— I: The Big Trees and the Yosemite." The resulting wood engravings, based on other sources, appeared in the January 1872 issue of *Scribner's Monthly.*[1] It was another commission—to illustrate "The Plains and the Sierras," an article by E. L. Burlingame for *Picturesque America*—that actually prompted Moran's California trip.[2] Compared to his rapturous response to Yellowstone's spectacular natural wonders, Moran found Yosemite to be a less exciting wilderness, apart from the stately grandeur of the monolithic Half Dome (called South Dome by Moran) depicted in these two views.

Moran rapidly brushed the small wash drawing on site from the valley floor (no. 54). Beneath the gray washes of this field study, one can see touches of graphite in the contour of the dome, as well as the scribbled zigzag lines (indicating serrated silhouettes of evergreen trees) at the left. The artist manipulated the ink wash so it ranged from jet black (for the "curtain" of unruly trees and the singly stroked shadowy underside of the boulder in the right foreground) to the silvery mountain backdrop. The unpainted portions of the paper provide sunlit and cloud accents. Like Japanese calligraphy, which is deliberately placed but appears utterly spontaneous, Moran's calculated applications of grisaille wash distill the scene's freshness into an unlabored composition of rock and tree forms.

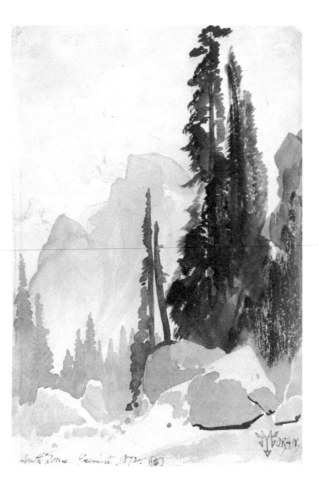

54

Ck Cotman Japanese Friedrich

The dazzling more finished watercolor of the dome (no. 55), a view from the rim of Glacier Point, was executed later in the artist's studio. This sweeping vista features the colossal granite peak looming between boulders and trees in the foreground and a distant snowcapped mountain range. Clearly evident here is Moran's mastery of the nuances possible in the watercolor medium, especially in the shadowy areas veiled in blue. The great art of J. M. W. Turner had influenced Moran's early studies in watercolor, and, by this time, Moran could achieve picturesque landscapes composed of luminous tints that rivaled Turner's. The edges of the image, where general outlines in graphite are visible, are left unpainted so that Yosemite's most distinctive monument commands the viewer's gaze. In 1887 Moran made an etching of this same view as an illustration for the publication *Picturesque California*.3

While Yellowstone and Grand Canyon scenery inspired Moran to create vast quantities of drawings and watercolors, and later paintings, Yosemite did not.4 Perhaps one reason for his lack of enthusiasm was the fact that unlike Yellowstone and the Grand Canyon, Yosemite had been much photographed and depicted by others before he got there.5 Yet Moran lavished enough artistic care on these two pictures of Yosemite to place them among his best works on paper.

1. See Clark 1980, p. 49.
2. See Kinsey 1992, p. 130.
3. See Storrs 1985, pp. 47–48, no. 16. An impression of this etching can be found in the Cooper-Hewitt National Design Museum (1949–102–2).
4. Clark 1980, pp. 135–136, cites only six Yosemite watercolors, including the one discussed here. There are five other drawings of Yosemite subjects in the Museum's collection.
5. E. J. Muybridge, C. E. Watkins, and C. L. Weed made photographs of Yosemite in the mid-to-late 1860s. The painter Albert Bierstadt (1830–1902) had made his first trip to Yosemite in 1863.

56
The Canyon of the Virgin River, South Utah, 1873

Watercolor over graphite on paper

3¹⁵/₁₆ x 9¹/₁₆ inches (100 x 231 mm)

Initialed in graphite, lower left: *TM*. On verso, indecipherable studies in graphite.

Cooper Union stamp 1, lower right.

Cooper-Hewitt National Design Museum, Smithsonian Institution

Gift of Thomas Moran, 1917–17–27

57
The Canyon of the Virgin River, South Utah, 1873

Graphite on gray paper

10¾ x 15 inches (273 x 382 mm)

Inscribed, initialed, and dated in graphite, lower left: *Rio Virgen Canon* [sic] / *T. M. 1873*; lower right: *Spanish Bayonet / young oak / cactus / Large Cottonwoods in Valley*; color and other descriptive notes throughout. On verso, vague landscape study in graphite.

Cooper Union stamp 1, lower right.

Cooper-Hewitt National Design Museum, Smithsonian Institution

Gift of Thomas Moran, 1917–17–22

After painting Yellowstone scenes almost exclusively for two years, Moran yearned to see different western scenery, particularly the Grand Canyon. In the summer of 1873 he accepted an invitation to serve as the expedition artist for Major John Wesley Powell's survey of the Colorado River canyons through Utah and Arizona. Although photographer Jack Hillers was also on the survey team, photographs could not capture the extraordinary colors of the terrain. Powell knew that the technical difficulties in making photographic negatives could not compete with the ease of portability and execution afforded an artist armed with pencil, watercolor paints, and paper. An artist like Moran could sketch whenever the mood struck, and he did not necessarily need the full light of day, as was required for photographic exposures.

In early July 1873, after a journey via the Union Pacific Railroad, Moran arranged to meet Powell in

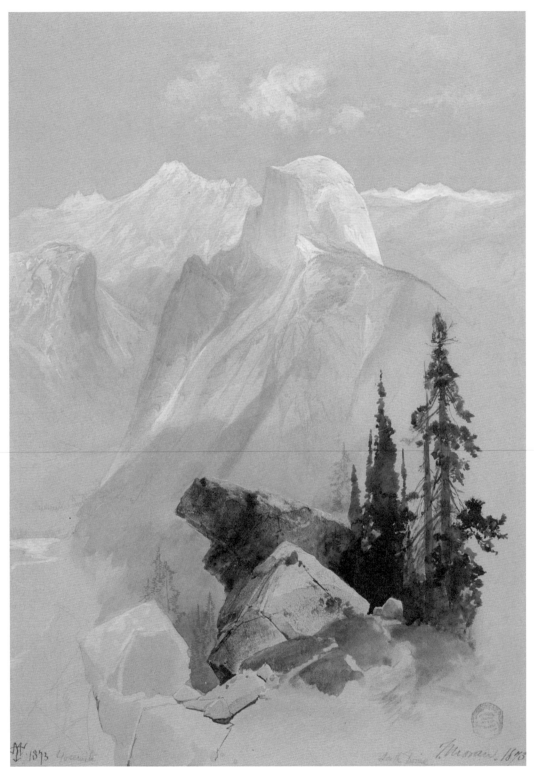

55 1873 Yosemite

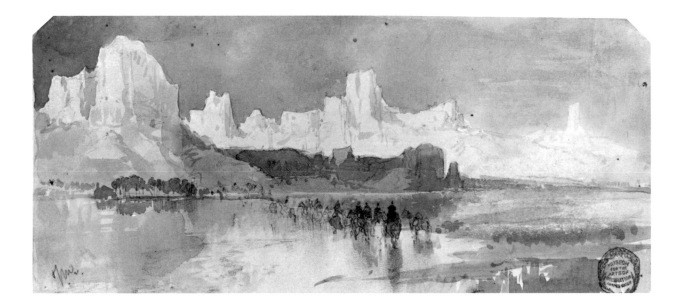

56

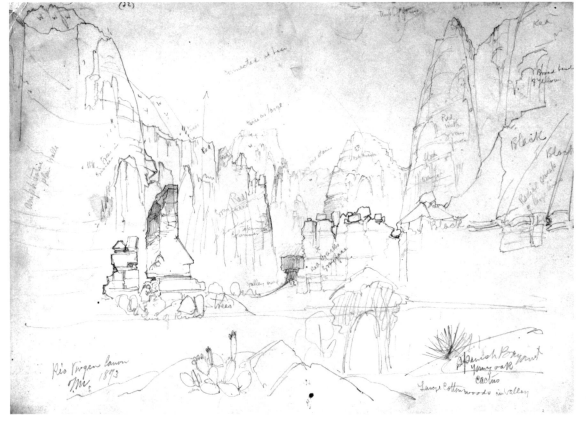

57

Salt Lake City.[1] Moran's traveling companion was J. E. Colburn, a *New York Times* writer commissioned to do a chapter on the Grand Canyon for *Picturesque America*.[2] Heading south toward the Grand Canyon, the group left Salt Lake City via train for the first thirty miles, then made their way via stagecoach, wagon, and eventually horseback.[3] By late July–early August, they were surrounded by the dramatic cliffs of the Virgin River (called Rio Virgen by Moran), much of which is now part of Zion National Park.

Moran was enthralled with this desert landscape. As he later wrote:

southern Utah is where Nature reveals herself in all her tumultuous and awe-inspiring grandeur. . . . There is a canon off the Rio Virgen known in the local Indian vernacular as Mu-Koun-Tu-Weap, that for glory of scenery and stupendous scenic effects cannot be surpassed. Its cliffs rise up in rugged massiveness for 5000 feet, with some of the most peculiar formations believable toward the top. It is a marvelous piece of nature's handiwork that is worth going a long distance to see.[4]

The small oblong watercolor (no. 56) shows an almost spectral group of horsemen crossing a mirage-like shallow river to approach the canyon entrance and buttes, which gleam like exalted temples. Moran used the white of the unpainted paper to highlight the sunstruck cliffs which blaze between an azure sky and gray-lavender shadows. In spite of the small format, Moran's chromatic study conveys the monumentality of the Virgin River's towering geologic formations.

The drawing of the canyon (no. 57) is typical of Moran's on-site method of using pencil to outline the chief features of the terrain and to augment his visual record with numerous notations referring to color and descriptive identifications, for example (at left) *"amphteatre* [sic] */ plain walls"*; (lower center) *"line of River / trees"*; (center) *"red cracks / gray face"*; (right) *"radial sweep / of large lines"* and *"Black Black"* and *"Broad band / of yellow"* and *"Red / with gray face"*; (above, in the sky) *"connected at base" "Temple of Janus"* and *"Cleopatra's Needle."* On the peaks at the upper left are scattered *w*'s and *y*'s as shorthand references to color.

Never intended for public display, this drawing was made to note the glorious natural scenery Moran had beheld so that he could better recall it back in his studio. While today's viewer can never interpret the drawing as Moran did, it is an important document, providing some insight into how he observed and recorded nature. Compared to Church's meticulous

precision in his field study *Valley of the Yemen* (no. 18), Moran's drawing is looser, sketchier, indeed, even messier in parts. These characteristics suggest that Moran felt some frantic urgency as he set down as many details as he could of the vast panorama before his party moved on. These drawings, along with those he made of the Grand Canyon later in the 1873 trip, became part of the artist's repertoire of western scenery that would later prompt paintings or illustrations for survey reports and publications.

1. See Lindstrom 1984 for more details regarding Moran's experience in Utah. Moran also planned to use the trip to make sketches that he could fashion into illustrations for various periodicals, such as the *Aldine* (ibid., p. 2).
2. Clark 1980, p. 51, and Kinsey 1992, p. 104.
3. In a letter (dated July 17, 1873) to his wife Mary Nimmo Moran, the artist wrote from near Nephi, Utah: " We came to this point by private team. We are just 160 [80] miles south of Salt Lake City. We leave here tomorrow morning and shall make a bee line for the Grand Can[y]on which we shall reach in 5 days [actually not until mid-August]. . . . We go the rest of the distance [about 350 miles] on horseback, and Powell has the animals all ready It is an awful country that we have been traveling over and I cannot conceive how human beings can stand to live in it." (Letter published in Bassford/ Fryxell 1967, pp. 31–33.)
5. From *Salt Lake Tribune*, June 9, 1900, as quoted in Lindstrom 1984, p. 5.

58

View from Powell's Plateau, 1873*

Watercolor, white gouache over graphite on tan paper

7⁷⁄16 x 10¹¹⁄16 inches (190 x 271 mm)

Signed and dated in graphite, lower left: *T. Moran. / 1873.*

Cooper Union stamp 1, lower right.

Cooper-Hewitt National Design Museum, Smithsonian Institution

Gift of Thomas Moran, 1917–17–26

Powell's Plateau, named for explorer and geologist John Wesley Powell, offered one of the most glorious scenic outlooks of the Grand Canyon. Experiencing this view in the presence of Powell himself, who probably also provided knowledgeable commentary, was the highlight of Moran's trip.[1] While they were there, they also experienced the drama of an approaching thunderstorm, shown in the upper left of this watercolor.

Although written accounts of the Grand Canyon existed for centuries, the first American pictures by the Pacific Railroad surveys appeared in the early

1850s. Powell was well aware of the impact Moran's artistic documentation of Hayden's Yellowstone expedition had had on Congress—Hayden received increased federal funding for subsequent surveys. Powell had asked Moran to accompany his 1872 survey, but the artist had declined, only to eagerly accept his invitation in 1873. By this time, Moran was intensely curious to see the Grand Canyon, and he had lined up scores of commissions for pictures based on Grand Canyon subjects. Since his painting *The Grand Canyon of the Yellowstone* (1872) had been such a critical triumph and financial success, he planned to create an equally impressive companion piece.[2]

View from Powell's Plateau served as one of the more important field studies for Moran's great oil painting *The Chasm of the Colorado*, 1873–1874 (National Museum of American Art, Smithsonian Institution, Washington, lent by the Department of the Interior). In the watercolor, Moran showed a rocky ledge in the foreground, rendered in rich browns and sandy ochers. Beyond the rim is a spectacular vista extending for miles of sculpted canyons flanking the narrow gorge, cut by the meandering sliver of the far away Colorado River. While the irregular landscape, with its vertiginous cliffs in varying terra-cotta colors, fills most of the sheet, there is a strip of sky at the top. The hint of falling rain in the distance suggests the sweeping torrents that, over the ages, carved the colossal canyon. To represent the almost overwhelming panorama—with its myriad earthen tonalities and configurations of landform edges and strata—was a daunting challenge to Moran. This watercolor succeeded in capturing the Grand Canyon's brutal beauty and served as a vivid visual source that helped Moran bring this awesome scenery to the world's attention.

1. Moran probably saw this view of the Grand Canyon between August 14 and August 22. See Lindstrom 1984, p. 6, which cites Moran's August 13, 1873, letter to his wife saying that they departed the following morning for Powell's Plateau. Also see Kinsey 1992, p. 106, regarding Moran's Powell's Plateau excursion, and Chapter 6 for information on Powell and his surveys, including the 1873 expedition with Moran. Powell, a one-armed Civil War veteran, who had been exploring the Colorado River region since 1867, would later, after 1879, head the United States Geological Survey and become director of the American Bureau of Ethnology. His intellectual, philosophical, and practical expertise in geology, geography, hydrology, and ethnology greatly contributed to American understanding of the southwestern landscape and its native inhabitants.

2. Kinsey 1992, p. 95, and Washington 1991, p. 251.

59
Green River, Wyoming Territory, 1879

Watercolor and white gouache over graphite on tan paper

12⅝ x 19⅜ inches (320 x 494 mm)

Inscribed and dated in graphite, lower left: *Green River. Wyoming / 1879*; at right center: *salmon.*

Cooper Union stamp 1, lower left.

Cooper-Hewitt National Design Museum, Smithsonian Institution

Gift of Thomas Moran, 1917–17–39

Moran's first glimpse of the castellated buttes along the Green River was in June 1871, when he disembarked from the Union Pacific train at this Wyoming stop located on the Oregon Trail. Since he had never encountered scenery like this before, he marked the occasion with a watercolor inscribed "First Sketch Made in the West at Green River, Wyoming 1871" (Thomas Gilcrease Institute of American History and Art, Tulsa). He then headed north (via stagecoach) to join F. V. Hayden's Yellowstone expedition. Since this part of the Green River was like a "gateway" to the Rocky Mountain wilderness and the Northwest, Moran passed through it repeatedly on his frequent trips west. The Green River landscape became one of his favorite subjects, and it inspired numerous watercolors, canvases, and prints during the next thirty years.[1]

In the early 1870s, Moran had made several summer trips west to see its most spectacular wilderness areas: Yellowstone (1871); Yosemite, California (1872); southern Utah and the Grand Canyon (1873); and the Mount of the Holy Cross, Colorado (1874). He remained in the East until August 1879, when he again journeyed west with his artist brother Peter to gather field studies in parts of Nevada, Utah, and Idaho for a Union Pacific Railroad commission. By the end of August they were making the arduous pilgrimage, with a military escort, to see the picturesque Teton range (which included a peak Hayden named Mount Moran in 1872).[2]

In September 1879, heading home from the Tetons, Moran again crossed the Green River, renewing his acquaintance with its colorful cliffs by making fresh studies, including this serene view. Beneath the thinly applied blue washes of the vast hazy sky, towering russet and white rock formations preside fortress-like over their brilliant reflections on the river

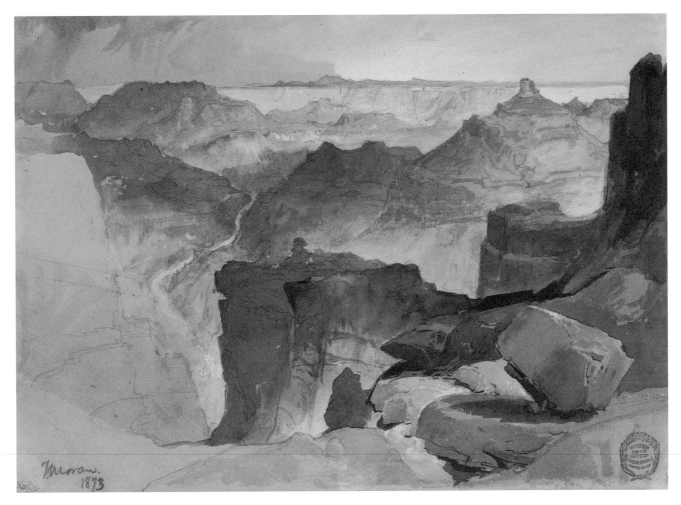

58

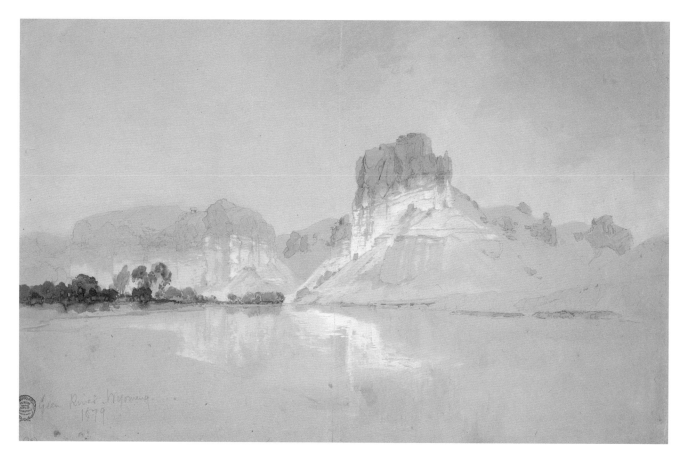

59

surface. An oasis of green dabs suggests trees and other foliage on the left bank of the water's edge. Characteristically, Moran began the composition by strategically placing pencil marks to generally define the terrain. He then carefully selected those colors that best approximated the desert hues and proceeded to paint over most of the pencil lines. He left much of the paper unpainted as its tan color ideally suggested the ubiquitous sandstone and the river's muddy waters. While this watercolor could stand as a powerful work on its own merits, it was undoubtedly a point of reference for two oil paintings Moran executed a few years later: *Green River Cliffs, Wyoming*, 1881 (Spring Creek Art Foundation, Dedham, Massachusetts), and *Cliffs of the Upper Colorado River, Wyoming Territory*, 1882 (National Museum of American Art, Smithsonian Institution, Washington).[3]

1. See Boston 1993, p. 64; Kinsey 1992, p. 29.
2. Clark 1980, p. 54.
3. See illustrations in Washington 1991, pp. 249–250. Nancy K. Anderson's essay in this catalogue (pp. 243–248) presents an informative discussion on Moran's landscapes and the evolution of Green River from trapper meeting place to frontier settlement.

60

Toltec Gorge, Colorado, ca. 1881

Brush and black, brown and blue ink washes, white gouache, over graphite on brown paper

12⁹⁄₁₆ x 9½ inches (318 x 241 mm)

Initialed with monogram in black ink, lower right: *TYM*; inscribed in graphite, upper left: *Toltec Gorge*. On verso: mountain and river valley panorama in graphite; signed and inscribed, left center: *Toltec Gorge / Colorado / T Moran*, top: ?*land Range*, bottom: *Los Pinos*.

Cooper Union stamp 1, lower left. On verso, Cooper Union stamp 2, upper right.

Cooper-Hewitt National Design Museum, Smithsonian Institution

Gift of Thomas Moran, 1917–17–68

Moran traveled twice through the dramatically narrow Toltec Gorge in southwestern Colorado, on the route between Antonito and Durango. In 1881, as part of a publicity campaign, the Denver and Rio Grande Railway Company invited him along with other artists, writers, and photographers on a special trip through its Colorado mountain route. The deluxe private train stopped at all the most picturesque

sights, like Toltec Gorge, so that artists and photographers could record the remarkable views. Articles, guidebooks, and promotional literature describing the Rocky Mountain scenery and the advantages of experiencing it by train, resulted. Several of Moran's images, including a view of Toltec Gorge, were featured in Denver and Rio Grande Railway publications in the late 1880s and 1890s.[1] In 1892, Moran took a regularly scheduled train through this part of the Rocky Mountains during his last major tour of the West.

An inscription on an old mount for this drawing proposed a 1892 dating for two Toltec Gorge studies in the collection: a related watercolor titled *Toltec Gorge and Eva Cliff from the West* (1917–17–31), probably done on site, and this more finished view, probably executed afterward. However, Moran's train did not make a stop there in 1892. Only the stop on the 1881 trip would have provided him ample time to clamber over the rocks and locate the best vantage point to sketch a view of the tumbled boulders and "God's masonry."[2] He may have later referred to William Henry Jackson's photograph of an almost

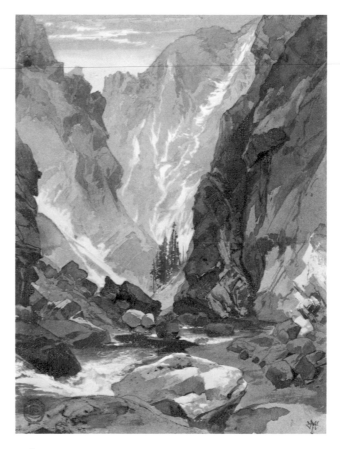

60

identical view of Toltec Gorge in order to better recall its details for the more finished drawing.[3] Since this drawing exhibits such fine care in compositional and tonal balance, Moran must have had more time to execute it than working on site would have afforded. As one can see, he applied the dark washes to shape the steep mountainsides and the clutter of fallen boulders. A lone grove of evergreens marks the middle distance. He used white highlights to indicate the cascading stream and the patches of reflected light that licked some of the rock faces, meandering gullies, and the cloud over the distant mountaintop. While the precise date is not certain, it can be pinpointed to the early 1880s, since a reproduction of the picture appeared in Ernest Ingersoll's *The Crest of the Continent: A Record of a Summer's Ramble in the Rockies and Beyond* (Chicago, 1885).[4]

As one of Moran's most vigorously rendered wash drawings, this imposing view evokes the savagely rough terrain more typical of the Rockies than of the Swiss Alps, where generations of European and American artists trekked in search of sublime scenery.

1. Kinsey 1992, p. 164, fig. 90. Also refer to Kinsey's chapter "The Popularizing of Colorado," especially pp. 163–167, for insights regarding the circumstances behind Moran's Toltec Gorge pictures.

2. This phrase is from Patience Stapleton's poem "Toltec Gorge" in *Rhymes of the Rockies* (ca. 1880s) cited in Kinsey 1992, pp. 166–167, 212 (n. 12).

3. Ibid., pp. 164–166 (fig. 92), provides the reasoning for the ca. 1881 dating and the connection to the Jackson photograph.

4. Ibid., p. 164. Ingersoll, who had been one of Moran's fellow companions on the 1881 Denver and Rio Grande excursion, based his text on impressions derived from that trip.

61

Chama below the Summit, 1892

Gray wash and watercolor over graphite on paper

8⅝ x 11⅞ inches (219 x 302 mm)

Inscribed, initialed, and dated in graphite, along top: *Chamma* [sic] *below Summit T M 1892.*

Cooper Union stamp 1, lower left.

Cooper-Hewitt National Design Museum, Smithsonian Institution

Gift of Thomas Moran, 1917–17–50

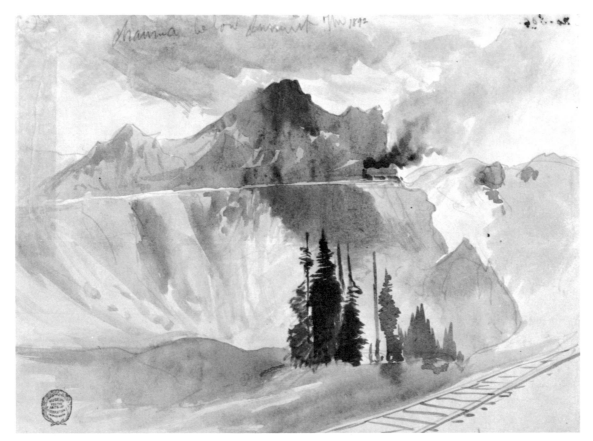

61

In 1892, at age fifty-five, Moran made his last major trip west with his son Paul. The trip was sponsored in part by the Santa Fe Railroad, which provided him free transportation in exchange for a painting that they could use for publicity.[1] Besides gathering images of scenery he had never seen before, Moran revisited the Grand Canyon, Toltec Gorge, and Yellowstone in the company of the photographer William Henry Jackson, a longtime friend and colleague whom he had met on the 1871 Yellowstone expedition. Jackson was helpful in making various travel and business arrangements that benefited them both in promoting their work.

This briskly painted watercolor shows part of the railroad route in what is now northwestern New Mexico. It may have been executed from a moving train. Moran made loose carefree pencil outlines and then almost splashed on the wash and watercolor. Yet his expert technique controlled the flow of the subtle tints just enough to suggest overcast skies, wave-like mountain peaks, a grove of trees in a mountain basin, and, chugging around the bend, a tiny black locomotive. Among the freest of his watercolor sketches, this work reveals his zestful command of the spontaneous potential in the medium.

1. Clark 1980, p. 59

62
Lizard Head Peak, Colorado, 1893 $fan!$

Graphite on Denver and Rio Grande Railroad Co. stationery

11 x 8½ inches (279 x 215 mm)

Inscribed, dated, and initialed in graphite, upper left: *Lizard Head / Jan 8th / 1893 / T.M.* Imprinted at top of sheet: THE DENVER AND RIO GRANDE RAILROAD CO. / OFFICE OF / PRESIDENT AND GENERAL MANAGER. / DENVER, COLORADO.

Cooper Union stamp 1, lower left.

Cooper-Hewitt National Design Museum, Smithsonian Institution

Gift of Thomas Moran, 1917–17–73

There is little information about Moran's being in Colorado again in January 1893, so soon after his summer 1892 tour through the Rockies. Yet this graphite sketch of Lizard Head Peak, in the San Miguel Mountains near Telluride, on Denver and Rio Grande Railroad stationery is so incisive and, being

precisely dated, has the immediacy of a diary entry and personalized souvenir. It serves as proof of his visit.

On July 26, 1892, Moran had written his wife from Yellowstone (after he had been in Denver):

I am very well satisfied with the artistic side of the trip so far and I think the financial part will pan out all right when I get some work out. Altogether this trip will prove of great advantage to me I am sure. . . . I think I have opened the way to come out again whenever I want to without paying R.R. fares.[1]

Although Moran's letter does not provide full details, he was in Yellowstone to gather new impressions in order to fulfill a Wyoming World's Fair Board painting commission for the 1893 Columbian Exposition. However, his letter might have also been alluding to plans for a Denver exhibition scheduled for later that year. In December 1892 a retrospective exhibition of 261 works by Moran was held at the Denver Art League.[2] Perhaps he took advantage of a free railroad pass offer to go to Denver around Christmastime to deal with the exhibition arrangements. Then, he probably took a Denver and Rio Grande train ride

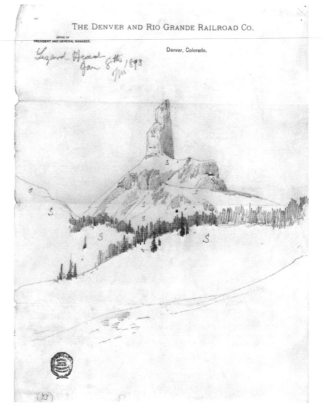

62

through the mountains to see the effects of winter snow.

As this drawing shows, Lizard Head Pass is wide enough to permit a clear view of the distinctively chiseled mountain peak. Since Moran probably drew this from a moving train, his rapid use of pencil was economical, but sure, in it descriptive purpose. Behind the crest of a ridge defined by a row of ragged parallel vertical strokes for evergreen trees, the lone tooth-like peak, carefully modeled, stands silhouetted against an undrawn sky. Scattered *s's* were the artist's shorthand to indicate snowy areas. Although the mountain's name, suggesting a resemblance to an alert lizard, might be hard for some to imagine, Moran's concise study of the memorable scene—done just over a hundred years ago with a few flicks of graphite on a piece of writing paper—can astonish today's viewer with its powerful simplicity.

1. Bassford/Fryxell 1967, pp. 121–122; further information regarding the courtesy railroad passes is provided on p. 146.

2. Notre Dame 1976, p. 8. The Denver Art League published *Catalogue of Pictures of Thomas Moran Exhibited under the Auspices of the Denver Art League* (Christmas 1892).

William Trost Richards

Philadelphia 1833 — Newport, Rhode Island 1905
HM 1862, NA 1871

WILLIAM TROST RICHARDS was one of America's most prolific and talented delineators of nature working in the nineteenth century.[1] He is known particularly for his luminous watercolors of the New Jersey, New England, and Cornwall coasts. Richards's remarkable technical ability grew out of his training as a commercial draftsman for a lighting manufacturer in Philadelphia, in addition to his study of wood engravings and, perhaps, drawing manuals. He also received some instruction in 1846–1847 at Philadephia's Central High School and had intermittent private lessons (1850–1855) with Paul Weber (1823–1916), a German émigré who painted woodland and panoramic landscapes as well as portraits. For the most part, however, Richards was self-taught, and he learned to draw with constant practice.

From the beginning of his career, William Trost Richards demonstrated extraordinary facility in working on a very small scale. Surviving landscape vignettes for poems by American poets (see no. 63)

contain minutely rendered naturalistic elements as well as figures, animals, and houses. Also from the early 1850s comes a number of nature studies depicting tree trunks with profuse textural detail. In addition to these close-up drawings, Richards created broader views of the woods, rivers, and mountains of Pennsylvania and New York.

In the early 1850s, he regularly sketched scenery outside of Philadelphia. He also made sketching trips to the Catskill Mountains (1853, 1859) where he visited the places favored by the Hudson River school painters. He even made a pilgrimage to the Catskill home of Thomas Cole (q.v.), who was a major early influence on him, as was J. M. W. Turner. Drawing primarily in graphite or brush and wash, Richards created both intimate detailed studies of nature as well as panoramic vistas that he later worked up into finished paintings. Like the Hudson River school artists he admired, Richards responded to current antebellum ideas. He saw the landscape as the nation's glory, and, much like the transcendentalists, he viewed nature as the manifestation of God's presence in the world. Richards's penetrating observation of the natural world was further intensified by his reading of John Ruskin whose *Modern Painters* (1843) and *Elements of Drawing* (1857) encouraged artists to paint and draw directly from nature, reproducing in meticulous detail exactly what they saw. In the late 1850s and 1860s, Richards created fastidiously rendered, close-up graphite studies of trees and plants (see no. 64). American followers of Ruskin's doctrines formed the short-lived Association for the Advancement of Truth in Art, of which Richards became a member in 1863.

In 1859, Richards moved with his wife of three years, Anna Matlack, to Germantown, but he kept a studio in nearby Philadelphia. Summers were spent on sketching excursions, often in the Adirondacks. By the late 1860s, after two trips to Europe (1855–1856; 1866–1867) and travels to New England and along the coasts of New Jersey and Long Island, Richards turned his attention from woodland and inland subjects to marine and coastal views. Concurrently, he increased his use of watercolor for both detailed studies as well as the finished paintings he exhibited at the National Academy of Design, the Pennsylvania Academy of the Fine Arts, and elsewhere. Though he still painted regularly in oil, by 1873 critics were praising him as one of the country's foremost artists working in watercolor. During the 1870s, Richards's two major patrons, George Whitney, a manufacturer of rail-

road car wheels, and the Rev. Elias L. Magoon, collected watercolors the artist painted of the New Jersey and Rhode Island coasts that are considered some of his best works. The remarkable light and atmosphere captured in these paintings link Richards to the American luminists.

Under the influence of the Barbizon painters, the American taste for landscape at this time was shifting away from detailed romantic views toward more painterly, emotive scenes. Responding to this trend, Richards went to England in 1878 to expand his repertory and search for new markets for his work. During the next two decades, he and his wife made seven more trips to Great Britain and the Continent.

In his later years, Richards concentrated on the sea and the rugged coasts of such places as Cornwall and Dorset as well as Newport and Conanicut Island in Rhode Island, where he built his family house in 1881–1882. He continued to enjoy a respectable following in the period when tonalist landscape painting was popular in the United States. Although Richards attempted to broaden his drawing and painting style under Barbizon influence, he never strayed very far from the romantic landscape tradition of the Hudson River school—retaining his miniaturist sensibility until the end.

The provenance of the drawings, watercolors, and sketchbooks by William Trost Richards in this exhibition bears mentioning to explain why he is so prominently represented in the two museum collections. In 1952, Richards's daughter, Anna Richards Brewster (1870–1952), an artist herself, sought to give her inheritance of drawings, sketchbooks, watercolors, and paintings by her father to the National Academy of Design. Action on the gift was delayed for several months due to the illness and subsequent death of Mrs. Brewster. Her husband, William T. Brewster, carried on in her absence, and, in October of that year, over five hundred works were accepted by the governing council of the National Academy of Design. Recognizing the magnitude of the gift, it was decided that the bulk of the collection would be distributed to museum collections throughout the country. Cooper-Hewitt National Design Museum was one beneficiary of this dispersal, and its credit line appropriately honors the National Academy as donor. In the end, the National Academy kept only some fifty paintings, drawings, watercolors, and sketchbooks from this generous Brewster bequest.[2]

GSD

1. The authors wish to thank Linda S. Ferber for generously sharing her knowledge and research on the artist. Her publications on Richards have been instrumental in reviving the artist's reputation. For biographical information, see especially Ferber 1980b.

2. For further information regarding the Brewster bequest, see New York 1980 and the pertinent archival material in the collection of the National Academy of Design.

[The Richards entries: 63–67, 69–71, 73–74, 76–77, 81 (National Academy) are by Dita Amory; nos. 68, 72, 75, 78–80 (National Design Museum) are by Gail S. Davidson]

63
"Metempsychosis of the Pine," 1854

Graphite on paper

15⁵⁄₁₆ x 12¼ inches (386 x 311 mm)

Signed in graphite, lower center under image: *William T. Richards.*; inscribed in graphite, lower right, a verse by Bayard Taylor (see note 3); stamped on verso, upper center: *59.*

National Academy of Design

Bequest of Anna Richards Brewster, 1952 [1982.2502]

Late in 1853, Richards embarked on a publication project which, though it never reached fruition, proved felicitous for him in the early years of his career. On November 30, he described his proposed project:

> . . . To select the most beautiful and characteristic Landscape descriptions of a number of American poets—. . . then from these select one poem of each poet, the most beautiful and characteristic . . . for illustration . . . thus making a volume of Landscape poems with 12 or more illustrations, as the case may be, entitled, "The Landscape Feeling of American Poets."[1]

Richards selected passages from the landscape poetry of William Cullen Bryant, Nathaniel Parker Willis ("Spring"), George H. Boker ("I Have a Cottage"), Joseph Rodman Drake ("Bronx"); Henry Wadsworth Longfellow ("Voices of the Night" or "The Bridge"), Richard Henry Stoddard ("Castle in the Air"), Bayard Taylor ("Metempsychosis of the Pine"), Thomas Buchanan Read ("Closing Scene" and "Deserted Road"), Edgar Allan Poe ("Dream-Land"), John Greenleaf Whittier ("Pictures"), and Fitz-Greene Halleck. By May 1854, nine of the drawings had been completed, and Richards remained confident of the success of the endeavor, anticipating publication either in 1855 or 1856 at E. H. Butler & Company, Philadelphia.

Although there is no evidence that the illustrations were ever published, several examples of the drawings

63

The National Academy's drawing, also oval in format and inscribed with a verse from Taylor's lengthy romantic poem, presents another imaginary mountain landscape.[3] The "towering pine" teeters on a mountain ledge overlooking a gorge, bathed in radiant sunlight. The cloud formations seem to vaporize in fantastic arabesque patterns in the upper reaches of the image. Richards has also treated this sheet tonally, using veils of linear marks to build up the composition. It is really no surprise that he worked on this minute scale with such a deft hand. After all, he had been trained as a designer of ornamental metalwork, had early experience in illustration, and worked under the German landscape painter Paul Weber, whose own training in Düsseldorf stressed the essential importance of linear drawing.

Richards's poetic sensibility and romantic vision of untrammeled nature in these vignette drawings surely owe a debt to the landscapes of Thomas Cole (q.v.) and J. M. W. Turner. Richards was a great admirer of these artists, especially Turner whom he highly esteemed. However, as Richards did not travel to Europe until 1855, Turner's work would only have been known to him in the early 1850s through book engravings and *Liber Studiorum* prints available in Philadelphia.[4]

Despite the failure of "The Landscape of American Poets" to reach publication, the project did prompt several commissioned paintings, two from the poets themselves, Bayard Taylor and George H. Boker. Both of these pictures are unlocated. Though few of the drawings for the poems are known today, those that are, broaden our grasp of Richards's early years and evoke the romantic spirit of his youthful sensibility.

have surfaced in public collections, among them this vignette for Bayard Taylor's poem "Metempsychosis of the Pine." Before examining the National Academy's sheet, it might be useful to describe briefly the few other surviving examples of drawings, all in graphite, for this project: a drawing for John Greenleaf Whittier's "Pictures" and another for Edgar Allan Poe's "Dream-Land," both in the Brooklyn Museum; and a recently acknowledged drawing for Richard Henry Stoddard's "Castle in the Air," in the collection of the Stanford University Museum of Art.[2] On each of these fully finished drawings, meticulously prepared in an oval format on a tiny scale, Richards has inscribed the particular verse of the poem which inspired the illustration. The Whittier and Stoddard landscapes are precisely laid out. For the Whittier, Richards chose a pastoral view of verdant splendor, and for the Stoddard, a celestial city amid sylvan surroundings. The Poe drawing, by contrast, comes directly from the realm of imagination, capturing the dramatic spirit of the poet's Gothic verse. In varying tonal patterns, Richards has expressed the apocalyptic force of atmospheric motion in a mountainous setting.

1. Richards to James Mitchell, as quoted in Ferber 1980b, p. 24.

2. This drawing forms part of a large collection of drawings, watercolors, and oils on panel by William Trost Richards given to the Stanford Museum of Art by M. J. and A. E. van Loben Sels. See Osborne 1993, for further details.

3. The verse penciled in at the lower right reads as follows: "I was a towering Pine, / Rooted upon a cape that overhung / The entrance to a mountain gorge / [whereon / The wintry shadow of a peak was flung / Long after rise of sun. / Bayard Taylor." For a complete reading of the poem, see: *The Poems of Bayard Taylor* (Boston: Ticknor and Fields, 1866). Bayard Taylor (1825–1878) was one of a group of romantic poets—Richard Henry Stoddard, Edmund Clarence Stedman, and Thomas Bailey Aldrich among them—who flourished in New York in the 1850s. They all looked to the British romantics for inspiration, Byron, Keats, Shelley, Coleridge, and especially Tennyson. Bayard Taylor and his fellow poets believed in the primacy of the beautiful, the spiritual, the picturesque, and the sensuous. They embraced geographic and historic remoteness in their

literary themes. Given his adulation of Turner, it stands to reason that Richards would have been drawn to this poetry for its visual possibilities.

4. The *Liber Studiorum* is a series of seventy-one plates in etched outline and mezzotint published between 1807 and 1819. Its full title reads: *Liber Studiorum; Illustrative of Landscape Compositions, viz. Historical, Mountainous, Pastoral, Marine and Architectural*. This was a critical document for Turner as a theorist of painting. See London 1974, p. 61. A portfolio of color lithographs after Turner, once owned by Richards himself, was recently given to the Stanford University Museum of Art. See Osborne 1993.

64

Day Lilies by a Wooden Fence, 1862

Graphite on paper

9⅛ x 6 inches (232 x 152 mm)

Dated in graphite, lower left center: *June 26 1862*; numbered in graphite, lower left corner: *3½*. Stamped on verso, upper center: *66*

National Academy of Design

Bequest of Anna Richards Brewster, 1952 [1981.94]

64

Encouraged by an exhibition of British art at the Pennsylvania Academy of the Fine Arts in 1858 and by the persuasive writings of John Ruskin, William Trost Richards began sketching directly from nature on a regular basis in 1858. Plein-air painting and drawing were obsessive pursuits of the British Pre-Raphaelites, whose landscapes Richards would have had the opportunity to admire at the Pennsylvania Academy exhibition. Ruskin's *Modern Painters* (1843) implored landscape painters to draw every detail of nature with equal focus, transcribing even the most humble wayside plants with accuracy. Ruskin's writings fell on sympathetic ears in mid-century America where Hudson River artists had long established a native school of landscape painting deeply reverent of nature's bounty. Indeed, even in literary circles Ruskinian doctrines met with acceptance; for the contemplation of nature was central to transcendentalist writing.

An irrepressible sketcher, the young William Trost Richards made frequent excursions into the country-side around Philadelphia. Summers were often spent in the mountains, either the Adirondacks, Catskills, or White Mountains. He made innumerable botanical studies during these trips, often to be used later in his paintings. As in the present drawing, he often inscribed these sheets with precise dates, and, as in an-

other drawing (no.66), he sometimes noted the particular site studied. Although no locale is given for *Day Lilies by a Wooden Fence*, it is documented that Richards was sketching in the Adirondacks in the summer of 1862.[1]

This drawing, though Ruskinian in subject and perspective, is not exemplary of Richards's Pre-Raphaelite impulse to literally transcribe every detail. He uses graphite tonally in this sunlit sketch of day lilies, grasses, and rocks clustered alongside a post and rail fence. Through varying gradations of graphite, he has delicately handled the closely observed plant matter and suggested the dappling of sunlight against the dark massing of shade. The precisely sketched, spindly lilies reach toward the light source. This is indeed a fine example of many such plant sketches Richards made between 1858 and 1865 as he savored his outdoor excursions.

1. See Ferber 1980b, p. 410.

65

Study of Trees

Graphite on gray-green paper

10 x 7¹/₁₆ inches (254 x 180 mm)

Stamped on verso, upper center: *74*

National Academy of Design

Bequest of Anna Richards Brewster, 1952 [1982.2523]

This sketch probably dates from the late 1860s or 1870s when Richards's activity as a landscape painter climaxed. As the sheet is not signed, dated, or inscribed with site notations, its particular placement in Richards's corpus of graphite landscape drawings is still conjectural. Evidence of threading along the right edge suggests that the drawing came from a sketchbook, which may explain why it bears no date of execution.

Essentially a linear study of airy trees at the edge of a meadow, the view may have been sketched in a public park. Linda S. Ferber has suggested that Richards made this drawing in Germany in 1867; its manicured appearance suggests a European park. Richards and his family traveled to Paris in 1866 and then to Darmstadt the following year, a trip no doubt prompted in part by his early association with Paul Weber and eagerness to visit him.

The rustic chair sketched below the ruled boundary of the composition signals man's presence in this natural environment. The chair, commonly associated with garden furniture made in the Adirondacks, may be German in origin. However, rustic furniture of this type was actually available all over Europe by the 1850s.[1]

Rather than recording the minutiae of this woodland scene, Richard's pencil is mapping the structure of his composition, perhaps for later use in a painting. The brief thumbnail compositional sketch below the image gives us another indication of the drawing's function. Much like Samuel Isham's sketch (no. 53), this is an investigation of the formal aspects of the landscape, a test of boundaries. Small, vertical woodland landscapes were Richards's stock-in-trade at the end of the 1860s, when he generally drew inspiration from the countryside surrounding Germantown, Pennsylvania.

1. The author wishes to thank David R. McFadden for his suggestions regarding this type of rustic furniture.

65

66

Bank of the Wissahickon, 1869

Graphite on paper

22³/₈ x 17¹/₂ inches (567 x 444 mm)

Inscribed and dated in graphite, lower right: *Wissahickon / Aug 30. Sept 1.2.3 – / September 6, 1869*

National Academy of Design

Bequest of Anna Richards Brewster, 1952 [1981.97]

This meticulously detailed drawing of a forested bank along the Wissahickon Creek near Germantown, Pennsylvania, is a splendid example of one of William Trost Richards's penetrating landscape studies of the late 1860s and 1870s. Working in the countryside close to home, Richards spent long hours sketching and painting outdoors. His oils reflect the same attention to precise transcription as do his drawings. This sheet, patiently worked up over several days spent in the warm summer sun, was probably a preparatory study for one of several oil paintings dated to 1870 or 1872.

Linda S. Ferber has noted that Richards painted

several related landscapes in the early 1870s, all having a woodland setting close to a body of water. A number of these were even conceived as seasonal pendants.[1] While one may be inclined to consider this graphite drawing preparatory to Richards's grand landscape painting of 1872, *The Wissahickon* (Medical College of Pennsylvania, Philadelphia), it actually bears a closer formal affinity to its direct precursor, *June Day* of 1870 (Cleveland Museum of Art)[2] The bank of trees to the left in *June Day* seems to parallel the tall, vertical tapestry of feathery boughs so carefully laid out in this study on paper.

Minute attention to botanical detail, urged by Ruskin in his writings, appears throughout Richards's painted landscapes of the period. A critic for the *New York Evening Post* in 1885 mockingly reported that

Richards's attention to the minutest detail led him to paint a forest (referring to *The Wissahickon*) "leaf by leaf."[3] It has been noted that occasionally Richards used his studies of nature directly in paintings.[4] The versos were darkened with graphite, and the drawings' contours were then traced onto panel or canvas with a pointed instrument. This particular sheet never functioned in such a way; instead its ample dimensions and the intensity in some passages point to its use as a study for one of his paintings of a forest landscape.

The drawing's absence of finish allows us an instructive glimpse at the artist's graphic technique. He has fully completed in delicately hatched, unmodulated lines the meandering branches of the deciduous trees that rise gracefully in a lacy mantle above the wa-

ter. By contrast, he has left the evergreens summarily sketched in soft focus to suggest the impenetrable density of the forest. The boulders wedged in the creek and the stairs leading up to the woods are even more cursory in handling. This magnificent drawing clearly served to map the silhouette of the forest, its extremities firmly drawn in Richards's deft hand.

1. Three woodland paintings are known to have been painted in 1870: *Spring*, *June Day*, and *Autumn*. See reproductions in Ferber 1980b, pp. 510–511.

2. In 1872, Richards completed *The Wissahickon* for his patron George Whitney. Whitney, ever eager to support his dear artist friend, encouraged Richards to find a buyer who could pay a better price. The painting, however, remained in Whitney's collection until he died. Ibid., p. 214.

3. Ibid., p. 342, no. 63.

4. Ibid., p. 149

67

Moonlit Landscape

Watercolor and touch of gouache on blue-gray paper

7⅞ x 13⅜ inches (200 x 340 mm)

Stamped on verso, upper left: *193*

National Academy of Design

Bequest of Anna Richards Brewster, 1952 [1980.31]

Responsive to a growing interest in watercolor paint-

ing among fellow artists and the encouragement of his patrons, George Whitney and the Rev. Elias Magoon, William Trost Richards began working in watercolor in the 1860s.[1] Such a portable medium was well suited to plein-air studies and Richards's desire to capture transitory light and atmosphere in muted, reflective colors. With the founding of the American Society of Painters in Water Colors in 1866, there was now an opportunity to showcase watercolors in annual exhibitions.[2] Richards exhibited six coastal landscapes in the watercolor exhibition of 1872, and by 1873 he was recognized as "one of the best known watercolor painters of America." Indeed, he continued to work in watercolor for the rest of his life, almost always out of doors.

Although the landscape and distant buildings in this picturesque nocturne cannot be identified with certainty, the watercolor evinces the same delicate, unlabored touch characteristic of Richards's technique around 1870. Using tinted paper, he has broadly brushed the sheet with a cool blue wash and then, using point of brush, laid in the imagery in an unrelieved brown tonality.[3] The spare handling of trees presents an impression of undersea coral fans. The whole has a poetic content which transcends its topographic value. The monochromatic nature of the watercolor naturally suggests the evening twilight, a deep hue interrupted only by the shimmering moonlight and its reflective pools in the field. As in his

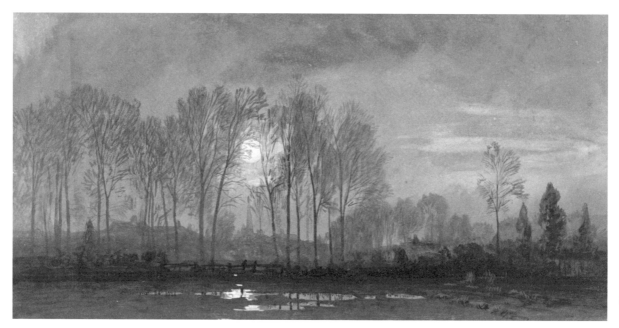

67

other watercolors of the period, Richards uses gouache sparingly, only to highlight the luminous moon and its watery reflections. Nocturnes are not uncommon among Richards's watercolors; there is, for example, another more expansive moonlit landscape in the collection of the Brooklyn Museum (1992.210.1). Richards's insatiable eagerness to record ephemeral light in all its values—from sunrise to sunset to the evening illumination by moonlight—naturally led to a rich production of watercolors, some demonstrably luminist in vocabulary.

This moonlit scene formed part of the inheritance of Richards's daughter, Anna Richards Brewster, an artist herself. When she decided to give her collection to the National Academy of Design, she and her husband, William T. Brewster, inventoried the material, noting sites and dates. Attached to this watercolor was a label in William T. Brewster's hand which read: "in Germany about 1867." Given the long tradition of romanticism in Germany, Brewster's label does give us pause. Linda S. Ferber, however, has suggested an American site for the watercolor—the countryside surrounding his native Germantown, Pennsylvania—and she has noted its similarity to his oil painting of 1870, *On Frankfort Creek near Philadelphia*.[4] While we cannot identify the locale with certainty, we can logically place this work fairly early in Richards's career as a watercolorist, recognizing his confident, though conservative manipulation of transparent washes.

1. The collector George Whitney was a steady, encouraging patron of Richards. When he died in 1885, his collection of watercolors by Richards numbered seventy-six. Whitney was also the recipient of innumerable miniature watercolors, the so-called coupons Richards routinely sent him (see no. 75). It was from these watercolors that Whitney commissioned larger watercolors for his collection. The Rev. Elias Magoon gave a collection of eighty-five watercolors by Richards to the Metropolitan Museum of Art in 1880 (most of which were later sold). His enthusiasm for Richards's work in watercolor led him to accompany the artist to prospective sites for future watercolors.

2. Watercolors were shown on a limited basis in exhibitions in Philadelphia, New York, and Boston during the first half of the nineteenth century—certainly in the annual exhibitions of the National Academy of Design—but this new society gave the medium its own well-deserved platform.

3. Richards sometimes sketched his imagery lightly in graphite before laying in the washes. As Linda S. Ferber noted, however, he was so comfortable with the watercolor medium that he often painted his washes directly on the open sheet. Ferber 1980b, p. 269.

4. *Moonlit Landscape* is illustrated and discussed as *Untitled (moonlight scene)* in New York 1980, pp. 139–140. *On Frankfort Creek near Philadelphia*, 1870, is in the collection of Ellicott Wright, Jamestown, Rhode Island. New York 1980, p. 140, n. 8.

68

Pool in the Woods, 1874

Brush and black wash over traces of graphite on paper

10¹⁵⁄₁₆ x 7⁹⁄₁₆ inches (278 x 191 mm)

Signed in graphite, lower left: *W. T. Richards*; initialed and dated in wash, lower right: *WTR July* [?] *1874*

Cooper Union stamp 2, center verso

Cooper-Hewitt National Design Museum, Smithsonian Institution

Gift of the National Academy of Design, 1953–179–63

Worked in grisaille washes, this woodland scene depicts two tall stately trees arching over a stream that meanders from the foreground to a waterfall in the distance at the right. The right-left-right movement of the stream and grouping of trees is enhanced by the alternating pattern of light and shadow. Sunlight comes in from the far distance at the center of the composition, touches the trees left and right, and hits the water at the brightest point in the foreground, where Richards allowed the white of the paper to come through untouched.

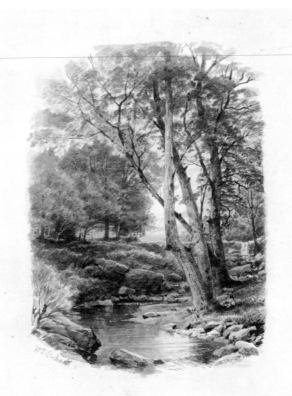

68

Dating from 1874 (not 1879 as previously interpreted), this drawing may have been inspired by the woodland scenes around Atlantic City or Newport, or in New Hampshire or Maine, places Richards visited during the summers from 1872 to 1874. The compositon corresponds to that in a number of small oil paintings from around 1870—all showing tall trees framing pools of reflecting water with a distant radiant light suffusing the foreground.[1] The vignette format, with corners rounded top and bottom, combined with the monochromatic washes and relatively tight handling, suggests that this drawing may have been intended for use as an illustration.

Richards's activities as an illustrator, though overshadowed by his painting career, are nonetheless noteworthy. While still in high school, he was part of a literary club, the Forensic and Literary Circle, for which he wrote essays and poems that he illustrated with landscape-decorated initials and other landscape vignettes.[2] In 1853 he launched an ambitious illustration project, a book of poetry "The Landscape Feeling of American Poets" (see no. 63).[3] Three years later, he and his wife collaborated on an album of her poetry, which he illustrated with small oval landscapes in brush and gray wash inspired by Turner's prints for the *Liber Studiorum*.[4] Then, before his second trip to England in 1878, Richards proposed a series of illustrated magazine articles about the Cornish coast to *Scribner's* and *Harper's*. Though the articles were never published, he seems to have worked on them.[5] Of the published illustrations, one can cite an undated wood engraving of a seascape illustrating the poem "Sands of Dee," by the English novelist and poet Charles Kingsley, which was designed by Richards and engraved by J. Dalziel.[6]

1. Ferber 1980b, pp. 510–511; figs. 149–152.
2. Richards Papers (2297).
3. Ferber 1980b, pp. 24–28; Osborne 1993, p. 122.
4. The book is on loan to the Brooklyn Museum (L1992.3) from James B. Conant. According to the Conant family, this unpublished book was made as a gift to Richards's mother, Hannah Whitall Smith. Richards also provided illustrations for an unpublished family magazine, "London Days," also in the collection of Mrs. James B. Conant, Richards Papers (2297).
5. Ferber 1980b, p. 299 and p. 336, n. 1.
6. This print exists in two states, Brooklyn Museum, 86.53.1 and 86.53.2. Richards also designed the frontispiece for an 1855 publication of *Merrie England, Travels, Description, Tales and Historical Sketches*, by Grace Greenwood (pseudonym of Sara Jane Lippincott). In addition he designed the half title engraved by Richardson & Cox for Washington Irving's *Sketch Book of Geoffrey Crayon, Gent.* (1864) and an illustration engraved by Marsh for *Gems of Tennyson* (1866), see Hamilton 1950, no. 695a, p. 118; no. 662, p. 112; no. 852, p. 150.

69
Seascape, 1875

Watercolor and gouache on paper

8⅞ x 13⅞ (219 x 353 mm)

Signed and dated in brown ink, lower right: *W^m T. Richards 1875*

National Academy of Design

Bequest of Anna Richards Brewster, 1952 [1980.32]

Beginning in the late 1860s, William Trost Richards increasingly turned his attention to marine painting and drawing, activities which would almost eclipse his pastoral landscapes. The sea would become an absorbing subject for the artist. Even during his later sojourns in England, spent along the southern coast, he would map the rugged topography in sketches and watercolors. In 1874, Richards rented a house in Newport, Rhode Island, where the family spent the summers. Eight years later they moved permanently to Rhode Island. The coves and inlets of its rocky shoreline filled his sketchbooks and later became the subjects of many radiant watercolors. Richards was drawn as much to the effects of light and atmosphere at the seashore as he was to the peaceful infinity of the sea and sky. He spoke of "the delight which I constantly feel in the beauty of air and sea . . ."

This highly finished marine of 1875, probably painted along the Narragansett coast, reflects the artist's painterly approach to watercolors of the period. Using a relatively unvaried palette, he has carefully manipulated transparent washes to build up the overcast sky and lapping sea. In a very circumscribed manner, he introduces gouache to dramatize the foaming waves as they toss against the rocks. Gouache also appears sparingly in the sky and on the precisely faceted rocks in the near ground. The low horizon line, panoramic view, and silhouetted schooners in the distance demonstrate Richards's sensitivity to the luminist school of marine painting, an affinity even more pronounced in the following watercolor.

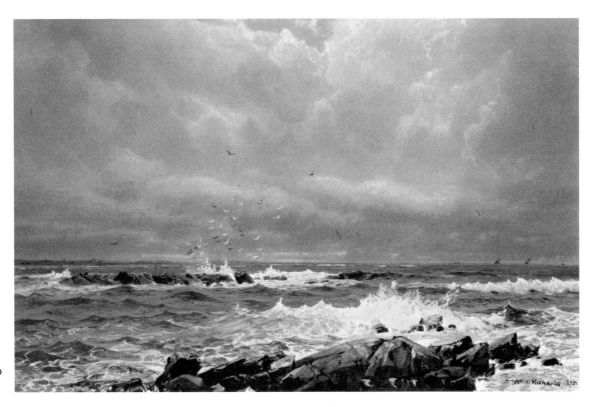

69

70
Marine with Yachts

Watercolor with a touch of gouache on paper

8⅛ x 13¹⁵⁄₁₆ (205 x 354 mm)

Stamped on verso, upper left: *196*

National Academy of Design

Bequest of Anna Richards Brewster, 1952 [1980.34]

Though William Trost Richards was certainly not a defining figure in the rise of the luminist style in American art, his paintings and watercolors dating from around 1870 clearly demonstrate a sensitivity to the same quiet, contemplative imagery. As with the most accomplished practitioners of luminism—Fitz Hugh Lane, Martin Johnson Heade, and Sanford R. Gifford—Richards relished his quiet days sketching the inlets and coves in and around Newport.[1] This crisply painted watercolor of various yachts in full sail—which pass from the brisk Atlantic to a protected inlet and back again—reflects his ready ease with the luminist aesthetic. The marine's clear light, lateral format, low horizon, distant space, and spare composition of little more than sea and sky signal this stylistic phenomenon.

The present watercolor is undated. Anna Richards Brewster and her husband William T. Brewster placed the scene somewhere on the coast of New Jersey.[2] In the late 1860s, Richards sketched near Atlantic City and Cape May.[3] From 1874 onwards, however, he spent summers in Newport, where he found its varied coastal headlands and promontories inspiring source material. He filled sketchbooks with quick little studies. A sketchbook in the collection of the National Academy of Design (1981.157) has numerous sketches of schooners and small gaff-rigged boats, some precisely detailed and some shown casting quiet shadows on the sea. Richards took more than a passing interest in the riggings of these vessels, clearly wanting to master their nautical configurations before transfering the imagery to a larger watercolor or oil painting. In this view, he has flecked his sails with a touch of gouache to note the reflective sunlight, scant evidence of light on a gray day. Only the ships interrupt the horizontal bands of greenish sea, mauve sky, and the natural breakwater faintly drawn in mossy green. Human presence is only implied by the

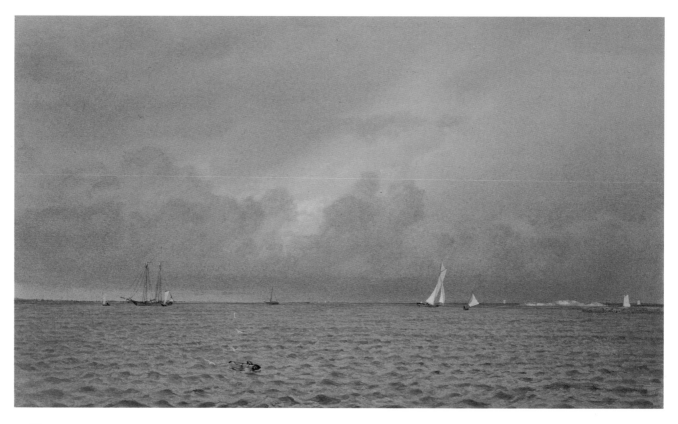

70

ships and delicately delineated buoy in the near ground. Richards has essentially captured the land and sea, its light and atmosphere, in simplified bands of spare, transparent color.

1. Richards often traveled to places "very lonely, rarely visited" because "there you seem to get a little closer to the heart of the sea than else where." Ferber 1980b, p. 248, n. 80.

2. A handwritten label attached to the watercolor indicated the New Jersey coast as the site for this watercolor. Whether the label was written by Anna or by William Brewster is uncertain. *Marine with Yachts* was illustrated and discussed as *Untitled (marine with sailboats)* in New York 1980, pp. 143–144.

3. Richards's son noted that his father "stood for hours in the early days of Atlantic City or Cape May, with folded arms, studying the motion of the sea, until people thought him insane." Morris 1912, p. 10.

71

Coastal Sunset

Watercolor and gouache on paper

9¾ x 15⅝ inches (248 x 397 mm)

Stamped on verso, upper center: *213*

National Academy of Design

Bequest of Anna Richards Brewster, 1952 [1980.45]

The dazzling, radiant light of a setting sun captivated American landscape painters from the early years of the Hudson River school. Thomas Cole (q.v.) is quoted as saying: "At sunset the serene arch is filled with alchemy that transmutes mountains, and streams, and temples, into living gold."[1] Martin Johnson Heade recorded the effects of variant light both day and evening in his New England paintings of the 1850s, while, later in the century, Sanford R. Gifford painted the glowing light of ancient Egypt. The transitory nature of light and shade provided incalculable opportunities to record both the shifting value of color and subtle atmospheric fluctuations.

William Trost Richards was greatly fascinated by the tonal changes of light, evidenced not only in his brilliant watercolors of sunsets and moonlit imagery but also by the innumerable tonal sketches laid out in the sketchbooks (see nos. 75 and 78). *Coastal Sunset* strongly demonstrates how much Richards adopted the sensibility of the luminists. Here he is entirely focused on the nuances of reflective light as it illuminates the sandy beach, translucent sea, and heavy clouds. His handling of this coastal image is somewhat looser and more rapidly brushed than his earlier watercolors in this catalogue. Only the clouds overhead, made palpable by vermilion gouache high-

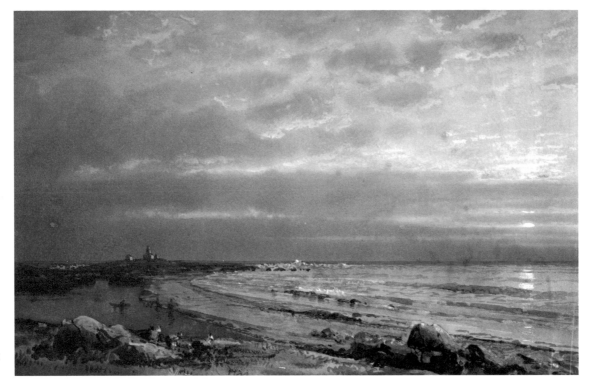

71

lights, seem a little studied. On close examination, several sheep appear in the near ground, animals so roughly laid in as to be almost lost.

This very finished watercolor might have been preparatory to an unlocated painting of the subject entitled *And the Stately Ships Go On*, 1871.[2] The painting has a similar coastal perspective and its date would support this theory, but without a close look at it, no firm conclusion may be drawn. The site is probably somewhere along the New Jersey coast, where Richards sketched with regularity in the late 1860s and early 1870s. Anna Richards Brewster and her husband also corroborated this site identification in the handwritten label attached to the watercolor.

1. Quoted in Washington 1980, p. 106.
2. For a reproduction of the painting *And the Stately Ships Go On*, see Ferber 1980b, p. 545, fig. 219. *Coastal Sunset* was illustrated and discussed as *Untitled (marine, sunset)* in New York 1980, pp. 144–145.

72
Mackerel Cove, Conanicut Island, Rhode Island, 1877

Pen and brush and black ink, watercolor, gouache, crayon, over traces of graphite on gray heavy wove paper ("carpet paper")

22¹⁵⁄₁₆ x 36¹⁵⁄₁₆ inches (582 x 937 mm)

Signed in gouache, lower left: *W. T. Richards*

Cooper-Hewitt National Design Museum, Smithsonian Institution

Gift of the National Academy of Design, 1953–179–1

Richards especially favored this spot in Mackerel Cove where he drew and painted on numerous occasions during the late 1870s and early 1880s.[1] It was nearby that he built his own house, Greycliff, in 1881–1882. The vantage point in this watercolor is near the eastern tip of the cove, looking out at high tide over the "dumplings" (the local term for rocky outcroppings) in a southeasterly direction toward the cove's western tip and Narragansett Bay.

There are a number of related drawings and watercolors. The same scene appears with a radiant sunset in a miniature watercolor coupon received by his patron George Whitney on September 11, 1877.[2] Around this time, Richards made at least three sketches and one watercolor that are related to the National De-

sign Museum's watercolor. In the Brooklyn Museum, one graphite study (on two facing sketchbook pages) shows a close-up view of the cove's eastern tip and the offshore rocks. For another larger graphite drawing (now in the collection of Dr. and Mrs. Ira Rothfeld), the artist moved up the hill, away from the water, achieving a slightly more distant view.[3] In addition to these studies, already identified by Linda S. Ferber, there is a very preliminary sketch in which Richards blocked out the composition with a few quick graphite strokes (fig. 14). Finally, a medium-sized (9 x 13 inch) watercolor of this setting exists in a private collection in Newport.

From these studies Richards composed this splendid picture in the studio, referring to his sketchbook and choosing to follow the close-up view. He added a small, "picturesque," gaff-rigged sailboat against the rocks as a point of focus and to emphasize the scale of the rocky hillside in the foreground and the "dumpling" in the middle distance. (In reality, the boat, which should be much larger, would never be sailing so dangerously close to the rocks in an onshore breeze.) Using various shades of green, brown, blue-gray, and yellow gouache applied in dabs or scumbled over the paper's fibrous surface, Richards conveyed the wild grasses and coarse, prickly pines interspersed with the lichen-covered granite boulders so particular to the coast around Newport. The gray "carpet paper," only lightly touched with gray-green, blue, and pale yellow watercolor for the water and sky, is used effectively to suggest the damp, foggy mist of a bleak summer morning or late afternoon.

Fig. 14. Richards, Study for "Mackerel Cove, Conanicut Island, Rhode Island," *1877, drawing, Spanierman Gallery, New York*

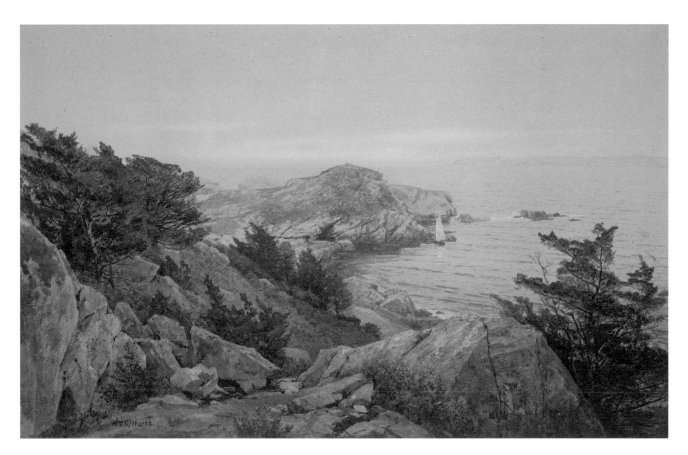

72

Several years later Richards explored this site again, in a closer view from the beach, when he painted another minature watercolor, or so-called coupon, which Whitney received on August 30, 1882.[4]

Such a spectacular tour de force as this view of Mackerel Cove originated from Richards's conscious decision to change his watercolor style in an effort to increase the market for his work. By the mid-1870s, demand was waning for the kind of small, delicate, carefully rendered watercolors he had produced since the late 1860s. Richards sought ways to invigorate his work by experimenting with the scale, technique, and medium of his pictures. Working in Germantown during the winter of 1876, he discovered a new, inexpensive heavy paper used for lining carpets that could be rolled out to any desired length. Because transparent watercolor washes would be totally absorbed in the fibrous, grayish-tan paper, he primarily used gouache, which also gave him more control than pure watercolor. He thereby achieved a dense, textured surface approaching the effects of oil impasto. He also worked to broaden his handling, what he jokingly referred to as "slinging his paint," following the general trend among American artists toward looser, more painterly, tonal picitures.[5]

Richards had great success with these large finished gouaches. They were shown in the annual exhibits of the American Society of Painters in Water Colors, where they were reviewed favorably. Whitney bought some and so did Newport summer residents Mrs. John Jacob Astor and Catharine Lorillard Wolfe.[6] The National Design Museum's drawing, *Mackerel Cove*, is one of the most successful examples of what Richards called his "new" style.

1. Other sketches, probably of Mackerel Cove, are included in Brooklyn Museum sketchbooks, 1975.15.14, 1993.225.1, 1993.225.9.
2. See New York 1982, p. 68, no. 21; see also entry no. 75.
3. Yonkers 1986, pp. 102–103, nos. 87–88.
4. New York 1982, p. 87, no. 75.
5. Richards to Whitney, October 11, 1877, Richards Papers (2296).
6. Richards to Whitney, October 1, 1877, ibid.

73
Coastline, Cornwall

watercolor and gouache on paper

7 x 9⅝ inches (178 x 245 mm)

National Academy of Design

Bequest of Anna Richards Brewster, 1952 [1980.55]

By the last quarter of the nineteenth century, American landscape painting in the realist genre was on the decline, soon to be eclipsed by a more painterly, tonalist expression of nature. William Trost Richards had staked his career on a style of painting now losing its foothold. Realizing the need to search for new material and a new audience, he moved with his family to England in 1878, a trip partly funded by commissions from *Scribner's* and *Harper's* magazines to produce illustrated articles describing the coast of Cornwall. He settled in London for the winter months but spent his summers roaming the rugged British coastline. Cornwall was his first destination, a region so captivating he often returned there over the next few years to sketch its spectacular scenery, eventually filling several sketchbooks with notations of the massive granite cliffs. For years to come, Cornwall's picturesque coast provided raw material for several large paintings as well as many sketches and watercolors. Richards was greatly invigorated by his stay in England and encouraged by the welcome reception accorded his Cornish paintings at the Royal Academy in London and the Paris Exposition of 1889. He also sent oils and watercolors back to New York, where they were shown in exhibitions at the National Academy of Design and the American Water Color Society.[1]

Fig. 15. Richards, sketchbook, drawing, National Academy of Design, 1981–158

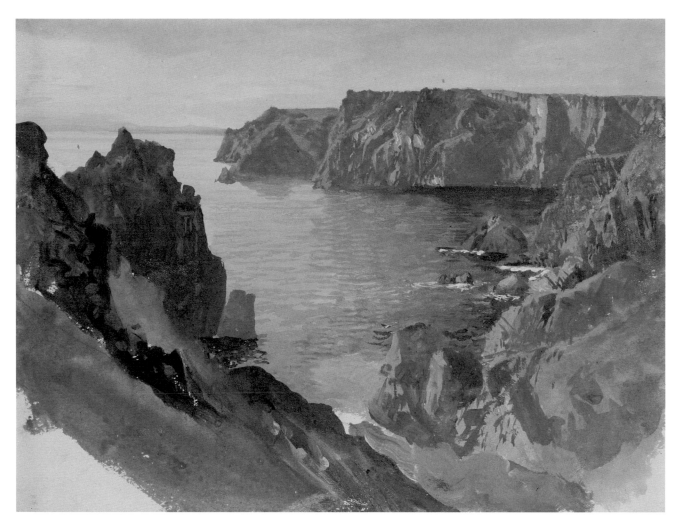

WILLIAM TROST RICHARDS 135

Although the location in the present drawing is not precisely identified, it surely belongs to the large group of watercolors Richards made during travels along the southern coast of England. We know from records of several currently unlocated paintings that he methodically studied the rocky coastline from north to south.[2] These studies on paper were later worked up in oils and finished watercolors in the winter months in his London studio. His painting of Land's End—a dangerous area of submerged rocks where the Atlantic meets the Channel waters—was "the best thing I have to bring home," he told George Whitney.[3]

A sketchbook by Richards in the National Academy's collection (1981.158) has dozens of studies of the Cornwall countryside, both inland and along the southwest coast. From rural villages to rocky outcroppings to meandering cliffs cascading to the sea, the little album offers a glimpse of the artist's working habits. From here he culled material for later use. In fact, this album bears a graphite sketch in which *Coastline, Cornwall* is roughly laid out (fig. 15).[4]

Richards painted the watercolor at the earliest between 1878 and 1880, using gouache more freely than in his previous watercolors. The color range is also richer, with varying tints of opaque green and purple solidifying the granite cliffs. Transparent washes are gently brushed in horizontal bands to lay in the placid waters. Sweeping strokes of color in the roughly painted near ground contrast markedly with the more studied, tonally delineated cliffs in the distance. Richards has subtly captured reflective light as it passes from the sea to the shaded waters beneath the forbidding granite cliffs. This watercolor was clearly a working study for later reference.

1. Richards contributed watercolors of the Cornish coast to the American Water Color Society exhibitions in New York in 1880, 1881, and 1882. See American Water Color Society catalogues for further documentation. For a record of Richards's contributions to the National Academy of Design exhibitions at this time, consult Naylor 1943, 2, pp. 790–791.

2. Reproductions of these unlocated paintings are in Ferber 1980b, figs. 244, 246, 248, 249, 250, 255, 256, 257, 261.

3. New York 1982, p. 56, n. 120.

4. This drawing in graphite (1981–158) comes from one of nine sketchbooks retained by the National Academy of Design as part of the Brewster bequest. The author would like to thank Gail S. Davidson for linking the design of the sketchbook drawing to the present watercolor.

74
Landscape with Trees on a Hillside

Graphite, watercolor, and touch of gouache on paper

9⅞ x 13¹⁵⁄₁₆ inches (250 x 354 mm)

Stamped on verso, upper center: *217*

National Academy of Design

Bequest of Anna Richards Brewster, 1952 [1982.2529]

The apparent lack of finish in this particular watercolor contributes to its charm, the subtle washes merely hinting at the resolution of imagery to come. Undated, unannotated, and seemingly unrelated to any known painting by the artist, its particular placement in Richards's prolific graphic oeuvre remains uncertain. The fluid, unlabored handling of transparent washes and ambitious spatial structure would seem to suggest a date for the drawing of around 1880. In that year, Richards returned to painting in transparent watercolor on white paper.[1] The discretely varied tinted washes—from acid green to dark viridian green—also suggest a late date; for Richards's watercolor palette grew richer as time passed.

The delicate touch of this watercolor is due in part to an economy of means. The soft handling of clouds and mere suggestion of the foliage in graphite outline provide an abstract context against which the fully realized, mature trees shimmer in the sunlight. This variable degree of finish actually enhances the impression of the whole. The predominant use of transparent color signals a departure from work of the mid-1870s when Richards experimented with imagery on a much larger scale, often in gouache on heavy, textured gray paper (see no. 72). Although gouache increasingly appears in his watercolors beginning in the mid-1870s, this study is notable for the absence of such opaque color. Gouache is only faintly evident in the minutely flecked flowers on the blooming tree at the left.

The unfinished aspect of this watercolor gives us a clear indication of Richards's working technique. He proceeded from a quickly sketched outline in graphite to delicately brushed passages of transparent color and then overlaid variant tints as forms developed. The sheet, left uncolored in the near ground, is fully realized in other passages; the trees on the hillside and those below the hill are strikingly rendered in rich green washes. The hillside, marked only by a touch of wash and graphite, is actually more powerful without

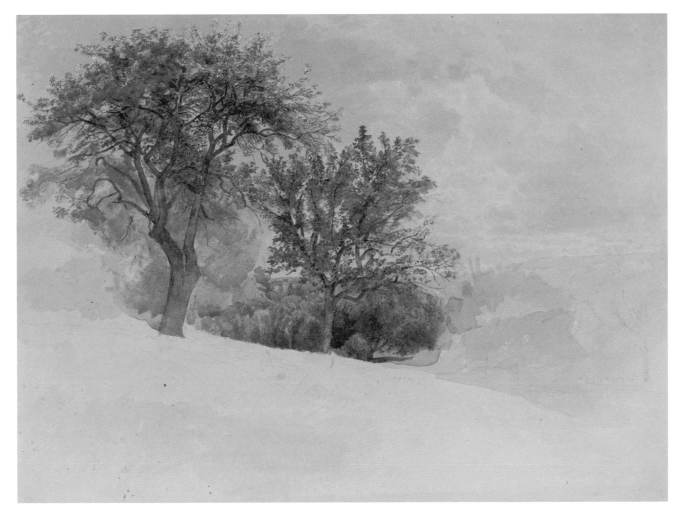

74

literal translation, its sloping gradation left to the imagination. Though we are unable to document this watercolor, it clearly belongs to the period in the artist's career when his brushwork loosened and his hand gained even stronger command of the medium. The overall freedom of handling and rich nuances of color have produced a dazzling drawing.

1. Ferber 1980b, p. 328.

75
Album of Drawings, 1860s–1880s

48 drawings mounted on 37 leaves of paper; 12 gouache and/or watercolor; 36 graphite (2 on blue paper); an autograph album bound in cardboard covers

Exhibited drawing: *Windswept Landscape,* 1880s

Gouache and watercolor on paper, laid down

3⁷⁄₁₆ x 5 inches (87 x 128 mm)

Cooper-Hewitt National Design Museum, Smithsonian Institution

Gift of the National Academy of Design, 1953–179–85 (1)

This exquisite little gouache of windswept bushes and a fenced-in hayfield with a village in the distance could well have been inspired by the landscape near Coatesville, Pennsylvania, where Richards bought a farm in 1884. It is a marvelous example of his predilection for working in a miniature format.

Starting in 1875 and lasting until 1884, Richards habitually included miniature detailed watercolor and gouache scenes, approximately three by five inches, in weekly letters to his Philadelphia friend and patron George Whitney. Sometimes he would inscribe these coupons as they called them (mimicking investment terminology) on the verso, and when Whitney received them, he would always annotate the verso with the number (a new series began each year), title, and date they arrived.[1] Functioning informally as the artist's agent and promoter, Whitney then would show potential clients these samples from which larger, fully realized oil or watercolor pictures could be ordered. Richards also sent miniature watercolors to his patron's daughter, Mary Whitney, as Christmas gifts, and to Whitney's grandson, George Whitney Outerbridge on the occasion of his birthday.[2]

This miniature and the eleven other mounted miniatures—some in watercolor only and others combining gouache and watercolor—suggest some-

thing of Richards's working process. He would first lay out the scene in a few quick watercolor washes, and only if he was satisfied with the result would he further build up the composition with a dense overlay of small gouache strokes, frequently masking the watercolor beneath. The "finished" miniatures in this album, which include *Lighthouse in a Storm, Mountain Landscape,* and *Woods and Stream,* may be examples of coupons sent back to Richards for his use in creating larger versions, or, more likely, they may be miniatures that simply remained in his possession.

1. See Ferber 1982, pp. 21–57. Whitney's collection (now collection of Gloria Manney), which originally numbered at least 184 coupons, is presently on deposit at the Metropolitan Museum of Art, New York.
2. Ibid., pp. 97–100.

76
The Harvest Field, ca. 1887

Watercolor and gouache on paper

9⁷⁄₁₆ x 14⁷⁄₁₆ inches (240 x 367 mm)

Inscribed in graphite on verso, lower right: *The Harvest Field -/ 3*; stamped on verso, upper center: *213*

National Academy of Design

Bequest of Anna Richards Brewster, 1952 [1980.51]

In 1884 William Trost Richards exchanged his house in Germantown for a Pennsylvania farm near Coatesville in Chester County. Oldmixon Farm's picturesque scenery renewed his interest in landscape painting, briefly interrupting his consuming fascination with the sea and its shore. Over the next few summers, Richards sketched and even painted out of doors, producing a number of small, quite painterly landscapes on heavily primed composition board.[1]

This glowing watercolor of haystacks in a meadow relates to several paintings of the period, specifically *A Harvest Field* of 1887 and *Some Fell among Thorns.*[2] As he did in these paintings, Richards uses much looser, painterly brushstrokes to build up the composition. Thus, his watercolors reflect a more varied palette. Over broadly brushed layers of transparent wash, he has generously applied gouache to the field of raked wheat and to the massing of trees. Gouache appears increasingly in Richards's watercolors beginning around 1876.[3] Bathed in shimmering sunlight, this very finished watercolor is surely one of many

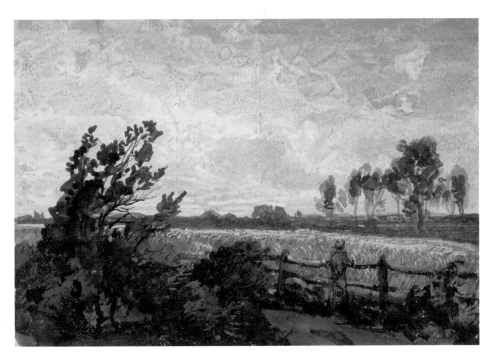

75

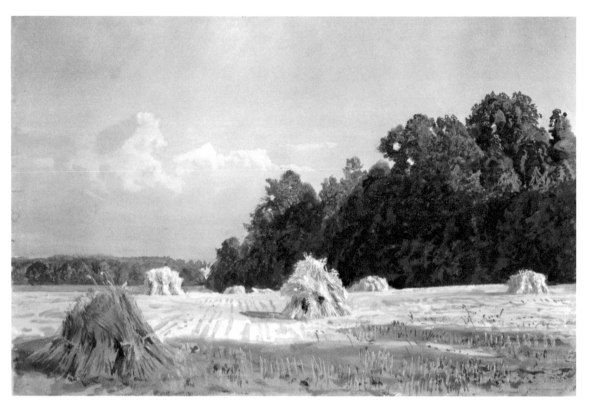

76

studies made in preparation for paintings which marked Richards's return to an interest in the Pennsylvania landscape.

1. Linda S. Ferber has noted that between 1884 and 1886 Richards resumed painting en plein air. This practice continued regularly for the rest of his life. Ferber 1980b, p. 361.

2. For reproductions of these paintings, see Ferber 1980b, p. 576, figs. 282, 283.

3. Opaque color had been growing in popularity among artists in general during the last quarter of the century. See Foster 1983, pp. 124–125.

77

Surf Breaking on Coastal Rocks, 1887

Watercolor and graphite on paper; upper edge ruled in graphite

9 1/16 x 14 inches (230 x 356 mm)

Signed and dated in brown ink, lower right: *W^m T. Richards. 1887*. Inscribed in graphite on verso, upper center: *218*

National Academy of Design

Bequest of Anna Richards Brewster, 1952 [1982.2528]

William Trost Richards returned from Great Britain in 1880 with a cache of drawings, sketchbooks, and watercolors of its dramatic coastal scenery. During his two years there, Richards traveled the coastline from the Isle of Wight on the English Channel to the Orkney Islands in the North Atlantic. Though most of his plein-air studies were made along the southern coast in Cornwall, he made excursions to Dorset and Devon, and to France and Belgium. He returned from these travels with enough source material to last him through the decade. Indeed, Richards produced some of the most thunderous imagery of waves breaking on the massive Cornish cliffs in paintings of the 1880s.

This watercolor probably belongs to that phase of production when the artist worked in his Pennsylvania studio from sketches and from memory. A luminous marine painted in transparent colors without gouache, it recalls the British seaside imagery that had so captured his attention abroad.

During the second half of the decade, Richards finished several Cornish paintings that clearly reflect his long-standing adulation of Turner's art.[1] Richards took every opportunity to study Turner's work first-

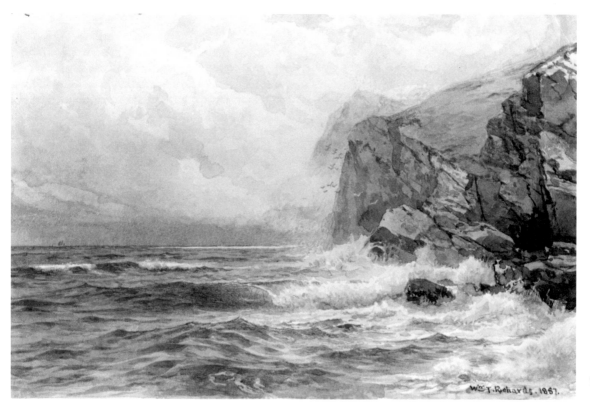

77

hand when in London. In 1879, he wrote a letter to his brother-in-law Charles Matlock, remarking: "Indeed there is a great deal to be learned about water colour drawing in London, and I wish I had the time to copy some of the Turners which after all are the most consummate pieces of art which have ever been produced in that material."[2]

The present watercolor, though infinitely calmer, certainly calls to mind Turner's romantic, metaphysical vision of the sea. With waves tossing against the granite cliffs and light radiating through hazy atmosphere, Richards depicts nature in a dramatic moment. Returning to an earlier technique of working in pure wash without the intervention of Chinese white, he applies pale colors sparingly and allows the whiteness of the paper to define the waves' foam. Always fascinated by the geological formations of any given coastline, Richards has captured here, in detail, the play of light on the faceted granite surfaces. Rather than conveying the solid, impenetrable properties of granite, he builds up these rocks in translucent shades of brown. To further enhance atmospheric haze, he paints patterns of parallel lines on the grassy slope of the cliff, along the horizon, and at the focal point where the cliffs meet the breaking waves. The barely perceptible silhouette of a schooner on the horizon serves to underscore the vastness of the open sea. This watercolor may well have been preparatory to one of Richards's coastal paintings of the period, inspired as they were by the picturesque British coast.

1. See Ferber 1980b, figs. 248, 249, p. 559; fig. 250, p. 560.
2. Richards to Matlack, November 26, 1879, quoted in New York 1982, p. 44.

78
Sketchbook, late 1880s–1890s

87 drawings on 89 leaves of paper (2 blank; 2 additional leaves torn out): 82 in graphite and 5 in pen and ink. Bound in cardboard with Harvard Co-Operative Society sticker on cover.

Exhibited drawing: *Moonlit Seascape*

Graphite on paper

4⅝ x 7½ inches (117 x 189 mm)

Cooper-Hewitt National Design Museum, Smithsonian Institution

Gift of the National Academy of Design, 1953–179–84 (69)

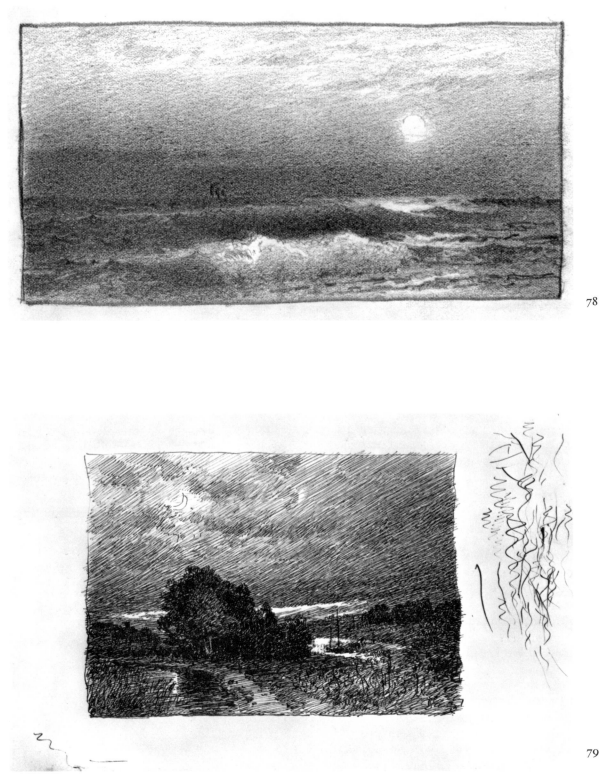

78

79

79

Sketchbook, 1890s

89 drawings on 88 leaves of paper (1 blank; 1 additional leaf torn out): 80 pen and black ink and 9 graphite. Bound in cardboard with Harvard Co-Operative Society sticker on cover.

Exhibited drawing: *A Country View by Moonlight*

Pen and black ink on paper

4¾ x 7 x¾ inches (122 x 199 mm)

Cooper-Hewitt National Design Museum, Smithsonian Institution

Gift of the National Academy of Design, 1953–179–89 (12)

According to his wife, Richards would occupy himself in the evenings "'blocking out' innumerable 'subjects' with lead pencil."[1] These two sketchbooks exemplify this practice. Like a pianist playing scales to keep the fingers nimble, Richards engaged in drawing exercises at day's end (when he could no longer paint in the studio or sketch on site), thereby training his hand to express modulations of light and dark in luminous, poetic compositions. Using pen and black ink (which he controlled by making test strokes in the margins of the page) or his preferred medium of graphite, he first drew a frame on the page and then composed within it imaginary or remembered scenes of surf, rocks, and coast, or inland landscapes under different weather conditions or times of day. Subtle alterations of light and dark, created with hatchings of various widths, convey distance, compositional balance, and startling theatrical lighting effects.

Richards also used sketchbooks for several other purposes in his creative process. On his repeated travels throughout Europe and along the East Coast of the United States, he would always sketch on the spot to record monuments, architecture, and sculpture or to register the topographic contours of the landscape. These studies are frequently annotated with the place and date of execution.[2] Other sketchbooks used on site show how the artist worked up earlier sketches to achieve harmonious compositions. In them, Richards often sketched across two pages of the book and then drew a rectangle around that part of the sketch which best achieved compositional balance.[3] Still other sketchbooks contain many small studies of ships or, occasionally, rural people at work, which might later figure in his oil paintings or watercolors.[4]

It is interesting to note that, unlike Frederic Edwin Church or Thomas Moran (qq.v.), Richards

hardly ever included color notations in his sketches. Drawing in black and white was the foundation of his art. He probably purchased the sketchbooks between 1885 and 1888 when he was living in Cambridge while his son Theodore attended Harvard University.

1. Anna M. Richards described the family's activities to Eleanor R. Price, Cambridge, Massachusetts, Thanksgiving day, 1888, quoted in Ferber 1980b, pp. 387–388, n. 93. Richards's granddaughter Edith Ballinger Price describes a similar image of Richards's evening work when he lived with the Price family in Newport after 1900: "In the evening as we all sat beside the round table in the library by the gas lamp Mother and Father reading and I 'drawing' he often pursued 'subjects.' In pencil or in purplish black writing ink on scraps of paper or backs of old envelopes he would scribble little compositions, a rock, thunder clouds, an island in the distance, a clump of trees. I think he saw pictures constantly, snatches of remembered configurations of rock and sea and shore." Price 1979, p. 4.
2. See sketchbooks in the Brooklyn Museum, 1975.15.2 or 1975.15.6.
3. For example, a sketchbook from 1880, documenting Richards's visit to England, is in the collection of Nelson Holbrook White.
4. An example of this sketchbook type is in the Brooklyn Museum, 1993.225.4 a–k.

80

Moulin Huet Bay, Guernsey, 1897

Watercolor over slight traces of graphite on paper

5 x 8 inches (127 x 202 mm)

Inscribed and dated in wash, lower right: *Wm T. Richards 97*

Cooper-Hewitt National Design Museum, Smithsonian Institution

Gift of the National Academy of Design, 1953–179–77

This charming watercolor depicts a bay on the island of Guernsey, off the coast of Cherbourg on a windy day.[1] Tall cliffs drop steeply into the sea as waves lap against a jagged boulder and onto a small stretch of beach at the lower left. A radiant light appearing through the wind-blown clouds produces a broad chromatic range of brown, blue, turquoise, green, yellow, and purple. The light catches vegetation growing on the top and along the sides of the cliffs turning it chartreuse (a lime-green wash overlaid with yellow) where the sun is strongest. As the brown cliffs recede into the right distance, they become purple in the hazy atmosphere. The sea below is bright blue at the base of the irregular boulder and turquoise closer to shore.

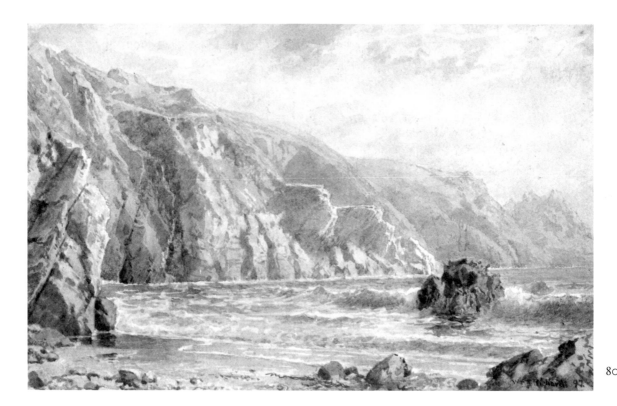

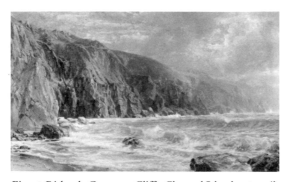

Fig. 16. Richards. Guernsey Cliffs, Channel Islands, *1897, oil on canvas, private collection*

Starting in the late 1870s, Richards returned to Europe eight times in search of new subject matter and markets for his work. On the third of these trips, from July 1896 until August 1897, he and his wife visited Cornwall, Guernsey, London, northern Scotland and the Orkney Islands. In a letter to his brother-in-law Charles Matlack, dated October 25, 1896, Richards described his living situation on the island of Guernsey and a bay nearby—most likely the scene represented in this watercolor:

We have found a very comfortable and roomy lodging place about 2 miles from the town of St. Peter Port to which there is an omnibus which stops nearby—We are *very* near the most beautiful bay I have ever seen, and in the midst of the prettiest country there is on the Island. . . . The weather has been very bad—much rain and wind, but for all that a part of every day was possible for outdoor sketching. . . .[2]

In addition to spectacular subject matter, his stays abroad gave him opportunity for renewed study of English watercolors by Myles Birket Foster, Frederick Walker, and especially J. M. W. Turner.[3] Since 1879, inspired by the watercolors he saw in London, Richards painted more in transparent watercolor, using bright colors and the white of the paper to express light, rather than white gouache as he did in his drawings of the first half of the 1870s. His usual practice was to paint major subjects in both watercolor and oil versions. In addition to this picture, which was probably executed during the spring in London following his stay in Guernsey, there is an 1899 oil painting of the site, *Guernsey Cliffs, Channel Islands* (fig. 16) in a private collection that shows the bay on a foggy day and with a slightly different configuration of rocks in the right foreground.[4]

1. The identification of the bay is taken from an inscription on the original drawing mount by Anna Richards Brewster or her husband William T. Brewster, and it seems to be borne out by comparison to views of the site.

2. From St. Martins, Guernsey, October 25, 1896, Richards Papers (2296).

3. See Ferber 1980b, pp. 328–335.

4. The author is indebted to Linda S. Ferber for supplying the location of this work. It is reproduced in Morris 1912, between pp. 12 and 13.

81

Mountainous Seashore, 1897

Watercolor and graphite on paper

8 x 12 inches (203 x 305 mm)

Initialed and dated in pale brown ink, lower right: *W.T.R.97;* inscribed in graphite, lower left: *B*; inscribed on verso in graphite, upper left: *289*

National Academy of Design

Bequest of Anna Richards Brewster, 1952 [1982.2527]

In the summer of 1896, William Trost Richards traveled once again to Great Britain, where he visited the now familiar coastal terrain of Cornwall and ventured again to the Orkney Islands of northern Scotland. Though he drew his native American landscape all his life and, beginning in the late 1860s, rendered it with increasing frequency in watercolor, it was the rugged Cornish cliffs that informed his dramatic late marine paintings.

This luminous, atmospheric watercolor, delicately painted in muted transparent color, clearly draws its imagery from the coast of Britain. The vignette format recalls Richards's early contribution to illustration, particularly his graphite drawings for the unrealized publication "The Landscape Feeling of American Poets" (see no. 63). Similarly, this sheet was probably painted from memory. With each visit to the British coast, Richards amassed a growing stock of sketches and studies later used for reference in his American studio.

Though painted a decade later, the present sheet bears similarities to *Surf Breaking on Coastal Rocks* (see no. 77), the recollection of Turner being a particular corollary. The watercolor is sparingly painted in translucent tones. In the atmospheric haze, heavy clouds obscure the distant mountainside. The ab-

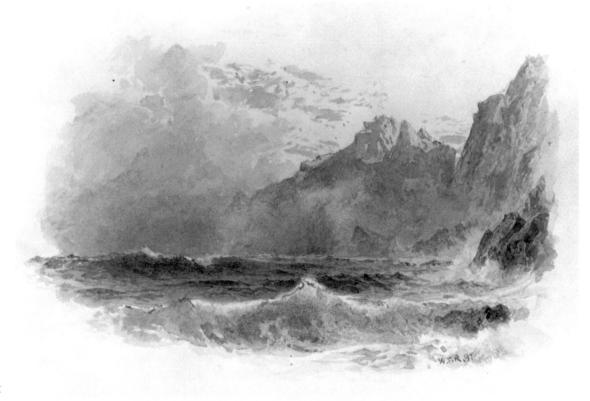

81

sence of gouache gives the whole an airiness and allows the subtle gradations of tinted wash to penetrate to the surface. Richards's confidence as a watercolorist is very evident here; for in using just a minimum of brushstrokes he has achieved a gentle balance in capturing nature's forces. The vignette arrangement, seemingly for some illustrative purpose, is a measure of his ongoing interest in the art of illustration some fifty years after his first forays in the field.

Walter Shirlaw

Paisley 1838 — Madrid 1909
ANA 1887, NA 1888

THOUGH PRIMARILY a mural painter, teacher, and illustrator, Walter Shirlaw produced some evocative landscape paintings and drawings during his career. Born in Paisley, Scotland, where his father was a maker of hand looms, Shirlaw grew up in Hoboken, New Jersey.[1] At the age of twelve, he left school to work in a real estate firm making maps and plans. From there, he apprenticed as a bank note engraver at Rawdon, Wright, Hatch, and Edson in New York, while taking night classes at the National Academy of Design.[2] By 1861 he was exhibiting his work at the National Academy and the Pennsylvania Academy of the Fine Arts. Financial problems, however, caused him to abandon his career as a professional painter temporarily and accept a lucrative job as superintendent for the Western Bank Note Company in Chicago. While in the Midwest, he succeeded financially and professionally, becoming a founder of the Chicago Academy of Design (later the Art Institute of Chicago). Determined to further his artistic education abroad, Shirlaw left his job in 1869, and a year later embarked for Europe.

The Franco-Prussian War prevented him from studying in Paris as he had planned, so he went instead to the Royal Academy in Munich, which by the 1870s had replaced its counterpart in Düsseldorf as the leading German art school. During the next seven years there, Shirlaw studied drawing with Georg Raab and painting with Alexander von Wagner, Arthur Georg Freiherr von Ramberg, and Wilhelm von Lindenschmit. In Munich, he painted his first two important works, *Toning the Bell*, 1874 (Art Institute of Chicago), which won a medal at the Centennial Exhibition in Philadelphia and *Sheep Shearing in the Bavarian Highlands* (location unknown), which won Honorable Mention at the 1877 Paris Exposition. Both works displayed the realist style, bravura brushwork, and *alla prima* painting technique that were encouraged at the Munich Academy under the directorship of Karl von Piloty.[3] There, Shirlaw formed close and long-lasting friendships with fellow American artists Frank Duveneck (1848–1919) and William Merritt Chase (1849–1916), with whom he went on summer sketching and painting trips to Polling, a small village near Weilheim, thirty-five miles south of Munich. Examples of early 1870s graphite landscape drawings of Polling, now in the National Design Museum, display dense graphite hatchings to convey strong contrasts of light and shadow, as well as energetic movement.

Upon returning to New York in 1877, Shirlaw was an immediate success, and for the next four years he was among the leaders of his profession in New York. His painting *Sheep Shearing* was praised at the 1877 National Academy of Design exhibition and declared the picture of the year. Also in 1877, he was elected the first president of the Society of American Artists—an organization of young artists created to protest the exhibition hanging policy of the National Academy. The same year, he was appointed professor of painting and drawing at the Art Students' League, where he taught. Three years later, in 1880, an exhibition of Shirlaw's work was held at Doll & Richards in Boston. He then went to London for a year, where he exhibited at the Royal Academy. Upon his return to New York, he continued to teach at the Art Students' League until 1891 and at the Cooper Union Woman's Art School from 1884 to 1887.

Shirlaw also earned his living making illustrations in charcoal primarily for *Scribner's Monthly* and *Harper's New Monthly Magazine*. In 1890 he was sent by the United States government to the Crow and Cheyenne reservations in Montana to record tribal life. He published some of his lively watercolors in the *Century Magazine*.[4] During the 1890s, he also participated in the great mural decorating projects for private and public buildings. For the 1893 World's Columbian Exposition in Chicago , he decorated one of the domes in the Manufactures and Liberal Arts building on the theme "Abundance of Land and Sea." His powerfully plastic allegorical figures with decorative, elaborate draperies echoed the tradition of sixteenth-century Italian fresco painting. Two years later, he painted a ceiling mural in the Library of Con-

gress, depicting the eight sciences. During the course of his career, Shirlaw worked in France, the Netherlands, Italy, England, and Spain. Among his pupils were the mural painter Robert Reid (1862–1929), the collector Katherine S. Dreier, and her sister, Dorothea A. Dreier.

Shirlaw's work is important in this exhibition of American landscape drawing as an example of the emotive, painterly, Munich-inspired drawing style.[5] While he only occasionally painted landscape for its own sake, throughout his career he did execute landscape drawings to use in preparation for the backgrounds of his figure paintings and for his landscapes with animals. After 1877, he frequently drew views of the countryside in Vermont and painted watercolors of Annisquam, Cape Ann, and Plumb Island in Massachusetts.

A word should be added about the Shirlaw drawings in the collections of the National Academy and the National Design Museum. After the artist's death, the Folsom Galleries in New York, with the help of Shirlaw's widow, Florence Manchester Shirlaw, organized a traveling exhibition of two hundred examples of Shirlaw's oil paintings, watercolors, and drawings. It traveled to the City Art Museum, St. Louis; the Buffalo Fine Arts Academy; the Art Institute, Chicago; the Carnegie Institute, Pittsburgh; the National Arts Club, New York; and the Corcoran Gallery of Art, Washington. Anxious to establish her husband's place in American painting, Mrs. Shirlaw donated portions of his estate to museums throughout the country, over the next few years. The majority of his drawings were given to the Cooper Union, the Museum of Fine Arts, Boston, and the Cincinnati Art Museum. In 1953, Katherine S. Dreier left a bequest of additional Shirlaw works to the National Academy of Design. After retaining some of the material for that collection, the Academy then distributed the remaining portion among other institutions. The National Design Museum was once more the recipient of the Academy's largesse with the receipt of ten more Shirlaw drawings. Today, Cooper-Hewitt National Design Museum holds nearly one hundred and forty Shirlaw drawings from all aspects of his career, including bank note designs, figure studies for mural paintings, drawings for illustration, and nature studies—the largest collection of Shirlaw's work in the country. GSD

1. The basic biographies on Shirlaw are: Bartlett, in Montgomery 1889, 1, pp. 53–78; Shirlaw 1912–1913, pp. 64–67; Dreier 1919, pp. 206–216. The most recent sholarship is Ketelhohn 1986 and Cooke 1988. The author thanks James Cooke for reviewing these entries.

2. Bartlett, in Montgomery 1889, 1, p. 20; the firm merged to form the American Bank Note Company in 1858.

3. On the history of the Royal Academy in Munich and its curriculum, see Quick, in Sacramento 1978, pp. 21–36; Quick, in Cincinnati 1987, pp. 14–16.

4. Shirlaw 1893, pp. 41–45.

5. In fact, the *alla prima* painting technique taught at the Munich Academy discouraged sketching in graphite and encouraged instead drawing in paint directly on canvas. In the United States, Shirlaw was criticized for his lack of drawing ability; see Dreier 1927, p. 51.

82

River and Trees, 1880–1890

Graphite on paper

10 x 6⅞ inches (255 x 175 mm)

Initialed with monogram in graphite, lower left: *W S*; inscribed and signed in graphite on paper attached to back of mount: *Nature Study Walter Shirlaw N. A.*

Cooper Union stamp 1, lower center

Cooper-Hewitt National Design Museum, Smithsonian Institution

Gift of Mrs. Walter Shirlaw, 1912–16–61

Describing her husband's landscapes, Florence Manchester Shirlaw called them "moods of Nature approached with a calm and wise judgment, always painted with movement and decision . . . with life and stir."[1] This drawing of a river with trees in the background is filled with "life and stir." Employing a velvety soft graphite pencil, Shirlaw worked over heavily textured paper in a series of short, energetic strokes, creating an emotion-filled view. The graphite caught the vertical chain lines in the paper producing a textured surface that further enlivens the scene. As the river flows swiftly from right to left, it creates eddies around small stones on the river bottom and rolls down a short waterfall at the drawing's left edge. The bare paper surface suggests daylight reflecting on the rushing water. Using different densities of graphite markings, Shirlaw described the tree trunks in vertical strokes and small masses of foliage with short broad diagonal hatchings. In between the trees bordering the far side of the river, a partial fence may be seen and possibly a figure lifting a log over the fence. The presumed figure has been heavily hatched over

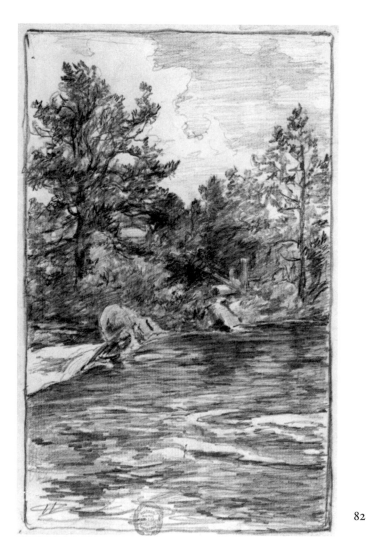

82

thereby creating an area of shadow that is also reflected in the water. Above the treetops, some lighter horizonal hatching creates clouds at the right, leaving the white of the paper to convey light coming through the clouds on the left.

Shirlaw's forceful handling of graphite in this drawing contrasts sharply with his early landscape style, so dependent on the controlled hatching technique typical of bank note engraving. Cooper-Hewitt National Design Museum has a number of his landscape drawings executed in the Bavarian village of Polling in the mid-1870s which display tight vertical, horizontal, and diagonal hatches for describing trees and buildings.[2] After returning to the United States in 1877, Shirlaw created a number of landscape studies in Hastings, New York, several of which are in the

National Design Museum. One of these, *Trees on a Hillside*, reveals a similar vocabulary of diagonal and vertical hatchings but with a softer graphite and a stronger massing of light and dark areas.[3] In the interim between these drawings and the one seen here Shirlaw became an accomplished etcher. During the mid-1880s, he exhibited his etchings as a member of the New York Etching Club.[4] His work in this medium demonstrates a varying line, from short choppy strokes to long finer strokes, and may have helped to liberate his handling of graphite and heighten his interest in mood and reverie as seen in *River and Trees*.[5] During the late 1870s and 1880s this emotive approach to landscape challenged the careful descriptive landscape style of the earlier Hudson River school artists.

After 1877, Shirlaw spent many summers sketching in southwestern Vermont, around Dorset and Manchester. Returning from a stay in Manchester in September 1883, Shirlaw carried with him "several broadly handled and effective out-of-door scenes: one view with figures at work in an oat field during the harvest; two others are views on the shores of a rocky brook."[6] This account indicates the varied Vermont landscape that attracted Shirlaw's attention and suggests that *River and Trees* may well depict a Vermont scene.

1. Shirlaw 1912–1913, p. 67.

2. For example *Tree Study with Road*, Cooper-Hewitt National Design Museum, 1912- 16–64.

3. Cooper-Hewitt National Design Museum, 1912–16–24.

4. For Shirlaw's membership and participation in the New York Etching Club exhibitions, see *New York Etching Club* catalogues for 1882–1889.

5. The author wishes to thank Kathleen A. Foster for suggesting a possible connection between Shirlaw's drawings and his prints. An example of Shirlaw's etchings is *Figures behind a Walled Garden* (undated but probably from the mid-1880s), New York Public Library (MEYG). Also among Shirlaw's etchings is a *Portrait of Sylvestor Rosa Koehler*, 1885, the first curator of prints at the Museum of Fine Arts, Boston, executed while Koehler was delivering a lecture on printmaking techniques. Koehler was instrumental in promoting etching in the 1880s. On Shirlaw's etchings, see Ketelhohn 1986, pp. 55–59; 3, CPr1–CPr10.2.

6. *Studio* 1883, p. 144.

Francis Hopkinson Smith

Baltimore 1838 — New York 1915

An accomplished civil engineer, an enthusiastic traveler, a facile writer of anecdotal novels and picturesque travelogues, Francis Hopkinson Smith also created numerous charcoal drawings and watercolors of New England landscapes and European views which were much exhibited and highly praised during his lifetime.

As a teenager, Smith studied the fundamentals of drawing with Baltimore artist Alfred Jacob Miller (1810–1874) and acquired what was to become a lifelong practice of sketching outdoors, but he was essentially self-taught as an artist. Forced to interrupt his schooling to support his family, Smith worked in a Baltimore iron foundry. After the Civil War broke out in 1861, he moved to New York where he soon established an engineering business in partnership with James Symington. Over the next thirty years, they received many public works commissions, notably the sea wall surrounding Governor's Island in New York Harbor, the Race Rock Lighthouse (off New London, Connecticut), and the foundation of the Statue of Liberty. In the summers, Smith traveled for relaxation and artistic inspiration.

In the 1860s and 1870s, Smith vacationed mostly in the White Mountains of New Hampshire. The natural beauty of the region had attracted other artists before him, among them Thomas Cole (q.v.), Asher B. Durand, and Daniel Huntington (q.v.), and, by Smith's day, it was a popular tourist resort. He created hundreds of drawings and watercolors during these vacations. Exhibiting for the first time in 1867, he submitted a watercolor to the inaugural exhibition of the American Society of Painters in Watercolors (later the American Water Color Society), which admitted him as an associate member in 1869 and as a full member in 1873. At the 1876 Centennial Exhibition in Philadelphia, he exhibited four White Mountain scenes.

In 1881, Smith began to travel farther afield, first to Cuba and later to the Caribbean Islands and Mexico. After 1884, he regularly visited Europe—primarily touring in England, France, Holland, Italy, Spain, and Switzerland. He exhibited a selection of his European views each year. Since Venice was a favorite destination from the 1890s until his death, Venetian canals, piazzas, architecture, and vistas are predominant in his art.

Although he had done some minor work in book illustration, his literary career was launched in 1887 with *Well-Worn Roads of Spain, Holland and Italy, Traveled by a Painter in Search of the Picturesque*, which featured autobiographical travel stories and impressions, accompanied by his own illustrations. The popularity of this work prompted similar illustrated travel books: *A White Umbrella in Mexico* (1889), *Venice Today* (1896), *Gondola Days* (1897), *In Thackeray's London* (1913), and *In Dickens's London* (1914). However, it was his first novel, *Colonel Carter of Cartersville* (1891), that was lucrative and brought him national attention, thereby enabling him to give up his engineering business and devote the rest of his life to writing, lecturing, traveling with his family, and artistic pursuits. Other novels followed between 1892 and 1911.

Although Smith was an amateur artist, he assumed a frequently publicized place in New York art circles. Admiration for his style of descriptive realism

prompted wealthy collectors John Jacob Astor and Charles F. Havemeyer to acquire some of Smith's drawings and watercolors. Reviews of Smith's exhibitions in New York (1880s to 1915), Boston (1892), Cleveland (1894), and Buffalo (1906) favorably noted the artist's technical mastery in conveying the fresh qualities of nature and brilliant effects of sunshine and shadow.[1] His preference for drawing outdoors in either watercolor or charcoal helped promote interest in these media and his own plein-air approach. As he proclaimed: "I have never in my whole life painted what is known as a studio picture evolved from memory or from my inner consciousness, or from any one of my outdoor sketches. My pictures are begun and often finished at one sitting."[2]

While works by Smith frequently appear in the American auction market, only a few major museums have him represented in their collections, including the Brooklyn Museum, the Mead Art Museum in Amherst, the Boston Museum of Fine Arts, and the National Museum of American Art, Washington. The Cooper-Hewitt National Design Museum possesses twenty-seven drawings by this artist: a view of Venice given in 1901 by Smith himself, and twenty-six given in 1923 by his widow Josephine Smith.[3]

MS

1. Notices about Smith's work appeared in such publications as: *New York World*, May 19, 1881, p. 4; *Boston Daily Evening Transcript*, February 2, 1892; *Sketchbook* 5 (June 1906), pp. 347–351; *Buffalo Academy Notes*, 1 (April 1906); *Journal of the American Institute of Architects* 2 (April 1914), p. 184ff. Following Smith's death, interest in his work declined, partly because modern art eclipsed nineteenth-century representational styles. His artistic reputation was revived in 1985 through the excellent essays by Teresa Carbone and Nick Madormo (see New York 1985 and Madormo 1985).

2. Smith 1915, p. 3. Although Smith often publicly claimed to finish his drawings at a single sitting, he also made quick studies of nature or European views in sketchbooks (ranging in date from the mid-1870s to the mid-1890s). Several of these are at the Spanierman Gallery, New York.

3. Smith had married Josephine Van Deventer in 1866, and they had two sons. In 1923, upon her instruction, William Clausen selected twenty-six watercolors and charcoal drawings to present as her gift to the Cooper Union Museum for the Arts of Decoration (now Cooper-Hewitt National Design Museum). These works include a very early descriptive graphite drawing *Mr. Shriner's Farmhouse* (1856); a dozen New Hampshire scenes; *The Old Hopkinson House, Bordentown, New Jersey,* home of the artist's great-grandfather, who signed the Declaration of Independence for New Jersey; other New England scenes; and views of Europe, primarily Venice.

83
Pool in the Woods, 1875

Watercolor and white gouache over graphite on tan paper

13⁹/₁₆ x 20 inches (345 x 508 mm)

Signed and dated in graphite, lower left: *F. Hopkinson Smith/1875*

Cooper-Hewitt National Design Museum, Smithsonian Institution

Gift of Mrs. Francis Hopkinson Smith, 1923–41-24

Smith made his first trip to the White Mountains in the summer of 1863. The wilderness scenery there so captivated him that he returned annually for the next fifteen years to depict the region's mountains, lakes, woods, rocky gorges, and boulders.

While many artists who sketched outdoors were compiling a repertory of studies to aid them in paintings executed later, Smith's New Hampshire drawings and watercolors, like this one, were almost always done as finished renderings. In an 1894 interview, he claimed:

If you are painting an outdoor picture and would truly express what you see, your work must be finished in four hours. . . . A requirement to be insisted upon in out-door painting is rapidity of execution. . . . In these four hours nature keeps comparatively still long enough for you to express some portion of her with your brush.[1]

By 1875 Smith had achieved a fair degree of visibility as an artist and active member of what was then-called the American Society of Painters in Water Colors. His proficiency in the medium was starting to receive favorable critical notice. In 1876, a reviewer wrote:

Mr. Smith's paintings are all of a fresh and summer-like character; and, though the arrangement of his compositions is sometimes a little formal, the detailed objects are well-handled; and whether it be rocks, water, or woodland glades, all indicate a very genuine love of Nature, and that a hard and enthusiastic student is diligently seeking to transcribe her moods.[2]

Such comments are also applicable to this watercolor, which ranks among the best Smith created at this time.

Smith first outlined the composition in graphite— most visible beneath the thinly applied watercolor in the thicket at the top of the sheet, or in the tree roots hanging over the rocky bank at the lower right— and then laid on transparent washes. The fallen tree spanning the brook pool and the log lying on the moss-

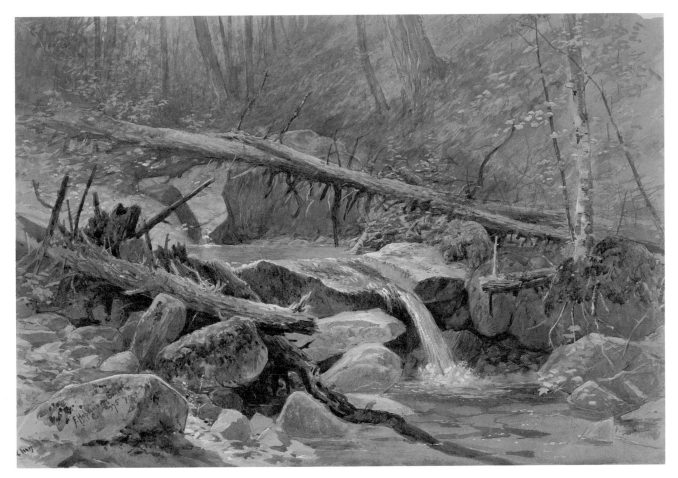

83

covered rocks at the lower left direct the viewer's gaze to the focal point of the picture, water cascading over a boulder. White gouache highlights the splashing water; some mixed with green make the scattered leaves at the right more opaque. By harmoniously balancing green and brown hues and exploiting the luminous qualities possible in watercolor, Smith evokes a sylvan retreat dappled in sunlight.

1. Willets 1894, p. 35.
2. "Smith Watercolors" 1876, p. 347.

84

Fishermen on a Rock, 1878

Charcoal, black and white chalk on gray paper

14⅜ x 22½ in. (366 x 573 mm)

Initialed with monogram and dated in black chalk, lower left: *FHS Sept 8/78*

Cooper-Hewitt National Design Museum, Smithsonian Institution

Gift of Mrs. Francis Hopkinson Smith, 1923–41-3

Smith enjoyed using charcoal (usually on gray or pale-colored paper) as his primary drawing medium from the 1870s until his death. This work is typical of the grisaille tonal nuances he could achieve. He extolled the ease of charcoal in one of his lectures:

Charcoal is the unhampered, the free, the personal individual medium. No water, no oil, no palette, no squeezing of tubes, nor mixing of tints; no scraping, scumbling, or other dilatory and exasperating necessities. Just a piece of [char]coal, the size of a small pocket-pencil held flat between the thumb and forefinger, a sheet of paper, and then 'let go.'[1]

In the early 1870s, Smith had taken some classes from R. Swain Gifford (1840–1905), who later taught at Cooper Union and whose landscapes showed inspiration from the Barbizon school. Perhaps through Gifford, Smith was introduced to the artistic example of Camille Corot and J. F. Millet, whose drawings and paintings revealed a massing of tones to re-create atmospheric views (rather than an emphasis on details), somewhat similar to the tonal handling found in this drawing. Later in his career, Smith occasionally cited the art of Corot and the Barbizon school as a model to follow.

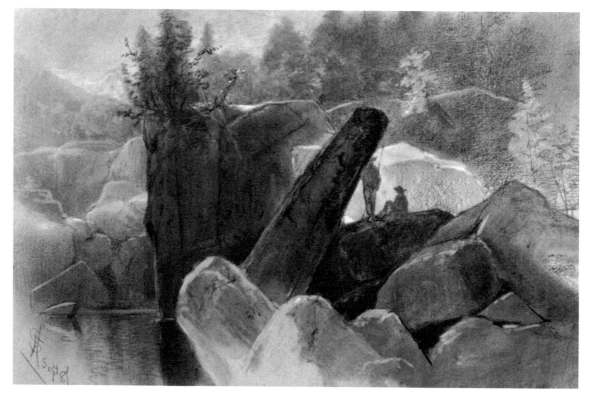

84

In this White Mountain scene, Smith placed his darkest darks and whitest highlights in the center of a sculptural arrangement of huge granite boulders. Two fishermen are silhouetted against a sunlit boulder, while beneath them intense black defines the hollows between the stones.[2] Around this riveting focal point, Smith tapers his tones into differing shades of light gray to suggest solid stone, feathery foliage, or the reflecting pool. In the National Design Museum's collection, another charcoal drawing, *Rock Cliff* (1923–41–1), bears the same date and was probably drawn at the same place.

1. See Smith 1914, p. 184. From address to the Architectural League on the use of charcoal.

2. See Strahan 1883, p. 64, where he noted that Smith's compositions revealed a deliberate selection of the darkest dark and the lightest light and that Smith placed the human figure where it would balance some striking accent in the scene.

Elihu Vedder

New York 1836 — Rome 1923
ANA 1864, NA 1865

AN AMERICAN expatriate in Italy, Elihu Vedder was drawn to the simple, quiet towns of the Roman Campagna rather than to the grandiose monuments of antiquity. His was a truly arcadian vision, characterized by intent observation of the rough contours and earthy tones of the rural landscape. Despite continual market pressures to create figurative works, Vedder executed numerous studies of the Italian countryside, from the mountains of Umbria to the coastal shores of Viareggio.[1] Working in oil, pencil, and pastel, he recorded his impressions of the landscape and returned to the studio to adjust and compose his pictures.

Vedder first traveled to Europe at the age of twenty-one. In Paris, he studied briefly in the atelier of François Edouard Picot, but, driven by "fate, the stupidity of drawing from casts, [and] the roving instinct," he soon left for Italy on foot.[2] In Florence, Vedder improved his draftsmanship under the guidance of Raffaello Bonaiuti, but he gleaned the most significant technical knowledge from his association with the reactionary Macchiaioli group. Painting en plein air, the Macchiaioli rejected traditional realism in favor of a proto-Impressionist aesthetic. Accompanying Nino Costa, a leading figure in the Macchiaioli,

Vedder roamed the countryside, sketching landscapes in broad, flat strokes of color. It was during these early years in Italy that he cultivated the foundations of his stylistic vocabulary. Although his motifs varied greatly throughout his career, he continued to paint in the language of bold lines and color patterning that he developed during this first trip to Italy. Even as early as 1864, James Jackson Jarves recognized the distinctive features of Vedder's style and commented on his talent: "He understands emphasis and punctuation in painting, and has already seized upon that rarest of qualities, the indefinable touch of a master."[3]

When Vedder returned to the United States in the early 1860s, he was made an associate member of the National Academy of Design. Painting in New York and Boston, he began to develop a vivid figurative imagery which appealed to his urban patrons. Vedder depicted a variety of spiritual themes, from the most orthodox biblical depictions to pagan mythology. Paintings such as *The Soul between Doubt and Faith*, 1887 (Herbert F. Johnson Museum, Cornell University, Ithaca, New York), embodied Vedder's ruminative spiritual vision. In addition to classical and Judeo-Christian imagery, he plumbed the depths of his imagination to seek out weird creatures like elves and sea serpents for his pictures.

Vedder returned to Europe in 1866 and, except for several visits to the United States, he made his home in Rome and spent the summers with his family, first in Perugia and later in Viareggio. Often accompanied by other artists, among them Thomas H. Hotchkiss (1833–1869) and Charles Caryl Coleman (1840–1928), Vedder continued his painting excursions through the countryside, sketching the contours of mountains and trees in sinuous lines and recording color in a patchwork pattern. These painted records of his travels in Italy were largely unfinished, and he would return to a sketch ten, twenty, or thirty years later to compose a new painting from it. His landscape sketches also functioned as a kind of visual dictionary from which he would borrow and quote specific forms. Trees, doorways, and rooftops gathered in Italy cropped up in a variety of places including his allegorical works and figure studies.

During the second half of his life, Vedder increasingly turned from easel painting to stained glass, mosaic, mural decoration, and greeting card design. In 1883, he illustrated Edward Fitz Gerald's celebrated translation of the twelfth-century Persian mystical poem, *The Rubaiyat of Omar Khayyam*. The *Rubaiyat*

project brought Vedder widespread popularity in addition to significant financial reward (which enabled him to build a villa in Capri in 1900). In the 1890s, he began using pastels rather than oil paints for both landscapes and figures, and by the time he was seventy, he practically ceased working in oil altogether.[4] In addition to dabbling in a variety of visual media, Vedder wrote and published several books, including two volumes of poetry, *Miscellaneous Moods in Verse* (1914) and *Doubt and Other Things* (1922).

Thirteen years before he died, he published his autobiography, *The Digressions of V.* In it, he described the crucial stages in his career and put forth his central tenets of art and life. "My idea of the aim of art," he wrote, "was first have an idea, and then from your experiences and the nature about you get the material to clothe it . . . take a soul and give it a body."[5] This philosophy underlies all of Vedder's work, both figurative and landscape, oil and pastel, visual and literary. In all, one can discern something beyond what is actually depicted. Beyond the body of unpretentious words or brushstrokes, there invariably lies a mood, an idea, a soul. AM

1. Vedder wrote: "I loved landscape but was eternally urged to paint the figure." Vedder 1910, p. 139.
 2. Ibid., 1910, p. 132.
 3. Jarves 1864, p. 198.
 4. Van Dyke 1937, p. 23.
 5. Vedder 1910, p. 140.

85
Orvieto, 1897

Pastel on dark gray paper

6½ x 12¾ inches (165 x 324 mm)

Initialed and dated in pastel, upper right: *V. / Orvieto / May / 19th/97*

National Academy of Design

Gift of the American Academy of Arts and Letters, 1955
[1980.40]

The decade of the 1890s was a busy time for Vedder. Having secured a reputation for his illustrations to *The Rubaiyat of Omar Khayyam* he received several major mural commissions, including one for the World's Columbian Exposition, which he left unfinished. Later, he painted a ceiling decoration in the Collis P. Huntington mansion in New York and a mural for the Walker Art Gallery at Bowdoin College. In 1896, he designed five panels for the Library of Congress. During these years, Vedder spent long stretches in Italy, returning to the United States only to fulfill his commissions.

In 1897, Vedder was in Rome, concentrating his efforts on the studies for a *Minerva* mosaic which was to face the main entrance at the Library of Congress. The majority of his works from this year were figure studies: allegories, biblical themes, and classical nudes in chalk on heavy gray paper. He sketched *The*

85

Soul in Bondage (Cooper-Hewitt National Design Museum, 1955–38–1) in crayon, outlining the body in black and shading it with white which stood out against the dark ground of the paper. Vedder used pastels and the same type of gray paper for his *Orvieto* drawing. Despite the presence of several warm highlights—green in the foreground, golden orange in the crumbling wall—the small sketch possesses an aura of cold desolation, intensified by the gray ground of the support and the stark white sky.

Orvieto owes much to Vedder's Macchiaioli days. Like many works by his Italian colleagues, the composition is strongly horizontal. This format is exaggerated by the foreground, striped with muddy colors, and the wall, firmly outlined in black crayon. The ensemble of jaggedly formed treetops and roofs against the sky is also characteristically Macchiaioli. Unconcerned with rendering precise detail, he recorded his visual impressions in unmodulated tones, looking to create an overall unity or pattern among the shapes. He has contrasted this color patterning with passages of sharply defined form. The doorway, for example, is crisply drawn, with attention to spatial depth and shadow.

It is unclear whether Vedder actually visited Orvieto in 1897 when he did this small pastel. It would have been an easy trip from his studio in Rome. The scene may have been a product of his mind, a memory of a previous trip to Orvieto during the 1860s and 1870s. Vedder frequently composed pictures from his imagination, culling forms from his many previous excursions. Perhaps *Orvieto* was one such composition. In a year like 1897, when Vedder was so busy with figurative commissions, the Orvieto landscape sketch would have provided a welcome respite.

86
Huts, Viareggio, 1911

Pastel on dark gray paper

6¼ x 8¾ inches (159 x 222 mm)

Initialed and dated vertically in orange pastel, lower right: *V. / Sept / 1911.* Inscribed in black crayon, lower left: *Viareggio*

National Academy of Design

Gift of the American Academy of Arts and Letters, 1955

Viareggio lies on the Italian Riviera, between Pisa and Genoa. Vedder and his family spent summers in the tiny coastal town, beginning in 1880 up until the completion in 1900 of their villa in Capri. Vedder painted and sketched the Ligurian scenery numerous times, from the windswept docks of the port to the pine forests to the thatched huts in the muddy inland. He returned often to the huts, attracted to their unique mushroom shape and organic quality. He wrote in *The Digressions of V:*

> These huts of Viareggio, owing to the dampness of their location, get to be of a velvety blackness from the mingling of black and green moss; bright green vines grow over them, with orange coloured gourds, and the evening sun through the trees flecks them with orange gold.[1]

In preparation for an exhibition at the Macbeth Gallery in New York in January of 1911, Vedder dug up a number of his Viareggio sketches from the 1880s and repainted them. A small oil in the collection of Kennedy Galleries, New York, entitled *Huts, Viareggio* (fig. 17), was, according to an inscription on the back, "commenced long ago [and] finished [in] 1911." The oil painting presents an interesting contrast to this pastel. The pastel, which is only slightly smaller than the oil, was probably executed after the painting because it is dated September 1911. It is possible that Vedder returned to Viareggio at the end of 1911 and sketched the huts again, taking care to record the rich browns and golds of the early autumn landscape. The huts, however, were clearly imprinted in his memory, and another visit to Viareggio in 1911 would not have been necessary for him to complete this small study in pastel.

Vedder may have found pastel a more appropriate medium than oil for rendering atmospheric effects. Thus he could easily re-create the thatched hut motif by switching media. In the pastel, the huts occupy the left half of the composition, whereas in the painting they are pushed to the foreground, front and center.

Fig. 17. Vedder, Huts, Viareggio, *1911, oil on canvas, Kennedy Galleries, New York*

Vedder's prime concern in the pastel is to convey an environment rather than focus on the huts. He accomplishes this through his usual play of rhythmic color patterning and dark outlines, accenting unmodulated tones with highlights of orange and gold. The gray ground of the paper permeates the composition, enhancing the luminous highlights by contrast.

The huts in the pastel are primarily interesting shapes with sinuous contours, just as the surrounding mountains and trees are significant mainly for their formal presence. Vedder organized his composition by layering the various forms on top of one another and knitting them together with black lines to form a kind of picturesque quilt. In contrast, he was much more attentive to the huts as objects in the oil painting, taking care to delineate interior space and three-dimensionality. In the oil, Vedder's trees have individual leaves and branches while in the pastel they are amorphic configurations.

1. Vedder 1910, p. 500.

Bibliography

Adams et al. 1985
Henry Adams, John Caldwell, John R. Lane, Kenneth Neal, and Elizabeth A. Prelinger, *American Drawings and Watercolors in the Museum of Art*, Pittsburgh, 1985.

Adams 1990
Henry Adams, "The Identity of Winslow Homer's 'Mystery Woman,'" *Burlington Magazine* 132 (April 1990), pp. 244–252.

Adamson 1981
Jeremy Elwell Adamson, *Frederic Edwin Church's "Niagara": The Sublime as Transcendence*, 3 vols., Ann Arbor, 1981; Ph.D. diss., University of Michigan.

Aitken 1926
Robert Ingersoll Aitken, ed., *Arnold Brunner and His Work*, New York, 1926.

Albany 1993
Christine T. Robinson, John R. Stilgoe, Ellwood C. Parry III, Frances F. Dunwell, *Thomas Cole: Drawn to Nature*, exh. cat., Albany Institute of History & Art, Albany, 1993.

Altman 1938
Sol Altman, "U.S. Designers & Engravers of Bank Notes and Stamps," 1938, unpublished manuscript, Print Room, New York Public Library.

Appleton 1985
Carolyn M. Appleton, "Indians Taxed and Indians Not Taxed: Walter Shirlaw, Gilbert Gaul and the 1890 Census," *Gilcrease Magazine* 7 (January 1985), pp. 29–32.

Atlanta 1972
The Düsseldorf Academy and the Americans: An Exhibition of Drawings and Watercolors, exh. cat., Munson-Williams-Proctor Institute, Utica, New York; National Collection of Fine Arts, Washington; and High Museum, Atlanta, 1972.

Bardin 1985
Robert Bardin, "The Studio Work: Another Perspective on Samuel Isham," Master's thesis, Columbia University, New York, 1985.

Bartlett 1889
Truman Howe Bartlett, *American Art in American Collections*, 2 vols., Boston, 1889.

Bassford/Fryxell 1967
"Home–Thoughts, from Afar: Letters of Thomas Moran to Mary Nimmo Moran," Amy Bassford, ed., intro. and notes by Fritiof Fryxell, East Hampton, New York, 1967.

Benjamin 1879
Samuel Greene Wheeler Benjamin, *Our American Artists*, Boston, 1879.

Benjamin 1881
Samuel Greene Wheeler Benjamin, "Daniel Huntington, President of the National Academy of Design," part I, pp. 223–228, and, "Daniel Huntington, Second and Concluding Article," part II, pp. 1–6, *American Art Review* 2 (1881).

Berger 1980
Maurice Berger, "Arnold Brunner's Spanish and Portuguese Synagogue: Issues of Reform and Reaffirmation in Late Nineteenth–Century America," *Arts Magazine* 54 (February 1980), pp. 164–67.

Bermingham 1988
Peter Bermingham, *Barbizon Art in America: A Study of the Role of the Barbizon School in the Development of American Painting, 1850–1895*, Ann Arbor, 1988; Ph.D. diss., 1972, University of Michigan.

Betts 1974
Richard B. Betts, "The Streets of Belmont and How They Were Named," 1974, unpublished manuscript, Belmont Historical Society, Belmont, Massachusetts.

Betts 1985
Richard B. Betts, *Footsteps through Belmont*, Belmont, Massachusetts, 1985.

Bolger et al. 1989
Doreen Bolger et al., *American Pastels in the Metropolitan Museum of Art*, New York, 1989.

Bolton 1921
Theodore Bolton, *Early American Portrait Painters in Miniature*, New York, 1921.

Boston 1992
Theodore E. Stebbins, Jr., *The Lure of Italy: American Artists and the Italian Experience, 1760–1914*, exh. cat., Museum of Fine Arts, Boston; Cleveland Museum of Art; Museum of Fine Arts, Houston; Boston, 1992.

Boston 1993
Sue Welsh Reed and Carol Troyen, *Awash in Color: Homer, Sargent, and the Great American Watercolor*, exh. cat., Museum of Fine Arts, Boston, 1993.

Brooklyn 1985
Linda S. Ferber and William H. Gerdts, Jr., *The New Path: Ruskin and the American Pre-Raphaelites*, exh. cat., Brooklyn Museum; Museum of Fine Arts, Boston; New York, 1985.

Brooklyn and Philadelphia 1973
Linda S. Ferber, *William Trost Richards: American Landscape and Marine Painter*, exh. cat., Brooklyn Museum; Pennsylvania Academy of the Fine Arts, Philadelphia; Brooklyn, 1973.

Brownell 1895
W. C. Brownell, "Recent Work of Elihu Vedder," *Scribner's Magazine* 17 (1895), p. 157.

"Brunner Drawings" 1928
"Arnold Brunner Drawings Given to Cooper Union Widow of Noted Architect Provides Collection, Including Water Colors, to Be Permanent Exhibition . . . Students in Free Arts Courses of Union to Benefit by Study of Master's Methods," *New York Herald Tribune*, January 29, 1928.

"Brunner's Work Placed" 1927
"Arnold Brunner's Work Permanently Placed in Cooper Union," *American Institute of Architects Journal* 15 (1927), pp. 385–391, 397.

Bryant 1848
William Cullen Bryant, *Exhibition of the Paintings of the Late Thomas Cole, at the Gallery of the American Art–Union*, New York, 1848.

Caldwell and Rodriguez Roque 1994
John Caldwell and Oswaldo Rodriguez Roque, *American Paintings in the Metropolitan Museum of Art, Volume I: A Catalogue of Works by Artist Born by 1815*, New York, 1994.

Campbell 1985
Catherine H. Campbell, *New Hampshire Scenery*, Canaan, New Hampshire, 1985.

Carr 1980
Gerald L. Carr, *Frederic Edwin Church: The Icebergs*, Dallas, 1980.

Carr 1990
Gerald L. Carr, "Master and Pupil: Drawings by Thomas Cole and Frederic Church," *Bulletin of the Detroit Institute of Arts* 66 (1990), pp. 47–60.

Carr 1994
Gerald L. Carr, *Frederic Edwin Church: Catalogue Raisonné of Works of Art at Olana State Historic Site*, 2 vols., Cambridge and New York, 1994.

Carter 1879
S. N. Carter, "The Water-Color Exhibition," *Art Journal* 5 (March 1879), pp. 93–95.

Cincinnati 1987
An American Painter Abroad: Frank Duveneck's European Years, exh. cat., Cincinnati Art Museum, 1987.

Clark 1927
Eliot Clark, "Studies by American Masters at Cooper Union," *Art in America* 15 (June 1927), pp. 180–188.

Clark 1954
Eliot Clark, *History of the National Academy of Design, 1825–1953*, New York, 1954.

Clark 1980
Carol Clark, *Thomas Moran: Watercolors of the American West*, Austin, 1980.

Cole Papers
Thomas Cole Papers, New York State Library, Albany. On microfilm, Archives of American Art, Smithsonian Institution, ACL–I.

Cooke 1961
Hereward Lester Cooke, "The Development of Winslow Homer's Water-Color Technique," *Art Quarterly* 24 (Summer 1961), pp. 169–191.

Cooke 1988
James Cooke, "Individualism and Tradition: Walter Shirlaw and the American Artist's Experience in Munich," Master's thesis, University of Illinois, Urbana-Champaign, 1988.

Cooper Union Annual Report
Cooper Union Annual Report, New York, 1896 through 1920.

Cowdrey 1943
Mary Bartlett Cowdrey, comp., *National Academy of Design Exhibition Record, 1826–1880*, 2 vols., New York, 1943.

Craven 1976
Wayne Craven, "Samuel Colman: Rediscovered Painter of Far–Away Places," *American Art Journal* 7 (May 1976), pp. 16–37.

Cummings 1865
Thomas Seir Cummings, *Historic Annals of the National Academy of Design*, Philadelphia, 1865. Reprint: Kennedy Galleries, New York, 1969.

DAB
Dictionary of American Biography, Allen Johnson and Dumas Malone, eds., 22 vols., New York, 1946.

Davidson 1983
Marshall Davidson, *The Drawing of America: Eyewitness to History*, New York, 1983.

De Silva 1970
Ronald Anthony De Silva, "William James Bennett," Master's thesis, University of Delaware, Newark, 1970.

Deák 1988
Gloria Deák, *Picturing America, 1497–1899: Prints, Maps and Drawings Bearing on the New World Discoveries and on the Development of the Territory That Is Now the United States*, 2 vols., Princeton, 1988.

Dearinger 1982
David B. Dearinger, "Charles Cromwell Ingham: Exhibitions and Critical Response," unpublished seminar paper, Graduate Center, City University of New York, 1982.

Dee 1975
Elaine Evans Dee, "Drawings of Winslow Homer," *Antique Collector* 46 (January 1975), pp. 44–47.

Dee 1982
Elaine Evans Dee, *Nineteenth–Century American Landscape Drawings*, Washington, 1982.

Downes 1887
W. H. Downes, "Elihu Vedder's Pictures," *Atlantic Monthly* 49 (June 1887), p. 845.

Dreier 1919
Dorothea A. Dreier, "Walter Shirlaw," *Art in America* 7 (Autumn 1919), pp. 206–216.

Dreier 1927
Katherine S. Dreier, "Walter Shirlaw," *Brooklyn Museum Quarterly* 14 (April 1927), pp. 51–54.

Dunlap 1834
William Dunlap, *A History of the Rise and Progress of the Arts of Design in the United States*, 2 vols., New York, 1834. Reprint: Dover Publications, New York, 1969.

Durand 1855
Asher B. Durand, "Letters on Landscape Painting, Letter II," *Crayon* 1 (January 17, 1855), pp. 34–35.

East Hampton 1969
East Hampton: The American Barbizon, exh. cat., Guild Hall Museum, East Hampton, New York, 1969.

East Hampton 1976
Artists and East Hampton, exh. cat., Guild Hall Museum, East Hampton, New York, 1976.

Edmonds 1985
Catharine Livingston Edmonds, "The Road to Petra," *Arts & Antiques* 2 (February 1985), pp. 81–84.

Fabri 1969
Ralph Fabri, *History of the American Water Color Society: The First Hundred Years*, New York, 1969.

Faude 1975
Wilson Faude, "Associated Artists and the American Renaissance in the Decorative Arts," *Winterthur Portfolio* 10 (Winter 1975), pp. 9–130.

Felker 1992
Tracie Felker, "First Impressions: Thomas Cole's Drawings of His 1825 Trip Up the Hudson River," *American Art Journal* 24 (1992), pp. 60–93.

Ferber 1978
Linda S. Ferber, "William Trost Richards at Newport," *Newport History, Bulletin of the Newport Historical Society* 51 (Winter 1978), pp. 1–15.

Ferber 1980a
Linda S. Ferber, "Glorious Infinity: Notes on Light and Its Significance in Some Drawings by William T. Richards," *Drawing* 1 (January–February 1980), pp. 97–100.

Ferber 1980b
Linda S. Ferber, *William Trost Richards (1833–1905): American Landscape and Marine Painter*, New York, 1980; Ph.D. diss., Columbia University.

Fosburgh 1972
Pieter W. Fosburgh, "Winslow Homer, Painter of Fishes and Fishermen," *Conservationist* 26 (1972), pp. 4–7.

Foster 1983
Kathleen A. Foster, "Summary: The Typical American Watercolor Painter and the American Watercolor Movement," vol. I, pp. 340–356, *Makers of the American Watercolor Movement: 1860–1890*, Ann Arbor, 1983; Ph.D. diss., 1982, Yale University.

Gardner 1952
Albert Ten Eyck Gardner, "Ingham in Manhattan," *Bulletin of the Metropolitan Museum of Art* 10 (May 1952), pp. 245–253.

Gerdts, *NAD*
Abigail B. Gerdts, ed., "Catalogue of Paintings and Sculptures in the Collection of the National Academy of Design," unpublished, National Academy of Design, New York.

Gerdts 1964
William H. Gerdts, Jr., *Painting and Sculpture in New Jersey*, Princeton, 1964.

Goodrich 1944
Lloyd Goodrich, *Winslow Homer*, New York, 1944.

Greenhouse 1987
Wendy Greenhouse, "The Daniel Huntington Sketchbook Collection in the National Academy of Design," 1987, unpublished manuscript, National Academy of Design, New York.

Gregorovius 1879
Gregorovius, *The Island of Capri*, trans. by Lilian Clarke, New York, 1879.

Groce and Wallace 1957
George G. Groce and David H. Wallace, *Dictionary of Artists in America, 1564–1860*, New Haven, 1957.

Hamilton 1950
Sinclair Hamilton, *Early American Book Illustrators and Wood Engravers, 1670–1870: A Catalogue of a Collection of American Books . . . in the Princeton University Library . . .*, Princeton, 1950.

Haskell 1942
Daniel C. Haskell, *The United States Exploring Expedition, 1838–1842 and Its Publications, 1844–1874: A Bibliography*, New York, 1942.

Hathaway 1936
Calvin S. Hathaway, "Drawings by Winslow Homer in the Museum's Collection," *Chronicle of the Museum for the Arts of Decoration of Cooper Union* 1 (April 1936), pp. 53–63.

Henderson 1993
Andrea Henderson, "Water Rambles on the Lagoon: William Stanley Haseltine in Venice," *American Art Review* 5 (Winter 1993), pp. 154–160.

Hendricks 1979
Gordon Hendricks, *The Life and Work of Winslow Homer*, New York, 1979.

Henry 1984
John Frazier Henry, *Early Maritime Artists of the Pacific Northwest Coast, 1741–1841*, Seattle, 1984.

Horne 1976
Philip Field Horne, *A Land of Peace: The Early History of Sparta, A Landing Town on the Hudson*, Ossining, New York, 1976.

Howat 1972
 John K. Howat, *The Hudson River and Its Painters*, 1972.
 Reprint: American Legacy Press, New York, 1983.

Humboldt 1849
 Alexander von Humboldt, *Cosmos*, 5 vols., London,
 1849–1859.

Huntington 1966
 David C. Huntington, *The Landscapes of Frederic Edwin
 Church: Vision of an American Era*, New York, 1966.

Ingham 1858
 Charles C. Ingham, "Public Monuments to Great Men,"
 Crayon 5 (November 1858), pp. 303–306.

Isham 1905
 Samuel Isham, *The History of American Painting*, 1905.
 Reprint: Macmillan, New York, 1942.

Ithaca 1971
 Jay E. Cantor, *Drawn from Nature/Drawn from Life:
 Studies and Sketches by Frederic Church, Winslow Homer
 and Daniel Huntington*, exh. cat., Ithaca College
 Museum of Art, Ithaca, New York, 1971.

Jarves 1864
 James Jackson Jarves, *The Art-Idea*, 1864. Reprint:
 Benjamin Rowland, Jr., ed., Belknap Press of Harvard
 University, Cambridge, Massachusetts, 1960.

Johnston 1986
 Patricia Condon Johnston, "Winslow Homer," *Sporting
 Classics* 5 (May/June 1986), pp. 42–51.

Kelly 1987
 Franklin Kelly, *Frederic Edwin Church and the North
 American Landscape, 1845–1860*, Ann Arbor, 1987; Ph.D.
 diss., 1985, University of Delaware.

Kelly 1988
 Franklin Kelly, *Frederic Edwin Church and the National
 Landscape*, Washington, 1988.

Ketelhohn 1986
 Erika Ketelhohn, "Walter Shirlaw: American Artist
 (1838–1909), with a Catalogue Listing of His Known
 Work," Master's thesis, 1986, Tufts University, 3 vols.

King 1860
 Thomas Starr King, *The White Hills: Their Legends,
 Landscape, and Poetry*, Boston, 1860.

Kinsey 1992
 Joni Louise Kinsey, *Thomas Moran and the Surveying of
 the American West*, Washington, 1992.

Koehler 1880
 Sylvester Koehler, "The Works of American Etchers:
 Samuel Colman," *American Art Review* 1 (1880),
 pp. 387–388.

Koke et al. 1982
 Richard J. Koke et al., *American Landscape and Genre
 Paintings in the New-York Historical Society*, 3 vols., New
 York, 1982.

Lanman 1845
 Charles Lanman, *Letters from a Landscape Painter*,
 Boston, 1845.

Levy 1925
 Florence W. Levy, "Arnold Brunner," *American Magazine
 of Art* 16 (1925), pp. 253–259.

Lindstrom 1984
 Gaell Lindstrom, *Thomas Moran in Utah*, Logan, Utah,
 1984.

London 1974
 Turner: 1775–1851, exh. cat., Tate Gallery and Royal Acad-
 emy of Arts, London, 1974.

Los Angeles 1981
 Michael Quick, *American Portraiture in the Grand Man-
 ner: 1720–1920*, exh. cat., Los Angeles County Museum of
 Art, Los Angeles, 1981.

Lynes 1981
 Russell Lynes, *More Than Meets the Eye: The History and
 Collections of Cooper-Hewitt Museum*, Washington, 1981.

Madormo 1985
 Nick Madormo, "Francis Hopkinson Smith (1835–1915):
 His Drawings of the White Mountains and Venice,"
 American Art Journal 17 (Winter 1985), pp. 65–81.

Mandel 1979
 Patricia C. F. Mandel, "A Look at the New York Etching
 Club, 1877–1894," *Imprint* 4 (1979), pp. 31–35.

Manthorne 1989
 Katherine Emma Manthorne, *Tropical Renaissance:
 North American Artists Exploring Latin America, 1839–79*,
 Washington, 1989.

Marzio 1976
 Peter C. Marzio, *The Art Crusade: An Analysis of Ameri-
 can Drawing Manuals, 1820–1860*, Washington, 1976.

Mayor 1965
 Hyatt Mayor, "Aquatint Views of Our Infant Cities,"
 Antiques Magazine 1 (September 1965), pp. 314–318.

McCoubrey 1965
 John McCoubrey, ed., *American Art, 1700–1960: Sources
 and Documents*, Englewood Cliffs, New Jersey, 1965.

McKinsey 1985
 Elizabeth McKinsey, *Niagara Falls: Icon of the American
 Sublime*, Cambridge, Massachusetts, 1985.

Meech-Pekarik 1982
 Julia Meech-Pekarik, "Early Collectors of Japanese
 Prints and the Metropolitan Museum of Art," *Metropoli-
 tan Museum Journal* 17 (1982), pp. 93–118.

Morris 1912
 Harrison S. Morris, *Masterpieces of the Sea, William T.
 Richards: A Brief Outline of His Life and Art*, Philadel-
 phia, 1912.

Moure 1973
 Nancy Dustin Wall Moure, "Five Eastern Artists
 Out West," *American Art Journal* 5 (November 1973),
 pp. 15–28.

Naylor 1973
 Maria Naylor, ed. and comp., *The National Academy of
 Design Exhibition Record, 1861–1900*, 2 vols., New York,
 1973.

New York 1850
Catalogue of Paintings by Daniel Huntington, N. A., Exhibiting at the Art–Union Buildings, 497 Broadway, intro. by Daniel Huntington, exh. cat., New York, 1850.

New York 1893
Catalogue of the Paintings in Oil and Water–Color by Samuel Colman, N. A., Fifth Avenue Galleries, New York, 29 March 1893.

New York 1972
Elaine Evans Dee and John Wilmerding, Winslow Homer, 1836–1910: A Selection from the Cooper–Hewitt Collection, Smithsonian Institution, exh. cat. for traveling exhibit, Cooper–Hewitt National Museum of Design, Smithsonian Institution, New York; Washington, 1972.

New York 1973
Lloyd Goodrich, Winslow Homer, exh. cat., Whitney Museum of American Art, New York; Los Angeles County Museum of Art; Art Institute of Chicago; New York, 1973.

New York 1974
Regina Soria, Elihu Vedder: American Visionary Artist in Rome, exh. cat., Graham Galleries, New York, 1974.

New York 1976
The Natural Paradise: Painting in America, 1800–1950, Kynaston MacShine, ed., exh. cat., Museum of Modern Art, New York, 1976.

New York 1978
William H. Gerdts, Jr., American Luminism, exh. cat., Coe Kerr Gallery, New York, 1978.

New York 1979
Martha Fleischman, Drawings by Elihu Vedder, exh. cat., Kennedy Galleries, New York, 1979.

New York 1980
Next to Nature: Landscape Paintings from the National Academy of Design, Barbara Novak and Annette Blaugrund, eds., exh. cat., National Academy of Design, New York, 1980.

New York 1982
Linda S. Ferber, Tokens of a Friendship: Miniature Watercolors by William T. Richards from the Richard and Gloria Manney Collection, exh. cat., Metropolitan Museum of Art, New York, 1982.

New York 1983a
William Stanley Haseltine: Drawings of a Painter, intro. by John Wilmerding, exh. cat., Davis and Langdale, New York, 1983.

New York 1983b
The Romantic Landscapes of Samuel Colman, exh. cat., Kennedy Galleries, New York, 1983.

New York 1984
Samuel Colman, 1832–1920: Paintings and Drawings, exh. cat., Salander–O'Reilly Galleries, New York, 1984.

New York 1985
Teresa Carbone, Summers Abroad: The European Water-colors of Francis Hopkinson Smith, exh. cat., Jordon–Volpe Gallery, New York, 1985.

New York 1986
Lloyd Goodrich and Abigail Booth Gerdts, Winslow Homer in Monochrome, exh. cat., M. Knoedler & Company, New York, 1986.

New York 1987a
American Paradise: The World of the Hudson River School, intro. by John K. Howat, exh. cat., Metropolitan Museum of Art, New York, 1987.

New York 1987b
Painters in Pastel: A Survey of American Works, intro. by Dianne H. Pilgrim, exh. cat., Hirschl & Adler Galleries, New York, 1987.

New York 1988
Gloria Gilda Deák, William James Bennett, Master of the Aquatint View, intro. by Dale Roylance, commentaries by Roberta Waddell and Theresa Salazar, exh. cat., New York Public Library and Leonard L. Milberg Gallery for the Graphic Arts, Princeton University Library; New York, 1988.

New York 1989a
Abigail Booth Gerdts, An American Collection: Paintings and Sculpture from the National Academy of Design, exh. cat., National Academy of Design, New York, 1989.

New York 1989b
Linda S. Ferber, Watercolors by William Trost Richards, exh. cat., Berry–Hill Galleries, New York, 1989.

New York 1989c
Gail S. Davidson and Elaine Evans Dee, Training the Hand and the Eye: American Drawings from the Cooper–Hewitt Museum, exh. brochure, Cooper–Hewitt National Museum of Design, Smithsonian Institution, New York, 1989 (circulated by SITES).

New York 1992
Meredith E. Ward, William Stanley Haseltine, 1835–1900 — Herbert Haseltine, 1877–1962, exh. cat., Hirschl & Adler Galleries, New York, 1992.

New York 1993
Kevin J. Avery, Church's Great Picture, The Heart of the Andes, exh. cat., Metropolitan Museum of Art, New York, 1993.

Noble 1853
Louis L. Noble, The Course of Empire, Voyage of Life, and Other Pictures of Thomas Cole, N. A., with Selections from His Letters and Miscellaneous Writings: Illustrative of His Life, Character, and Genius, New York, 1853.

Notre Dame 1976
Thomas S. Fern, The Drawings and Watercolors of Thomas Moran, 1837–1926, exh. cat., Art Gallery, University of Notre Dame, Notre Dame, Indiana, 1976.

Novak 1969
Barbara Novak, American Painting of the Nineteenth Century: Realism, Idealism, and the American Experience, New York, 1969.

Novak 1980
Barbara Novak, *Nature and Culture: American Landscape Painting, 1825–1875*, New York, 1980.

Osborne 1993
Carol M. Osborne, "William Trost Richards' Drawings at Stanford," *Drawing* 14 (March–April 1993), pp. 121–124.

Parry 1978
Ellwood C. Parry III, "Thomas Cole and the Practical Application of Landscape Theory," *New Mexico Studies in the Fine Arts* 3 (1978), pp. 13–22.

Parry 1988
Ellwood C. Parry III, *The Art of Thomas Cole: Ambition and Imagination*, London and Toronto, 1988.

Parry 1990
Ellwood C. Parry III, "Thomas Cole's Early Drawings: In Search of a Singular Style," *Bulletin of the Detroit Institute of Arts* 66 (1990), pp. 7–17.

Philadelphia 1992
Elaine Evans Dee, *Frederic Edwin Church: Under Changing Skies*, exh. cat., Arthur Ross Gallery, University of Pennsylvania, Philadelphia; Katonah Museum of Art, Katonah, New York; Hood Museum, Dartmouth College, Hanover, New Hampshire; Philadelphia, 1992.

Pittsfield 1990
Maureen Johnson Hickey and William T. Oedel, *A Return to Arcadia: Nineteenth-Century Berkshire County Landscapes*, exh. cat., Berkshire Museum, Pittsfield, Massachusetts, 1990.

Plowden 1947
Helen Haseltine Plowden, *William Stanley Haseltine: Sea and Landscape Painter (1835–1900)*, London, 1947.

Poesch 1961
Jessie Poesch, *Titian Ramsey Peale (1799–1885) and His Journals of the Wilkes Expedition*, Philadelphia, 1961.

Portland 1981
Samuel Colman, East and West from Portland, exh. cat., Barridoff Galleries, Portland, Maine, 1981.

Price 1979
Edith Ballinger Price, "A Child's Memories of William Trost Richards," *Newport History, Bulletin of the Newport Historical Society* 52 (Winter 1979), pp. 1–9.

Princeton and Hartford 1990
John Wilmerding and Linda Ayres, *Winslow Homer in the 1870s: Selections from the Valentine–Pulsifer Collection*, exh. cat., Art Museum, Princeton University; Wadsworth Atheneum, Hartford, 1990.

Provost 1993
Paul Raymond Provost, "Drawn toward Europe: Winslow Homer's Work in Black and White," *Master Drawings* 31 (1993), pp. 35–46.

Richards Papers
William Trost Richards Papers. Archives of American Art, Smithsonian Institution, Washington.

Roget 1891
John Lewis Roget, *A History of the 'Old Water–Colour Society,' now 'Royal Society of Painters in Water Colours,'* 2 vols., London, 1891.

Ruskin 1990
Judith A. Ruskin, "Thomas Cole and the White Mountains: The Picturesque, the Sublime, and the Magnificent," *Bulletin of the Detroit Institute of Arts* 66 (1990), pp. 19–25.

Rutledge 1945
Anna Wells Rutledge, "Handlist of Miniatures in the Collections of the Maryland Historical Society," *Maryland Historical Magazine* 40 (June 1945), pp. 119–136.

Sacramento 1978
Munich & American Realism in the 19th Century, Richard V. West, ed., exh. cat., E.B. Crocker Art Gallery, Sacramento, 1978.

St. Louis 1984
The Beautiful, the Sublime and the Picturesque, exh. cat., Washington University Gallery of Art, St. Louis, 1984.

San Francisco 1992
Marc Simpson, Andrea Henderson, and Sally Mills, *Expression of Place: The Art of William Stanley Haseltine*, exh. cat., Fine Arts Museum of San Francisco; Brandywine River Museum, Chadds Ford, Pennsylvania; San Francisco, 1992.

Sheldon 1879
George William Sheldon, *American Painters: with Eighty-three Examples of Their Work Engraved on Wood*, New York, 1879.

Sheldon 1882
George William Sheldon, *Hours with Art and Artists*, New York, 1882. Reprint: Garland Publishers, New York, 1978.

Shirlaw 1893
Walter Shirlaw, "Artist's Adventures: The Rush to Death," *Century* 25 (November 1893), pp. 41–45.

Shirlaw 1912–1913
Florence M. Shirlaw [Mrs. Walter Shirlaw], "Biographical Sketch of Walter Shirlaw," *Aesthetics* 1 (October 1912 – July 1913), pp. 64–67.

Simpson 1992
Marc Simpson, "The Early Coastal Landscapes of William Stanley Haseltine," *Antiques* 142 (August 1992), pp. 205–213.

Sleeper and Cantwell 1972
Frank Sleeper and Robert Cantwell, "Odyssey of an Angler," *Sports Illustrated* 37 (December 1972), pp. 62–73.

Smillie Diaries
James David Smillie Diaries. Archives of American Art, Smithsonian Institution, Washington.

"Smith Watercolors" 1876
"Smith's Watercolors from Abroad," *Appleton's Journal* 15 (March 11, 1876), p. 347.

Smith 1914
Francis Hopkinson Smith, "The Charcoal Drawings of Mr. F. Hopkinson Smith Shown at the Annual Exhibition of the Architectural League of New York," [text based on Smith's address to the Architectural League on the use of charcoal], *Journal of the American Institute of Architects* 2 (April 1914), pp. 184–187.

Soria 1970
Regina Soria, *Elihu Vedder: American Visionary Artist in Rome*, Cranbury, New Jersey, 1970.

Spassky 1984
Natalie Spassky, "Winslow Homer at the Metropolitan Museum of Art," *Metropolitan Museum of Art Bulletin* 39 (Spring 1984), pp. 4–48.

Spassky 1985
Natalie Spassky et al., *American Paintings in the Metropolitan Museum of Art, Volume II: A Catalogue of Works by Artists Born between 1816 and 1845*, New York, 1985.

Stauffer 1907
David McNeely Stauffer, *American Engravings upon Copper and Wood*, 2 vols., New York, 1907.

Stebbins 1976
Theodore E. Stebbins, Jr., *American Master Drawings and Watercolors: A History of Works on Paper from Colonial Times to the Present*, New York, 1976.

Stein 1975
Roger B. Stein, *Seascape and the American Imagination*, New York, 1975.

Storrs 1985
Thomas P. Bruhn, *American Etching: The 1880s*, exh. cat., William Benton Museum of Art, University of Connecticut, Storrs, 1985.

Strahan 1883
Edward Strahan, [pseud. Earl Shinn], "F. Hopkinson Smith's Watercolor Drawings," *Art Amateur* 3 (February 1883), pp. 62–64.

Strickland 1913
Walter Strickland, *A Dictionary of Irish Artists*, London, 1913.

Sturges 1987
Hollister Sturges, ed., *The Rural Vision: France and America in the Late Nineteenth Century*, Omaha, 1987.

Syracuse 1979
David Tatham, *Winslow Homer Drawings, 1875–1885, Houghton Farm to Prout's Neck*, exh. cat., Joe and Emily Lowe Art Gallery, Syracuse University, Syracuse, New York, 1979.

Taylor 1868
Bayard Taylor, "A Week on Capri," *Atlantic Monthly* 21 (June 1868), pp. 740–753.

Teitelbaum 1987
Gene W. Teitelbaum, "Winslow Homer in Canada," *Winslow Homer: An Annual* 2 (1987), pp. 3–53.

Thomas et al. 1993
David Hurst Thomas et al., *The Native Americans: An Illustrated History*, Atlanta, 1993.

Tuckerman 1867
Henry T. Tuckerman, *Book of the Artists*, New York, 1867. Reprint: James F. Carr, New York, 1966.

Van Dyke 1937
John C. Van Dyke, *Catalogue Exhibition of the Works of Elihu Vedder*, New York, 1937.

Van Zandt 1966
Roland Van Zandt, *The Catskill Mountain House*, New Brunswick, New Jersey, 1966.

Vedder 1910
Elihu Vedder, *The Digressions of V.*, Boston, 1910.

Vedder 1914
Elihu Vedder, *Miscellaneous Moods in Verse*, Boston, 1914.

Vedder 1922
Elihu Vedder, *Doubt and Other Things*, Boston, 1922.

Wallach 1990
Alan Wallach, "Making a Picture of the View from Mount Holyoke," *Bulletin of the Detroit Institute of Arts* 66 (1990), pp. 35–45.

Washington 1978
Theodore Stebbins, Jr., *Close Observation: Selected Oil Sketches by Frederic E. Church*, exh. cat., Smithsonian Institution, Washington, 1978 (circulated by SITES).

Washington 1979
Perceptions and Evocations: The Art of Elihu Vedder, exh. cat., National Collection of Fine Arts, Smithsonian Institution, Washington, 1979.

Washington 1980
American Light: The Luminist Movement, 1850–1875, John Wilmerding, ed., exh. cat., National Gallery of Art, Washington, 1980.

Washington 1985a
Magnificent Voyagers: The U.S. Exploring Expedition, 1838–1842, Herman J. Viola and Carolyn Margolis, eds., exh. cat., Smithsonian Institution, Washington, 1985.

Washington 1985b
Jeremy E. Adamson, *Niagara: Two Centuries of Changing Attitudes*, exh. cat., Corcoran Gallery of Art, Washington, 1985.

Washington 1988
Odilon Redon: The Woodner Collection, exh. cat., Phillips Collection, Washington, 1988.

Washington 1989
Franklin Kelly, *Frederic Edwin Church*, exh. cat., National Gallery of Art, Washington, 1989.

Washington 1991
The West as America: Reinterpreting Images of the Frontier, 1820–1920, William H. Truettner ed., exh. cat., National Museum of American Art, Smithsonian Institution,

Washington; Denver Art Museum; St. Louis Art Museum; Washington, 1991.

Washington 1994
Thomas Cole: Landscape into History, William Truettner and Alan Wallach, eds., exh. cat., National Museum of American Art, Washington; Wadsworth Atheneum, Hartford; Brooklyn Museum; Washington, 1994.

Washington and New Haven 1986
Helen A. Cooper, *Winslow Homer Watercolors*, exh. cat., National Gallery of Art, Washington; Amon Carter Museum, Fort Worth; Yale University Art Gallery, New Haven; Washington and New Haven, 1986.

Weitzenhoffer 1986
Frances Weitzenhoffer, *The Havemeyers: Impressionism Comes to America*, New York, 1986.

Wilkes 1845
Charles Wilkes, *The Narrative of the United States Exploring Expedition during the Years, 1838, 1839, 1840, 1841, 1842*, 5 vols., Philadelphia, 1845.

Wilkes 1978
Charles Wilkes, *Autobiography of Rear Admiral Charles Wilkes, U.S. Navy, 1798–1877*, James Morgan, David B. Tyler, Joye L. Leonhart, Mary F. Longhlin, eds., intro. by Rear Admiral John D. H. Kane, USN (Ret.), Naval History Division, Department of the Navy, Washington, 1978.

Willets 1894
Gilson Willets, "F. Hopkinson Smith, the Versatile American Who Built Race Rock Lighthouse and Wrote 'Colonel Carter of Cartersville': An Engineer and Contractor, an Artist and a Playwright," *Munsey's Magazine* 11 (May 1894), pp. 141–145.

Wilmerding 1968
John Wilmerding, *A History of American Marine Painting*, Boston, 1968. Also 2nd ed., Abrams, New York, 1987.

Wilmerding 1993
John Wilmerding, "William Stanley Haseltine's Drawings of Maine," *Master Drawings* 31 (Spring 1993), pp. 3–20.

Wilmerding 1994
John Wilmerding, *The Artist's Mount Desert, American Painters on the Maine Coast*, Princeton, 1994.

Yarnall and Gerdts 1986
James L. Yarnall and William H. Gerdts, comps., *The National Museum of American Art's Index to American Art Exhibition Catalogues . . .* , 6 vols., Boston, 1986.

Yonkers 1982
Howard S. Merritt, *To Walk with Nature: The Drawings of Thomas Cole*, exh. cat., Hudson River Museum, Yonkers, New York, 1982.

Yonkers 1983
Francis Murphy, *The Book of Nature: American Painters and the Natural Sublime*, exh. cat., Hudson River Museum, Yonkers, New York, 1983.

Yonkers 1984
Elaine Evans Dee, *To Embrace the Universe: Drawings by Frederic Edwin Church*, exh. cat., Hudson River Museum, Yonkers, New York, 1984.

Yonkers 1986
Linda S. Ferber, *"Never at Fault": The Drawings of William Trost Richards*, exh. cat., Hudson River Museum, Yonkers, New York, 1986.

Index

Numbers in parentheses indicate catalogue entries.

This book has been composed on a Macintosh IIvx computer using QuarkXpress. The typeface is Galliard, designed by Matthew Carter and based on the sixteenth-century typefaces of Robert Granjon. It was printed by Hull Printing Company, Meriden, Connecticut, on Monadnock Dulcet paper, an acid-free sheet for greater longevity. Book design by Christopher Kuntze.